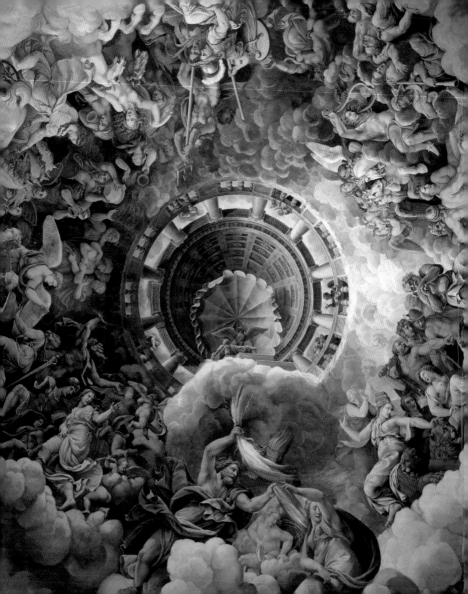

HOW TO READ
SYMBOLS

A crash course in the meaning of symbols in art

HERBERT PRESS
LONDON

Clare Gibson

First published in Great Britain in 2009 by
HERBERT PRESS
An imprint of A&C Black Publishers Limited
36 Soho Square
London W1D 3QY, UK
www.acblack.com

ISBN: 978-1-4081-1265-6

A CIP catalogue record for this book is available
from the British Library

Printed in China

This book was conceived,
designed and produced by

IVY PRESS

210 High Street
Lewes, East Sussex BN7 2NS, UK

CREATIVE DIRECTOR Peter Bridgewater
PUBLISHER Jason Hook
EDITORIAL DIRECTOR Caroline Earle
ART DIRECTOR Michael Whitehead
DESIGN JC Lanaway
ILLUSTRATIONS John Fowler
PICTURE MANAGER Katie Greenwood

CONTENTS

INTROD

We can all appreciate the sensual and aesthetically appealing qualities of art, and have all experienced its power to enchant, delight and move, as well as to depress, shock and disgust. But unless you look beneath an artwork's surface, and unless you then understand what you are viewing, you'll only ever see a small part of the picture. For art communicates largely through symbolism, and a symbol is something that represents something else.

Picking up the clues and making a connection between the symbolic references that artists have encoded in their paintings and artefacts will open your eyes to a rich realm of allusion and hidden meaning. For harnessing the age-old power of symbolism enables both artist and viewer to travel far beyond the limitations of creative media and cultural conventions to delve deep into the human psyche.

The symbolic images in this book have been arranged thematically, as well as geographically, with sacred symbols being followed by symbols of identity and symbolic systems (and in some instances, allegorical symbols, too). Note that certain symbols transcend these boundaries, however, and could consequently have been placed in more than one category – testimony to the complexity of human consciousness and culture.

Some symbols need little explanation – colours, for instance, or the qualities represented by certain birds or beasts – for we respond to them on an instinctive level. Indeed, the pioneering work of the psychoanalysts Sigmund Freud and Carl Gustaf Jung led the way in proposing that the human mind is hardwired to think and communicate symbolically, and that the language of symbols, and particularly of the archetypes, transcends time and space. In this respect, many of the artworks that you'll see in this book, and many of the symbolic details that are discussed alongside them, demonstrate that symbolism truly is an ancient and universal language.

That said, as different civilisations, faiths, societies and cultures evolved the world over, so each developed its own symbolic vocabulary with which to portray and express sacred concepts, aspects of individual and collective identity, and abstract theories and ideas. And in outlining the grammar of symbols and symbolism with reference to an array of wonderful artworks from every era and continent, this book provides a fascinating insight into how, in the words of Oscar Wilde, 'All art is at once surface and symbol'.

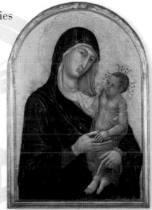

Mother and child
The portrayal of the Madonna and Child conforms to an ancient tradition of celebrating fertility and birth through mother-and-child depictions. So as well as being a profound expression of Christian piety, this is also an archetypal image.

Introduction

See also
Square, page 141
Yggdrasil, page 177

'Man, with his symbol-making propensity, unconsciously transforms objects or forms into symbols . . . and expresses them in both his religion and his visual art', wrote Aniela Jaffé in *Man and His Symbols* (1964), an observation confirmed by every continent's prehistoric rock art. For not only are these ancient images packed with familiar forms such as animals and handprints, but we know that later cultures accorded them symbolic significance. Humankind has therefore probably always made symbols of its surroundings, with 'hunting magic' symbols developing into sacred symbols, symbols of identity and symbolic systems, including those of many different artistic traditions worldwide.

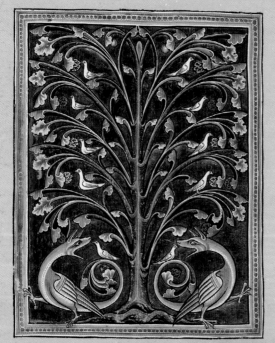

Tree of life
An illustration in the Ashmole Bestiary – a 13th-century English illuminated manuscript – depicts a pair of fantastic creatures snapping at doves perched on the branches of a tree of life. Trees like this are universal symbols of cosmic existence, and of the eternal cycle of life and death.

Tree

While deciduous trees' annual pattern of developing and shedding leaves has led them to signify the life cycle, evergreens symbolise immortality. Some cultures have envisaged a cosmic tree (such as the Norse tree Yggdrasil), while family trees represent continuity, be it of a bloodline or a sacred or esoteric concept.

Witch

According to Jungian theory, humankind's collective unconscious is teeming with archetypal symbols that are unconstrained by either history or geography. They include the witch, typically envisaged as an older woman, a black-hearted mistress of dark magical arts that she uses for malign purposes, aided by an infernal familiar.

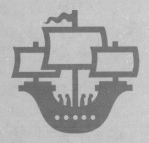

Ship

An example of symbolic visualisation is representing the course of life as a journey. In allegorical paintings, a ship may consequently symbolise the soul's vessel – the body – or the vehicle in which the waters of life are navigated. It may also represent the Christian Church.

Square

Shapes often have symbolic and allegorical significance in art. Its perceived solidity and stability has caused the square, for example, to represent the Earth and matter. Because it has four corners, the square may also allude to such quartets as the cardinal directions, elements and seasons.

The cosmos & the natural world

See also
Re, page 55
Sun *kachina*, page 77

Day-to-day survival was the overriding preoccupation of our early ancestors, which is why hunting scenes are so prevalent in rock art. Humankind's subsequent shift from being nomadic hunter-gatherers to settled agriculturalists was also reflected in its evolving art forms. Both the sun and water were vital for the successful cultivation of crops, for example, yet an optimum annual amount of sunshine and rainfall was not guaranteed. The desire to understand and control such natural forces led to their visualisation as divine beings or phenomena, and to the symbolic representations seen in early examples of sacred art.

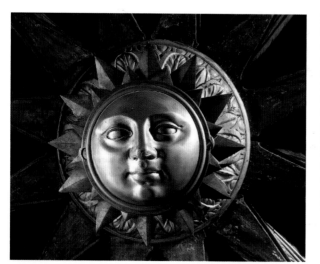

Face of the sun
Stylised portrayals of the solar disc as a human face reflect an ancient belief that the sun was a deity who might travel in a solar chariot. This sunny face was modelled in relief for a wheel of 'The Egyptian', a ceremonial Italian carriage that was built in 1817.

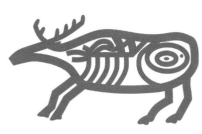

Deer

Deer, antelope, buffalo, bison and other hunted animals – the nature of the species depends on their prevalence – represented food in the Palaeolithic period. Their appearance in rock art symbolises 'hunting magic', or the hope that such depictions would be magically translated into reality.

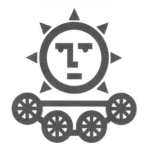

Solar chariot

As sacred symbolic thinking developed, the sun could be envisaged crossing the sky daily in a vehicle. While the ancient Egyptians portrayed this as a solar boat, other cultures imagined a horse-drawn cart or chariot driven, for example, by the Hindu sun god Surya.

Water

Regular rainfall or river inundations are of the utmost importance to the fertility of the land. Those who lived by it once also depended on the sea for sustenance, and the stylised representation of waves seen, for instance, in the art of Mediterranean cultures could consequently symbolise fertility.

Corn and wheat

Food crops are often represented in the art of those who rely on them for survival. As symbols of life, corn and wheat – maybe portrayed as ears or sheaves, and as the attributes of agricultural deities – for example, feature in the art of ancient Egypt, Greece and Rome.

Cosmologies & deities

See also
Zeus/Jupiter,
page 165
The Hindu *Trimurti,*
pages 104–5

The associations initially made between celestial bodies, natural phenomena, life on Earth and divine beings developed into elaborate cosmologies, mythologies and pantheons. In North America, indigenous creatures were envisaged as creator deities or culture heroes, for example, while Australian Aboriginal art depicts complex visions of Dreamtime creators. Of the pantheons, the most historically influential was arguably the Graeco-Roman, although Hindu gods and goddesses are still worshipped today. And despite their disparities (often due to syncretisation, *see page 249*), the fundamental similarity between the symbols and attributes of deities of related types from different pantheons is frequently striking.

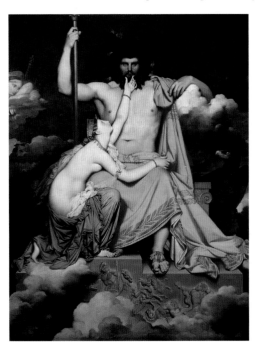

Celestial throne
Clouds obscure the base of Jupiter's throne in French artist Jean Auguste Dominique Ingres's painting *Jupiter and Thetis* (1811). Thetis, the mother of Achilles, is pictured imploring Zeus/Jupiter, the Graeco-Roman sky god and supreme deity, to intervene in the Trojan War in her son's favour.

Clouds

Clouds may simply symbolise rainfall, and plenty, when depicted in art. Yet clouds have an air of mystery about them, being visible, but immaterial; constantly changing; veiling what lies behind them, but sometimes giving way to glorious sunbursts. They may therefore symbolise divine thrones, vehicles or even means of concealment.

Spider

The spider's apparently magical ability to spin a beautiful web from nothing inspires awe. Certain cultures have consequently equated the web with the cosmos, and the spider with cosmic creation: the Native American Navajo tell of Spider Woman, for instance, who also taught Navajo women the art of weaving.

Coyote

The coyote is regarded ambivalently in North American tradition. For while some Native American cultures credit this animal with a role in cosmic creation, also considering Coyote a culture hero, others regard it as a trickster figure. All of Coyote's aspects may be alluded to in Native American art.

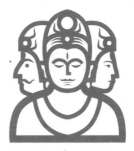

Trimurti

Often symbolised in artistic representations by three fused heads, the trio of Hindu gods that comprise the *Trimurti* are Brahma (the 'Creator'), Vishnu (the 'Preserver') and Shiva (the 'Destroyer'). Together, they represent the universal and interrelated principles of birth, life and death.

Social symbolism & symbolic systems

See also
Crown, page 21
Body art, page 31

As societies developed, so a fusion of symbolism and art was increasingly used to convey aspects of social identity. Collective identity, for example, was signalled by the display of symbols representing a particular tribe or group. Certain symbols came to denote supreme social authority, and were reserved for rulers. Symbolic systems also evolved with which to record and communicate, with early writing systems, such as ancient Egyptian hieroglyphs, initially using pictorial symbols with which to express concepts. In addition, the human imagination dreamed up a collection of fantastic creatures with which to symbolise inexplicable occurrences and complex notions.

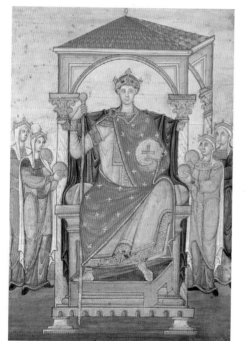

Symbolic regalia
The Holy Roman Emperor Otto II (955–83) is shown receiving the homage of various countries' representatives in an illustration from *The Gospels of Emperor Otto,* an 11th-century German manuscript. Otto's exalted status is signalled by his elevation on a throne and his crown, sceptre and orb.

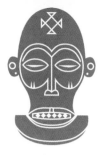

African mask

African masks enable wearers to assume a different identity while simultaneously asserting a collective tribal identity. This Chokwe mask, once worn by chiefs, represents Chihongo, the spirit of prosperity. The cruciform scarification mark on Chihongo's forehead is called the *cingelyengelye* and symbolises Nzambi, the Chokwe creator god.

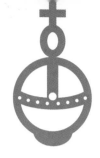

Orb

In formal portraits, European rulers may be portrayed holding an orb. The orb's circular shape equates it with the globe, while the cross that sometimes surmounts it symbolises Christianity. This orb – which is part of British monarchs' and Holy Roman emperors' insignia – signals the holder's global sovereignty as Christ's earthly representative.

Hieroglyphic ideogram

The ancient Egyptians developed a sophisticated writing system based on pictorial symbols, essentially comprising pictograms, ideograms, phonograms and determinatives. The ideogram illustrated above shows a pair of human lower legs, and was used as a determinative denoting movement.

Minotaur

The Minotaur was the offspring of a bull and Pasiphaë (wife of King Minos of Crete), who roamed the royal palace's labyrinth devouring young Athenians until he was killed by the Greek hero Theseus. With his bull's head and man's body, the Minotaur symbolises the animal passions lurking within humankind.

The symbolism of the unconscious mind

See also
Shakti, page 49
Herakles/Hercules,
page 173

The work of Sigmund Freud and Carl Gustav Jung led to a new understanding of human psychology during the 20th century, with concomitant implications for the creation and interpretation of art. Freud introduced the theory that the mind comprises the id, ego and superego, with the id, or subconscious, expressing its instinctual urges – particularly sexual ones – symbolically. According to Jung, the psyche consists of the conscious, the personal unconscious and the collective unconscious, with archetypal symbols – representing universal human experiences – lying within the latter. In both Freudian and Jungian theory, such symbols find an outlet in dreams – and art.

Heroic figure

The bronze figure of an athletic man gripping a stag's antlers as he forces it to the ground dates from the 1st century AD. Discovered at Pompeii, in Italy, this representation of the archetypal hero portrays Herakles/Hercules, whose third labour was to catch the Cerynitian hind.

Hindu *lingam* and *yoni*

Often seen in sacred Hindu and Tantric art, the *lingam* is an ancient phallic symbol, while the *yoni* that it may penetrate symbolises the vulva. The *lingam* denotes the masculine principle (and Shiva) and the *yoni*, the feminine (and Shiva's *shakti*), with their fusion representing sexual union.

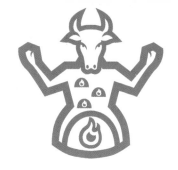

Moloch

Monstrous, threatening beings often loom large in nightmares, myths, fairy tales and art, when they may symbolise profound fears. A vision of children being sacrificed to Moloch, a Semitic deity mentioned in the Old Testament, may represent terror of losing a child or 'brainchild'.

Hero

Heroes, such as the Graeco-Roman Herakles/Hercules, are archetypal figures that feature in literature, legend, lore and art the world over, usually envisaged as warriors battling evil or proving their worth. A positive, active aspect of the masculine principle, the hero's negative counterpart is the villain.

Wise old woman

Like the Native American Grandmother, the archetypal wise old woman is usually portrayed as a grandmotherly figure, but may also be depicted as a priestess. The wise old woman symbolises wisdom and spiritual knowledge born of experience, which she uses for the good (unlike the witch, her negative equivalent).

Symbolism in art

See also
Upward-pointing triangle, page 141
Downward-pointing triangle, page 141
Yin and *yang*, page 149

Symbols are not always immediately apparent in art, yet may add to a painting's message if recognised and understood. Numbers – perhaps in the form of multiple figures – and shapes (they are often connected) may have significance, for example. Colours, too, may be symbolic, with red maybe alluding to blood and thus life or bloodshed, and yellow signifying the sun, gold or happiness. And fantastic creatures may symbolise more than just a mythological character, particularly in Symbolist or Surrealist works. Conversely, certain symbols that can be seen at the edges of paintings, namely makers' marks and artists' monograms, do not usually have profound meaning.

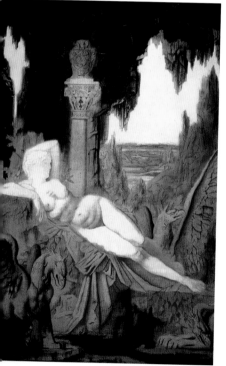

Symbolist fantasy
La Fée aux Griffons (*The Nymph with Gryphons*), by French painter Gustave Moreau (1826–98), illustrates how some Symbolists drew inspiration from mythology as a source of symbolic images with which to express inner truths and ideas. Fantastic creatures like the gryphon could allude to personal fantasies.

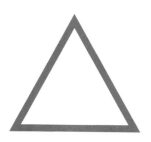

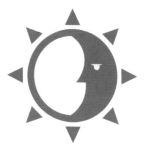

Triangle

Having three identical sides, the equilateral triangle can symbolise trios in which each component is equally important: Christianity's Holy Trinity, for instance, or the past, present and future. Depending on whether it points upwards or downwards, it may also symbolise masculinity and fire, or femininity and water.

Lightness and darkness

The significance of any light and dark areas of a painting may be linked to the symbolism of white and black. According to European convention, white represents such positive concepts as day, illumination, goodness, life and purity, while black denotes negative notions such as night, oblivion, evil, death and corruption.

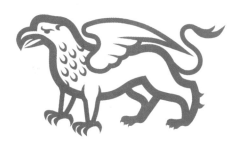

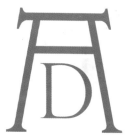

Gryphon

The many myths associated with the gryphon (or griffin) can be traced back to ancient Egypt and Mesopotamia. Envisaged as a vigilant guardian of gold, it is usually portrayed with an eagle's head, wings and talons and a lion's body, redoubling the solar, majestic symbolism of both creatures.

Monogram

Artists may sometimes sign off their work with such stylised signatures that they can be described as symbols in themselves. The German artist and engraver Albrecht Dürer (1471–1528), for instance, represented his name with a distinctive monogram based on his initials (AD).

Introduction

See also
Mother and child,
page 7
Elephant, page 51

A desire for fame and fortune aside, humans have typically been moved to create art to represent divine beings or sacred concepts; to identify individuals or proclaim kinship with others; or to record events and knowledge and express abstract ideas. And while its appearance or purpose may be aesthetically pleasing, spiritually satisfying, informative, instructive or influential, art concerned with the sacred, with signalling identity, and with conveying knowledge and notions, is usually symbolic. Many of the themes and symbols used by artists of every age and continent are furthermore remarkably similar, testimony to humankind's innate propensity to think symbolically.

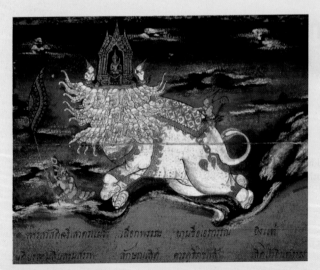

Fantastic creature
Airavata may be portrayed with 33 heads, as shown in this illustration from a mid-19th-century Thai manuscript. While Airavata (or Erawan) is said to be the king of the elephants, Indra is regarded in Buddhism as the lord of the *devas* (gods of the celestial regions).

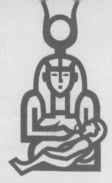

Isis and Horus
Among the most ancient mother-goddess representations are those of the seated Egyptian goddess Isis breastfeeding her infant son Horus (a cow-horn crown emphasises her milk-producing role). This image is thought to have inspired depictions of Christianity's Virgin and Child.

Pelican
The pelican was once believed to peck open its breast with its beak in order to nourish its young with its blood. It therefore has resonance in Christian art as a symbol of Christ's self-sacrifice for humankind, and as a symbol of the theological virtue of Charity (*Caritas*).

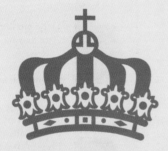

Crown
A crown, or any headdress that spectacularly differentiates its wearer from others, signifies distinction. In art, it may represent supreme social, temporal or spiritual authority, being a symbol of sovereign rulers (divine and mortal), or of glorification (as worn by martyred saints).

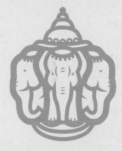

Airavata
Depicted with three or 33 heads, the fabulous white elephant called Airavata in India (Erawan in Thailand) is the mount of the sky god Indra, who, in Hindu belief, is the guardian of the east. Just as Indra is associated with thunder, so Airavata symbolises an enormous rain cloud.

Cosmic creation

See also
Arabic calligraphy,
page 135
Masonic symbol,
page 227

Most faiths' cosmologies include accounts of how the universe came into being, how it was shaped and how its components relate to one another. The monotheistic religions of the book (Judaism, Christianity and Islam) hold that God created the cosmos, for instance, while polytheistic faiths, like those of ancient Egypt, Greece and Rome, as well as Hinduism, ascribe various cosmic roles to different deities. Not only do many of these accounts have elements in common, but when the creation and structure of the cosmos are represented in art, the recurrence of certain symbols – most notably the circle – is particularly striking.

The act of creation
In *Ancient of Days*, a relief etching for his book *Europe: a Prophecy* (1794), the British visionary William Blake portrayed the Judaeo-Christian God in the act of creation, holding a pair of compasses. Blake's image is based on the Old Testament Book of Proverbs (9:27).

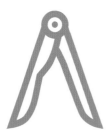

Pair of compasses

When, in Christian art, God is portrayed in the act of cosmos creation, the divine architect may hold a pair of compasses. These are an instrument of measurement and creation, and because they draw circles, they share the circle's symbolism in denoting the cosmos and eternity.

Holy Book

'In the beginning was the Word . . . and the Word was God' – the New Testament Gospel of St John (1:1) explicitly links God, the creator, with 'the Word'. God's sacred Word may be symbolised by the Christian Bible, and by the Jewish Torah and the Islamic Qur'an.

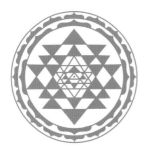

Tantric *yantra*

The Tantric *yantra* symbolises the universe and its cosmic components. While the enclosing circles ringed by lotus petals signify creation, the eternal round of existence and the cosmos, the interlocking triangles within represent the male and female principles, and the central dot, the centre or absolute.

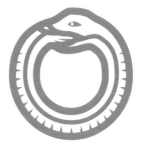

Ouroboros

The symbol of a serpent biting its tail – the *ouroboros* ('tail-eating' in Greek) – is ancient. Its circular shape and self-absorption have associated it with the universe and totality (in ancient Egypt and Greece), eternity and *samsara* (in Hinduism and Buddhism, the endless cycle of birth, death and rebirth).

Different deities

SACRED

See also
Shango, page 53

Spear
As a weapon,
the spear is the
attribute of war
deities. And warfare
traditionally being
a manly occupation,
such gods – like the
Graeco-Roman
Ares/Mars – are
generally male
(the spear is also
a phallic symbol).
Some, however, are
female, including
Athena/Minerva,
the Graeco-Roman
warrior goddess and
champion of heroes.

Many cultures have envisaged divine pantheons, whose members each symbolise an aspect of the human experience: the sun and moon, for instance, or the sky, earth and sea, arts and crafts, warfare and death. Considered remote figures, some deities have rarely been depicted. Others, however, have been frequently portrayed, or else symbolised by objects that represent their special powers or responsibilities. Although such objects might be specific to a particular culture, their general characteristics are often universal, so that thunder gods like the Yoruba Shango and the Norse Thor are respectively symbolised by a double-headed axe and hammer.

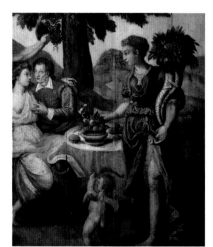

Horn of plenty
The right-hand
figure in *Allegory
of Love*, a 16th-
century panel
painting at the
Château de Blois,
in France, carries
a cornucopia. Like
the fruits of the
earth that it contains,
the cornucopia is
a fertility symbol,
hinting here that
the picture's central
couple will produce
offspring.

Thor's hammer

The Norse god Thor was imagined as a fearless and aggressive sky deity, the wheels of whose chariot produced the rumble of thunder when hurtling across the sky. The double-headed hammer, called Mjöllnir, that Thor hurled when furious (and which always returned), symbolised a thunderbolt.

Sacred sow

The sow, which gives birth to and nourishes large litters of piglets, has either represented, been the attribute of, or been sacred to a number of the world's mother goddesses. They include the ancient Egyptian Isis, the Graeco-Roman Demeter/Ceres and the Welsh, or Celtic, Ceridwen.

Cornucopia

The cornucopia, or horn of plenty, is a symbol of natural abundance that is the attribute of earth goddesses like the Graeco-Roman Demeter/Ceres. The horn (originally that of the goat Amalthea, which, in Classical lore, suckled Zeus/Jupiter) is typically portrayed overflowing with fruits and vegetables.

Distaff

Because spinning has usually been women's work, the distaff (around which flax is wound before being spun) has become a symbol of femininity. It may also represent the Graeco-Roman goddess Athena/Minerva, who is said to have invented the arts of spinning and weaving, and the Fate known as Clotho.

Good *versus* evil

See also
Tree of life, page 8
Skeleton, page 47

A clearly defined conflict is inherent in most mythologies and religions, in which the constructive forces of good are ranged against the destructive agents of evil. This cosmic conflict is constant and ongoing, and although the forces of good have the upper hand, the powers of evil present a constant threat until, perhaps, a final, apocalyptic battle heralds the end of the world. The representatives of goodness may be symbolised by the sky, sun and daylight, golden birds and white-winged beings, while the agents of evil are associated with the underworld, the moon and darkness, black bats and reptilian creatures.

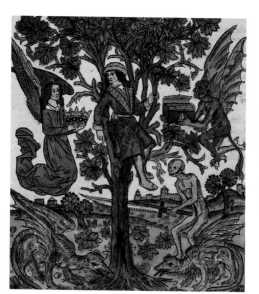

Angels and demons
Death saws at the tree of life in a xylograph from a 1486 French edition of St Augustine's *Civitas Dei* (*City of God*). Before dying, the man above must choose spiritual glory (the angel's crown) or worldly riches (the demon's treasure chest).

Eagles *versus* snakes

Their mastery of the sky, association with sky deities and habit of preying on snakes (which are viewed ambivalently in many cultures) have caused eagles to symbolise goodness in the struggle against evil. This battle is exemplified in Hindu art by the conflict between Garuda and the *nagas*.

Bodhisattvas

In Buddhist belief, a *bodhisattva* is an enlightened being who has elected to remain in the human realm in order to assist humankind attain nirvana. Although generally benign-looking, *bodhisattvas* may sometimes be portrayed fiercely battling evil beings in their wrathful forms.

Angels

Although Jesus may be portrayed being tempted by Satan, or standing gloriously victorious in harrowing-of-hell scenes, it is typically angels who are shown physically fighting the Devil and his devilish helpers in Christian art. Thanks to their haloes and exquisite wings, angels are unmistakable symbols of goodness.

Demons

Although many demons are credited with shape-shifting powers, in Christian art most are identifiable by their black bodies, wings and tails, animals' horns and ears, fangs and claws. Demons are not exclusive to Christianity, however, and similarly horned and fanged evil spirits are portrayed in Hindu art, for instance.

Expressing sacred concepts

See also
Hermes/Mercury,
page 167
Rainbow serpents,
page 239

Some sacred concepts are difficult, or too unwieldy, to convey in words, and are far more easily and elegantly expressed visually, as St Patrick found, according to legend, when explaining the Christian Holy Trinity to the Irish. In turning to the shamrock as a symbol, St Patrick continued a time-honoured tradition of using aspects of nature to represent complex abstract ideas. Indeed, all cultures and faiths have employed examples from the animal, vegetable and mineral worlds – in fact, all that is visible in the sky, sea and earth, be it natural or manmade – with which to symbolise the sacred.

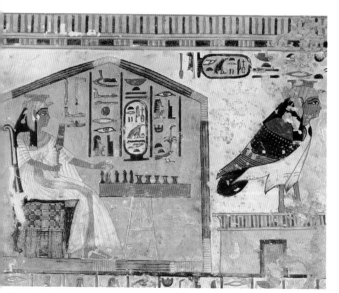

Nefertari and her *ba*
A wall painting from her tomb in the Valley of the Queens, Thebes, Egypt, depicts Queen Nefertari, wife of the ancient Egyptian pharaoh Ramesses II, playing a one-sided game of senet. The human-headed bird on the right, which shares Nefertari's features and vulture headdress, is her *ba*.

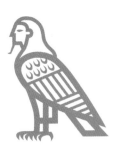

Ba

In ancient Egyptian art, the *ba* – which was regarded as the essential part of a human's personality or spirit that survived death – is depicted as a bird with a human head (the deceased's). Its hybrid appearance signals its unearthly nature, while its wings symbolise its freedom of movement.

Rainbow

While many traditions equate rainbows with serpents (with Australian Aboriginal rainbow serpents denoting water), Norse mythology describes 'the Trembling Way' (*Bifröst*) as a bridge linking heaven and Earth. The Judaeo-Christian rainbow symbolises God's covenant with humankind, and therefore peace, also acting as Christ's heavenly throne.

Rod of Asclepius

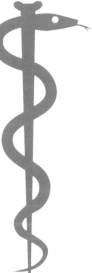

The primary attribute of Asclepius/ Aesculapius, the Graeco-Roman god of healing, is a snake coiled around a staff (the two elements of this symbol, which represents medicine, were originally portrayed separately). Because snakes shed their skin and emerge apparently 'reborn', they symbolise spiritual healing and rebirth in many cultures.

Holy Grail

In Christian lore, the Holy Grail – the cup or bowl used by Jesus at the Last Supper, in which Joseph of Arimathea later caught his blood – was sought by medieval Christian knights. Said to have the ability to confer eternal life, the Holy Grail symbolises Christ's powers of redemption.

Ancestral, tribal & clan identity

See also
Illuminated letter,
page 39
Koru, page 237

The handprints seen in prehistoric rock art testify to an ancient urge to make one's mark symbolically. Collective, as well as individual, symbols of identity have always featured in art, too, signifying, for example, membership of a family, clan, tribe or country. This powerful desire to proclaim unity, or being one of a kind, may be symbolised in portrayals of common ancestors; in the replication of tribal body markings on masks; in the depiction of totemic creatures; and through heraldry. Social status and initiation into such select groups as military units or secret societies may similarly be signalled symbolically.

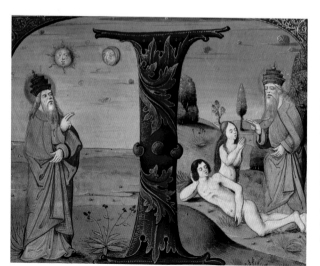

The first man and woman
Separated by an illuminated letter, two scenes from the Old Testament Book of Genesis are portrayed in an illustration in a 16th-century Bible from the Abbey of St Amand, France. On the left, God has created the sun and moon, and, on the right, Adam and Eve.

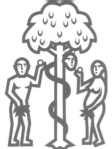

Adam and Eve

Be they an anonymous couple or Adam and Eve (the first man and woman, according to the Jewish, Christian and Islamic traditions), male and female figures that are clearly a pair usually represent a human group's original ancestors. As such, they symbolise blood ties, or kinship.

Body art

Certain of the decorative symbols visible in African, American and Oceanic human representations (and echoed in body art) have profound significance. The Maori *koru* motif described by tattoos signifies dynamic growth, while African scarification marks may symbolise initiation or tribal identity.

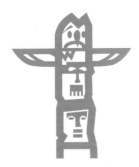

Totem pole

Totem poles are commonly seen in North America's Northwest Coast region. They are made up of distinctively carved and painted representations of totemic creatures and mythological beings, these crests symbolising aspects of a clan's mythical lineage and collective identity, as well as the characteristics of each creature.

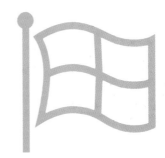

National flag

A national flag symbolises a nation or country and its people, a red cross on a white field – the cross of St George – representing England, for instance. A national flag may change over the course of time, but always signals something significant about the nation's collective history or character.

The symbolism of warriorship & initiation

See also
Handprint, page 49
Eagle and thunderbolts, page 163

Symbols have long conveyed concepts relating to warriorship, rites of passage and initiation, with some having crossed from battlefield to artist's canvas. It requires bravery and skill for people to prove themselves qualified to join a warrior élite, and success may be symbolically marked – by a medieval knight's spurs, for instance, or a *sirata* (symbol) on a Masai shield. Shields also display protective images, like Plains' Indian 'power' symbols, and identifying signs, as developed by European heraldry. Military banners additionally employ symbolism – often alluding to an aggressive bird or beast – to proclaim the unity and ferocity of those marching behind.

Battlefield heraldry

A skirmish portrayed in the Manesse Codex, a 14th-century German manuscript, illustrates European heraldry's battlefield origins. The standard, echoed in some shields below, represents Duke John I of Brabant and Limburg (*c*.1254–94), and combines the rampant gold ('or') lions of Brabant with Limburg's red ('gules') ones.

Knight's spurs

When attached to a rider's boots, the sharp pressure exerted by a pair of spurs goads a horse into running faster. In Europe, 'winning one's spurs' signified that a man was worthy of knighthood, which is why spurs denote a knight, also symbolising distinction or having proved oneself.

Native American shield

Shields protect those who carry them – literally and symbolically – and the images displayed on them also tell the foe facing them something about the bearer. In the warrior culture of the North American Plains' Indians, for instance, a red hand signifies courage, strength and vital energy.

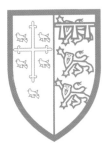

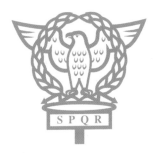

European heraldic shield

As the English heraldic system evolved from simply identifying noble individuals for battlefield purposes, ever more complex coats of arms were created. The arms of concession granted in 1397 by King Richard II to Thomas Mowbray, first Duke of Norfolk, for instance, incorporate the attributed arms of Edward the Confessor.

Roman military standard

Sometimes seen in art, the eagle standard (*aquila*) of the Roman legions depicts an eagle, perched on thunderbolts and framed by a laurel wreath, all symbols denoting power and victory. The letters SPQR below stand for *Senatus Populusque Romanus*, Latin for 'The Senate and the People of Rome'.

Noble, family & dynastic identity

See also
Battlefield heraldry,
page 32
Japanese *mon*,
pages 136–37

Natural symbols represent and identify family, clan, tribal and national groups the world over, often in the form of totems. Some particularly elaborate heraldic systems – examples of whose decorative, stylised symbols, often similarly drawn from nature, frequently appear in art – developed in European countries, and also in Japan. And while European armorial bearings and Japanese *mon* (heraldic badges) are thought to have originated in order to aid identification on the battlefield, both systems eventually became more genealogical in purpose, with particular hereditary symbols, or symbolic combinations, identifying noble families and dynasties (and later corporate and regional entities, too).

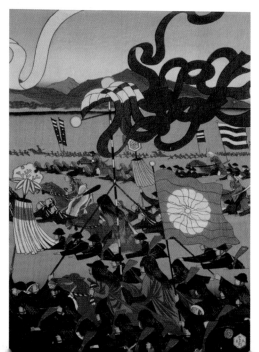

Japanese heraldic badges
An army of soldiers is shown powering across a lake in a dynamic depiction of a scene from a Japanese kabuki play. Symbols echoing those displayed by certain Japanese *mon* can be discerned in the form of military banners in this 19th-century *ukiyo-e* print.

Ermine fur

Ermine, the winter coat of the European stoat, is white, apart from the tail tip, which is black. Ermine (classified as a tincture in heraldry) symbolises nobility, a legacy of the medieval period, when only the upper echelons of society could afford to wear this warm, striking-looking fur.

Ermine cinquefoil

An ermine cinquefoil (a five-petalled, stylised flower) is the heraldic emblem of the Beaumont, and later Leicester, family. It is thought that it was first adopted – as a 'pimpernel' flower – as a punning reference by Robert FitzPernell, Earl of Leicester (who died in 1206).

Thistle

The thistle, a Scottish native, is the badge and symbol of Scotland. This prickly plant is also the emblem of the Most Ancient and Most Noble Order of the Thistle, a British chivalric order whose Latin motto is *Nemo me impune lacessit* ('No one attacks me with impunity').

Ogi-displaying *mon*

The Japanese *mon* shown above displays three folding fans (*ogi*). This style of fan could convey information about the noble status or occupation of its holder, with the number of supportive ribs, as well as the type, colour and pattern of its fabric, all having symbolic significance.

Personal & social identity

See also
Supporters,
page 209
Tudor rose,
page 213

Certain types of symbols may identify people, or impart information about their social identity, when seen in art. Heraldic badges may symbolise a noble or royal individual, for instance. And although not strictly hereditary, some badges have come to represent a social position rather than an individual, such as the ostrich-feather badge denoting the British sovereign's heir apparent. Remember, too, that a symbol or emblem is not restricted to the grand, but can represent anyone – including an artist – and that headgear and clothing, be it a jester's cap or a royal crown, can convey volumes about their wearers' identity.

Tudor heraldic symbols
Christchurch Gate, a gateway to the precincts of Canterbury Cathedral, in Kent, was erected in 1517, during the reign of Henry VIII, a member of the Tudor dynasty. Visible in this detail are a pair of Tudor supporters (a dragon and greyhound) and a Tudor rose.

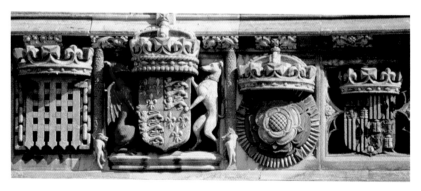

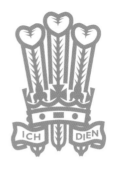

Royal sunburst

One of the heraldic badges used by the English kings Edward III (1312–77) and Henry VII (1457–1509) was a sunburst, a stylised depiction of the sun's rays emerging from behind a cloud. Although the sunburst's precise royal significance is uncertain, it is a positive symbol of hope.

Heir apparent's badge

Three ostrich feathers rising from a coronet, with the German motto *Ich dien* ('I serve'), is the heraldic badge of the heir apparent to the British throne, usually the Prince of Wales. It is derived from the family of Philippa of Hainault, mother of the Black Prince (1330–76).

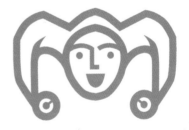

Artist's monogram

Artists usually sign their work, be it with a full signature or with a monogram, such as that devised by the Flemish painter Anthony van Dyck (1599–1641). Not only do identifying marks like this link an artwork with its maker, they add to its value, too.

Jester

The distinctive, multi-coloured cap and clothing in which they are portrayed in art – and playing cards – has made jesters, the professional jokers employed at medieval European courts, instantly identifiable, even in the 21st century. (Such 'fools' may personify folly in allegorical paintings.)

Writing & recording

See also
Egyptian hieroglyphs: the pharaoh's five names, pages 66–67
Arabic calligraphy, page 135

The desire to record information, and the writing systems that were accordingly devised, went hand-in-hand with the evolution of human language and civilisation. The earliest characters were pictograms, ideograms and logograms (*see page 247*), which depicted the object, concept or word being symbolised. These eventually proved too limiting, however, prompting the development of abstract scripts, yet the strong links between characters, symbolism and art survived. Indeed, ancient Egyptian hieroglyphs and European runes, for example, may provide a written commentary on accompanying images; Greek characters form the basis of many early Christian symbols; and Chinese characters painted on scrolls are commonly viewed as artworks.

Runic symbols

The Anglo-Saxon runes r and t are included among the runic characters with which this whalebone casket was carved during the 8th century. The detail shown here is of a panel of the Franks Casket, which, it is thought, was crafted in Northumbria.

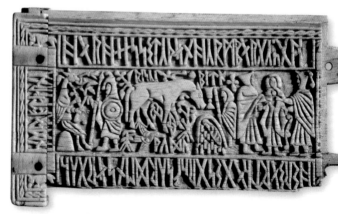

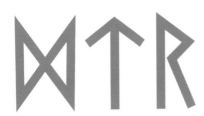

Runic characters

The runes, or characters, of the Germanic runic alphabets used in Scandinavia and Western Europe from the 3rd century AD were believed to have magical symbolism. The runes above, from the Anglo-Saxon futhorc (alphabet), are d (for 'day', *daeg*), t (for 'Tir', *tir*) and r (for 'ride', *rad*).

Mayan glyph

Dating from the Classic Mayan period (AD 300–900), the glyph shown above is a logogram, or a symbol that denotes an entire word or phrase. Based on a representation of a jaguar's head, this Mayan logogram symbolises the word *balam*, which means 'jaguar'.

Illuminated letter

'Illuminated', or decorated, initial letters – miniature artworks in themselves – are an exquisite feature of the Christian texts copied and created by European monks from around AD 400 to the end of the Middle Ages. The 'D' above, taken from the Irish Book of Kells, is based on a bird.

Chinese character

The Chinese character written above conveys the basic idea of rectitude, or of doing what is right, although it encompasses many nuances of meaning, including honour and morality. It also signifies justice, one of the Five Virtues of Confucianism (along with benevolence, propriety, wisdom and sincerity).

The macrocosm & microcosm

See also
The Five Chinese Elements,
pages 152–53
The Four Humours,
page 225

In trying to comprehend the workings of the universe, and how cosmic energies or celestial bodies might affect life on Earth, societies the world over developed various macrocosmic–microcosmic theories, the best-known (and most frequently represented in art) being encapsulated in the principles of Chinese and Western astrology. Although these symbolic systems' details differ, both share a belief that an individual's date of birth – or rather its associated correspondences – influences his or her personality. Elemental and astrological factors are also said to affect human health, as symbolised by Chinese medical diagrams and Western 'zodiacal man' (melothesic) illustrations.

Zodiacal man
Ophthalmodouleia, Das ist Augendienst, a treatise on eye disorders published in 1583 by German physician Georg Bartisch, includes the woodcut reproduced at left. Lines connecting the central figure and the 12 images surrounding it link the Western zodiacal signs, including Leo, with parts of the human body.

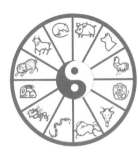

Chinese zodiac

In Chinese belief, the universe is regulated by the interaction of the passive and active energies *yin* and *yang* (as illustrated by the *tai-chi* symbol). The 12-year 'zodiacal' cycle of the 12 Terrestrial Branches is represented by a circle of 12 symbolic creatures, each corresponding to a year.

Chinese medicine

Traditional Chinese medicine holds that *chi* (or *qi*) – envisaged as the life force – flows through the body along meridians (channels), and that disruptions within these can adversely affect health. Each meridian is influenced by *yin* or *yang*. (And each of the five elements corresponds to an organ.)

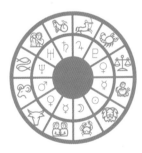

Western zodiac

Western astrological principles revolve around the ten planets and 12 signs of the zodiac (symbolised by glyphs and figurative images). While the signs create a framework of potential, their ruling planets act as directional forces, their effect being experienced on Earth and within the body.

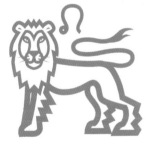

Leo's physical correspondences

While the action of the Four Elements, in the form of 'humours', was once thought to be reflected within the human mind and physique, the zodiacal signs were believed to influence body parts and organs. Leo, the Lion's connection, for instance, was with the spine, back and heart.

Influencing fate

See also
Handprint,
page 49
Tarot's Hanged Man,
page 227

Their observations of life's random qualities have led people of all eras and civilisations to the conclusion that a divine hand is controlling their destinies. In art, as in mythology, this concept is symbolised, perhaps, by Dame Fortune turning her wheel or by the Three Fates holding the thread of life. And in trying to gain some measure of control over their fates, humans have turned to divination, or fortune-telling, in the form, for instance, of symbol-packed Tarot cards; have invested amulets with the symbolic power to protect against evil; and have developed complex symbolic systems like alchemy.

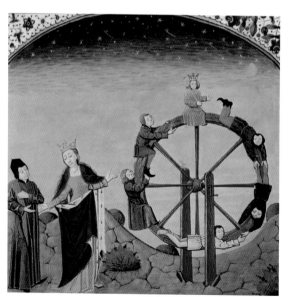

Lady Luck's wheel
Dame Fortune is shown turning her wheel in a 15th-century French illustration from Jean de Meung's translation of the Roman writer Boethius's *De consolatione philosophaie* (*The Consolation of Philosophy*). With the turning of the wheel of Fortune, people's fortunes and social positions are reversed.

Wheel of Fortune

The wheel of Fortune symbolises life's unpredictability, so that as time passes, those at society's apex may find themselves at the bottom, and *vice versa*. Usually crowned, and sometimes blindfolded, Dame Fortune (whose precursors were the goddesses Tyche and Fortuna) is shown turning her wheel in Renaissance art.

Three Fates

The Graeco-Roman *Moirai/Parcae*, or Three Fates, were said to hold a person's destiny, symbolised by a thread, in their hands. While Lachesis's rod measured it out, her sister Clotho's distaff spun it and her sister Atropos's shears severed it, these three processes corresponding to birth, life and death.

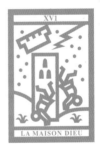

Hamsa or hamesh

An amulet in the form of a stylised hand is usually known as the *hamsa* or *hamesh* ('five' in Arabic and Hebrew) or hand of Fatima in the Middle East. It symbolises protection against the evil eye.

Nigredo

Nigredo, the first phase of alchemy's great work, is equated with the death and putrefaction required to experience rebirth. It may be symbolised by the bodies of the king (or Sol) and queen (Luna) in a coffin.

Lightning-struck Tower

The 16th of Tarot's major-arcana cards, this depicts a tower struck by lightning, sending two men hurtling to the ground. It may symbolise release from earthly confines by divine inspiration or retribution.

Fantastic creatures

See also
Ba, page 29

Siren songs
A mosaic depicts
Odysseus/Ulysses
sailing past the
Sirens. The ship's
crew blocked their
ears with wax so
that they were deaf
to the Sirens' songs,
while being tied to
the mast rendered
Odysseus/Ulysses
unable to respond.

Fantastic creatures feature in the art of every continent.
Yet they do not exist, so why were such monsters of the
sky, sea and earth ever envisaged? The answer to this
lies in their symbolic significance, for each creature
represents an aspect of existence that was once either
unknown or not properly understood, although its
powerful presence was all too evident. Such hybrid
creatures may therefore signify mysterious natural realms
like the sea (as represented by Triton); randomly
destructive forces (the Chimera); the bestial or sensual
side of humankind's nature (the Minotaur and the Sirens);
or the fear of death (Cerberus).

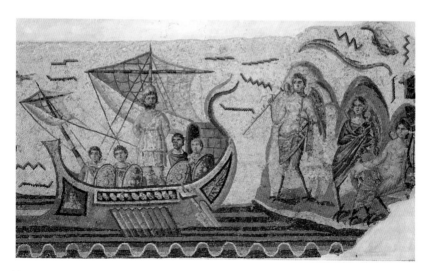

Triton

Although Triton was the son of Poseidon and Amphitrite. 'Tritons' may refer to mermen: aquatic beings with a man's upper half and the tail of a fish or dolphin. Often depicted blowing a conch-shell trumpet, Triton represents the force that controls the seas.

Chimera

The Chimera of Greek myth may have the head of a lion, the body of a goat and a snake-headed tail, and sometimes an extra head or two. This monstrous embodiment of storms laid waste to land and sea until despatched by the heroic Bellerophon.

Sirens

As described in the Greek myth of Odysseus, Sirens were sea nymphs who deliberately lured sailors on to treacherous rocks by their irresistibly attractive singing. Often portrayed – on vases, for instance – as birds with women's heads, Sirens symbolise the potentially disastrous temptation posed by sensual distractions.

Cerberus

In Greek mythology, Cerberus was the ravening, three-headed dog that guarded the threshold to the underworld of Hades, ensuring that no living being entered and that no dead soul escaped. Despite being occasionally outwitted, Cerberus represents both the terrible prospect of death and its finality.

Allegories of human existence

See also
Mmere dane,
page 69
Daphne, page 173

Art lends itself perfectly to allegories, which, through symbolism, convey a far more profound meaning than is immediately apparent. Such allegories refer to the human lifespan, for example, or warn that death awaits the living, no matter how beautiful or powerful. Death was the focus of European *Vanitas* still-lifes, and of allegorical Renaissance triumph paintings. Such collectives as the five senses – vital aspects of the human experience – and the Christian virtues may be represented allegorically, too, often by female figures bearing attributes that symbolise an appropriate quality, property or feature.

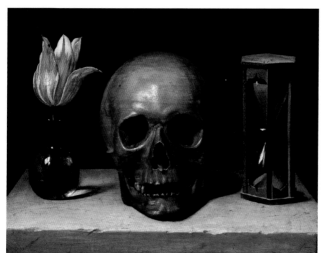

Memento mori
A dark and gloomy painting by French artist Philippe de Champaigne (1602–74) presents a stark reminder that life inevitably ends in death. While the tulip symbolises ephemeral beauty, the hourglass denotes the passing of time, and the skull – part of a skeleton – represents death.

Sense of smell

The five senses (hearing, sight, smell, taste and touch) may be portrayed in European art by five women, each of whom carries an attribute appropriate to the sense that she represents. Smell, for instance, holds fragrant flowers. Scented blooms like violets can symbolise smell in other allegorical contexts, too.

Ermine or stoat

Chastity was once such a highly prized quality in Christian Europe that it was personified in art as a virtue. In Renaissance and Baroque paintings, chastity may be represented by an ermine, a stoat whose pure-white winter coat (despite retaining a dark tail tip) symbolises virginity.

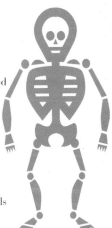

Skeleton

Natural symbols of death the world over, skulls and skeletons have, since medieval times, been incorporated into European art as *memento mori* (Latin for 'Remember you must die'), thereby sending a symbolic message that death awaits us all. As such, they may be juxtaposed with symbols of worldly success.

Laurel wreath

The laurel wreath first appeared in Graeco-Roman art when Apollon/Apollo, the sun god, was portrayed crowned with its evergreen leaves. Although it was associated with military victory in ancient Rome, this traditional mark of a 'laureate' (a person worthy of honouring) originally highlighted poetic or musical achievements.

Introduction

See also
**Native American
shield**, page 33

From prehistoric times, humankind has used art to express
profound concepts relating to the past, present and future,
to the sacred and secular, to the fundamentals of human
identity, and to the most abstract of philosophies. However
disparate the subject matter, or the artistic styles employed,
the images used to convey these concepts are similar the
world over, testimony to an ancient and fundamental
human tendency to think pictorially – and symbolically.
In the following pages you'll be introduced to some of the
symbolic messages conveyed by the diverse art forms of
Africa, the Americas, Asia, Europe and Oceania.

Pschent
In art the world
over, headgear
frequently conveys
something about
the identity of its
wearer. The ancient
Egyptian *pschent*
illustrated above,
worn by the
pharaoh, combines
the *deshret* (red)
crown of Lower
Egypt and the
hedjet (white)
crown of Upper
Egypt, consequently
symbolising
dominion over the
united 'two lands'.

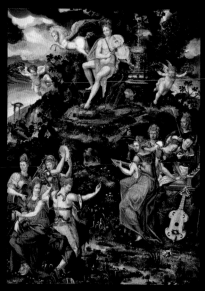

Source of inspiration
The Graeco-Roman
god Apollon/Apollo
is depicted making
music on Mount
Parnassus in this
16th-century
French painting,
after an engraving
by Italian artist
Giorgio Ghisi.
The nine Muses
and Pegasus are
portrayed, too, as
is the fountain of
Castalia, from
which flowed the
waters of poetic
inspiration.

Shakti

In the art of the Hindu and Buddhist Tantric traditions, the *shakti* (the active feminine divine energy) may be portrayed as a goddess frozen in an intimate embrace with the (passive) god Shiva or a Buddhist deity. This *yab–yum* ('father–mother') posture symbolises the *shakti*'s animating and creative power.

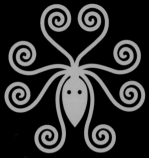

Octopus

Symbols drawn from the natural world can be simultaneously simple and complex. The octopus, for instance, may represent the sea, but the spiral-ended tentacles with which it is portrayed in ancient Mediterranean art also equate it with dynamic energy, creative and destructive power, and with thunderstorms.

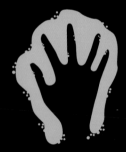

Handprint

Among the oldest pictorial symbols is the handprint, red-ochre stencils of which feature in the rock art of Queensland, Australia. This symbol of identity, which is also seen in the prehistoric art of the American Southwest, is thought to represent presence, kinship and protection.

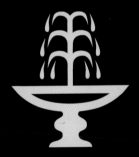

Fountain

A fountain is often used as an allegorical symbol in European art, when it may allude to a source ('a fount') of a desirable quality, such as knowledge or inspiration. And because water springs from it, it shares water's positive symbolism as a source of life, creation and healing.

Introduction

See also
Egyptian hieroglyphs, the pharaoh's five names, pages 66–67
Popular Hindu deities, pages 106–7
Buddhism's Seven Treasures, pages 116–17

The close relationship between the peoples who have inhabited Africa and their natural surroundings is evident in their art, as is the profound symbolic significance with which they have imbued all that they saw in the sky, land and sea. In portraying their worldview, the ancient Egyptians, for example, drew clear parallels with the creatures that they observed. Aspects of tribal belonging, martial identity and kingship could similarly all be conveyed through natural symbolism. And Egyptian hieroglyphs and Ashanti *adinkra* motifs (*see pages 68–71*) are just two of the sophisticated African symbolic systems that express complex concepts by means of elegant designs, many of them inspired by nature.

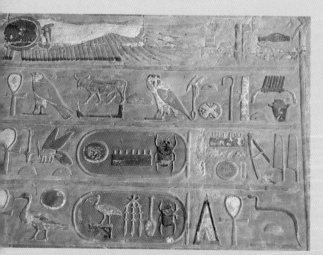

Hieroglyphic symbols
The throne and birth names of Pharaoh Thutmose III (ruled 1479–1425 BC) are contained in cartouches in this detail of hieroglyphs from a relief at the mortuary temple of Hatshepsut at Deir el-Bahri, Egypt. The falcon above left introduces the pharaoh's Horus name (*see page 66*). The phrase 'Given life forever' can be seen in the bottom right-hand corner.

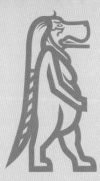

Taweret

Ancient Egyptian mothers-to-be sought the protection of Taweret, the goddess of childbirth. Envisaged with a pregnancy bump and sagging breasts, her body was mainly modelled on that of a hippopotamus, which aggressively defends its offspring, her crocodile's tail and lion's paws further symbolising her ferocity.

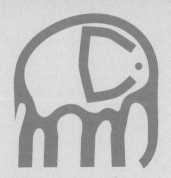

Elephant

Its intelligence, longevity, size, strength and lack of natural enemies (apart from humankind) caused the elephant to be admired, feared and respected throughout Africa, and consequently to be identified with chieftains and kings. In African art, the elephant therefore symbolises the wise, compassionate – and powerful – leader.

Sankofa

The *sankofa* motif is one of the Ashanti (or Asante) people's *adinkra* symbols. Depicting a bird twisting its head to retrieve an egg, the message conveyed is 'go back and get it', implying that the key to a fruitful future lies in returning to one's past.

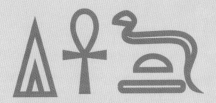

'Given life forever'

Five hieroglyphs spell a phrase often seen in Egyptian art in connection with pharaohs: 'Given life forever'. The triangular hieroglyph (meaning 'Given') represents a conical loaf of bread; the *ankh* or looped cross denotes 'life'; while the hieroglyphs signifying 'forever' symbolise a cobra, a bread loaf and a strip of earth.

Yoruba deities

See also
Thor's hammer,
page 25

The deities that are venerated by the Yoruba people of western Africa are collectively known as the *orisha* (or *orisa*, meaning 'gods'). Although there are numerous *orisha*, not all are depicted in art, and the symbols associated with them are relatively fluid, reflecting their frequently complicated characteristics. Among the most often portrayed are those that represent various forces of nature, or *orisha* that have archetypal significance, such as Shango, the temperamental storm god; Yemoja, a mother goddess; Ogun, a war god; Oshosi, the *orisha* of hunting; and Oshun, the goddess of love.

Oshun
One of Shango's trio of wives, Oshun is identified with Nigeria's Oshun (or Osun) river, and is therefore associated with fresh water. She is mainly honoured as a goddess of sexual love and beauty, though, which is why she may be symbolised by a hand mirror.

Virility and violence
A stylised interpretation of the god Shango's double-headed axe dominates this artefact from the west African republic of Benin. Shango is considered such an extreme masculine, procreative force (he is also the protector of twins) that his male priests may dress as women to counterbalance his virility.

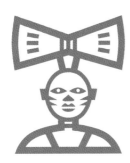

Shango

Once a martial, merciless, magician king of Oyo, the violent Shango became deified following his death as the Yoruba god of thunder and lightning. His primary symbol is the double-headed axe, which symbolises the thunderbolts that he hurls at those on Earth who arouse his fury.

Yemoja

As the mother of many *orisha*, Yemoja is the divine representative of the maternal principle, and of the Ogun river, which is why she is particularly associated with water and fertility. She may therefore be symbolised by a fish's tail or by signs of motherhood, such as a pair of full breasts.

Ogun

Ogun is the *orisha* who is identified with war and sacrifice, and with iron and steel, from which such traditional Yoruba cutting weapons as knives are made. He is therefore usually portrayed wielding knives or swords with fearsomely large blades, which are his main symbols.

Oshosi

The Yoruba *orisha* who is regarded as presiding over the hunting of animals – and of enemies – is Oshosi. As such, Oshosi is consequently most often symbolised by a crescent-shaped bow and lethal-looking pointed arrow, these being the hunter's traditional attributes.

Egyptian gods

See also
Egyptian kingship,
pages 64–5

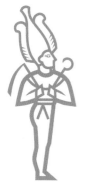

The natural world inspired many of the symbols with which Egyptian scribes and artists represented their gods. Looking heavenwards, they believed that they saw the sun god, Re, crossing the sky in one of his many manifestations, while a soaring falcon might represent Horus, and a pair of wheeling kites, Isis and her sister, Nephthys. As kites, these goddesses sought and mourned their brother Osiris, whose death and resurrection underpinned his own symbolic representation. Isis was also venerated as a mother goddess, as was Hathor, and, as such, both could be represented by nurturing cows.

Osiris
After Osiris was murdered and dismembered, his body parts were reassembled and embalmed, whereupon he was revived and became the immortal ruler of the underworld, or afterlife. His conquering of death is symbolised by his mummified body, and his sovereignty by his crook and flail and *atef* crown.

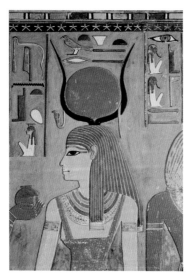

Isis, the mother goddess
Both Isis and Hathor could be portrayed wearing a headdress comprising a sun disc and a pair of cow's horns. The throne hieroglyph at left helps to identify the goddess seen in this detail of a wall painting in the tomb of Pharaoh Horemheb (1319–1307 BC) as Isis.

Re

Re, the Egyptian sun god, had many forms: as Re-Horakhty, for instance, he was represented as a falcon. His most constant symbol was a circle, often red, that denoted the sun disc (over which was sometimes draped the *uraeus – see page 65*), which was frequently depicted as his headdress.

Horus

Horus, with whom the pharaoh was identified, was symbolised by the high-flying, all-seeing falcon, being represented entirely as such or as a man with a falcon's head. As the epitome of divine kingship, he wore the double crown (the *pschent*); as Re-Horakhty, his crown was a sun disc.

Isis and Nephthys

Isis was the wife (and sister) of Osiris and the mother of Horus. Her name (Isis means 'Throne') is symbolised by her headdress, the hieroglyphic representation of a throne (left). Nephthys was the sister of Isis and Osiris. Her headdress (right) represents the hieroglyphic form of her name: a basket atop an enclosing wall delineating a large residence, spelling out 'Lady of the House'.

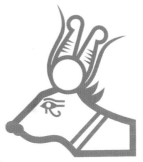

Hathor

Hathor was worshipped as a mother goddess, and was therefore mainly represented by a nurturing, milk-producing cow. This bovine symbolism was often abbreviated to a cow-horn headdress enclosing a sun disc, which Isis could also share, both Egyptian goddesses being identified as the mother of Horus in different mythic traditions.

Egyptian gods

See also
Cybele,
page 171

One of the most frequently represented scenes in Egyptian Books of the Dead was that of the weighing-of-the-heart ceremony. Among the deities present in Osiris's judgement hall were Thoth, the divine scribe; Anubis, the god of embalming; and Ma'at, the goddess of truth and justice. The primary symbols of each of these deities – and of many others – were drawn from nature, for the ancient Egyptians were particularly inclined to see a symbolic connection between the creatures that lived in their world and those who inhabited the divine realm.

Ma'at
Ma'at, the goddess of universal order and harmony, justice and truth, was represented by an ostrich feather, which she often wears on her head. Her presence may also be symbolised by the feather alone, for example, in the weighing-of-the-heart ceremony, when the feather signifies truth.

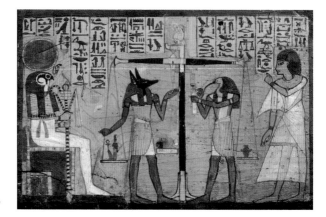

Weighing-of-the-heart ceremony
This detailed scene from a painted wooden chest dating from the Third Intermediate Period (1070–712 BC) shows Anubis weighing the deceased's heart against the tiny, feather-crowned figure of Ma'at. The ibis-headed Thoth records the result as the deceased is 'justified' in the presence of the enthroned Re-Horakhty.

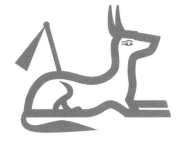

Anubis

Anubis, the god of necropolises, was symbolised by a black jackal or dog, for canines frequented burial grounds, and it was reasoned that he would guard Egyptians' tombs from these scavengers. A psychopomp (*see page 248*), Anubis also led the dead to Osiris's hall of judgement.

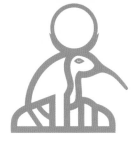

Thoth

Thoth, the god of the moon, wisdom, knowledge, measurement and scribes, was symbolised by two creatures: the baboon and the ibis. A headdress comprising a crescent moon supporting a full moon underlined his lunar link, and he was also often portrayed with scribal equipment.

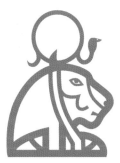

Sekhmet

The war goddess and disease-bringer Sekhmet ('Mighty One') was represented as a lioness. This leonine form symbolised her savage aggression, and also her connection with the fiery sun, for golden lions were considered solar creatures, and Sekhmet was believed to be the daughter (or 'eye') of Re.

Khepri

The Egyptians drew a parallel between the ball of excreta pushed by the dung beetle and the sun's movement across the sky, with the young dung beetles that emerged from the ball prompting a comparison with the sun's dawn appearance. The scarab therefore symbolised Khepri, the sun god's morning manifestation.

Egyptian sacred symbols

See also
Third eye, page 123
Celtic cross, page 174

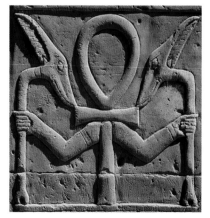

Among the symbols that appear the most frequently in Egyptian art are those that simultaneously denote the most basic and important concepts to any human being: life, health, prosperity and eternity. Represented by the *ankh*, the eye of Horus, the *was*-sceptre and the *shen*-ring, these symbols were believed to possess powerful magical properties. When fashioned in amuletic form, they could be worn or carried on the person, and were also buried with the dead, in the hope that they would aid the resurrection of the deceased, enabling them to live an untroubled existence forever after, following their revival.

Ankh

The *ankh* symbolises eternal life. While some see a key in its shape, and others a sandal strap, its combination of an oval and a T-shaped cross may represent the fusion of the feminine and masculine principles, or the coming-together of Isis and Osiris and the overcoming of death.

Life and power

An *ankh* has been given a useful pair of arms with which to grip two *was*-sceptres in this detail from a decorative bas-relief, dating from the Ptolemaic Dynasty (304–30 BC), at the Temple of Sobek and Haroeris, Kom Ombo. The tops of the *was*-sceptres emphasise their animal-head links.

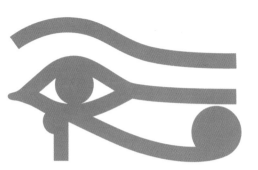

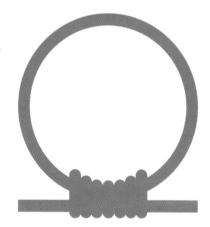

Eye of Horus

The eye of Horus (*wedjat*) could be depicted as the left or right eye. Although both represent the divine Horus falcon's all-seeing eyes, the left eye signified the moon, and the right the sun. The *wedjat* symbolised healing, strength, wholeness and perfection, and was believed to protect against evil.

Was-sceptre

Egyptian gods are portrayed holding the *was*-sceptre, and the symbolic message sent by this staff when in divine hands was primarily 'power' or 'rulership', with prosperity and well-being otherwise being signified. The staff's angled top and forked bottom may have been based on an animal's head and legs.

Shen-ring

Because it has no beginning or end, the *shen*-ring symbolises the eternal cycle of birth and death, or infinity. The horizontal band adjoining the ring may represent the ends of a knotted rope, from which the ring has been formed, while its central, circular shape gives the *shen*-ring positive, protective solar connotations.

Egyptian sacred symbols

See also
Lotus, page 113
Lotus, page 123
Lotus *chakra,*
page 140

Many of the symbolic elements commonly seen in Egyptian art were intended not only to affirm, but magically to evoke, the principles of unity, harmony and stability that were considered so vital to the success and well-being of the pharaoh's kingdom, and to that of his people. Such natural symbols as the lotus flower and papyrus plant were consequently imbued with layer after layer of meaning (both singly and as a pairing), while further symbols – for example, the *sema-tawy* motif and the *djed* pillar – evolved to express profound concepts relating to duality and permanence.

Reborn into the afterlife
A double portrait of Khabekhent, who lived during the 19th Dynasty (1307–1196 BC), and his wife has been painted on his wooden sarcophagus. Watched over by a protective pair of eyes of Horus, the couple are delighted and adorned by prominently depicted lotus flowers that symbolise rebirth.

Lotus plant

Because the beautiful, fragrant blue lotus is rooted in murky water, opens in response to the sun's rays and closes its petals at dusk, it symbolised the emergence of life from the primeval waters, as well as fertility and resurrection after death. The lotus also represented Upper Egypt.

Papyrus plant

Egyptians greatly valued the papyrus plant, providing as it did sheets of tough 'paper' and all manner of useful items. Said to have grown on the primeval mound of creation, and to hold up the sky, it came to signify thriving life, health and happiness, also symbolising Lower Egypt.

Sema-tawy

The *sema-tawy* symbol, which denoted the 'union of the two lands' (Lower and Upper Egypt), often adorns the pharaoh's throne. Its central feature is the *sema* ('union') hieroglyph, representing a windpipe and lungs, around which papyrus and lotus plants (respectively representing Lower and Upper Egypt) are bound together.

Djed

It may originally have been a fertility symbol, but the *djed* pillar eventually came to represent the backbone of the divine Osiris, and thus stability. A 'raising-of-the-*djed*' ceremony was enacted on a pharaoh's jubilee or death, and ordinary Egyptians were buried with representations of this strengthening symbol.

Masai shields

See also
Native American shield, page 33
European heraldic shield, page 33

Although increasingly regarded as art forms, the shields borne by the warriors (*moran*) of east Africa's Masai people traditionally serve both a defensive purpose and, through the symbols that decorate them, convey much information about the bearer. On reaching the appropriate age, a group of Masai boys undergoes circumcision together, before proving themselves worthy of initiation as *moran* or warriors. The symbols (*sirata*) painted on the oval, buffalo-hide shields that proclaim their *moran* status identify both their particular age-set and clan and (eventually) their individual feats of bravery. Black, white and grey are the basic colours used, with red being reserved for proven warriors.

Marks of a Masai warrior
Instantly recognisable as belonging to a Masai *moran*, or warrior, this buffalo-hide shield is bisected by a *sirata segira*, a vertical line of stylised cowrie shells. It also displays symbols that convey information about the bearer's brother warriors, personal background and performance in battle.

Sirata segira

The *sirata segira* design runs through the centre of the shield, bisecting it vertically to create two equal-sized halves. Although the patterns and colours that make up the *sirata segira* vary, they are traditionally based on the cowrie shell, a symbol of power and good fortune.

Age-set and clan symbols

Identical elliptical-shaped patterns are displayed by those who belong to the same age-set or clan, generally on the left-hand side of the shield. These therefore symbolise membership of a particular, close-knit group of *moran* who are bonded by both shared experience and blood.

Individual symbols

When seen from the front, the symbols that decorate the right-hand side of a shield usually impart information about the individual *moran* who owns it. These may, for instance, signify belonging to a particular family group, or may record the performance of a certain admirable exploit.

Sirata el langarbwali

The red patch or flower motif called the *sirata el langarbwali* may be compared to a medal won in the heat of battle by a soldier, for it denotes extraordinary courage in combat. *Moran* may paint this symbol on a shield only with the consent of a chief.

Egyptian kingship

See also
Pschent, page 48
Osiris, page 54

Gods, as well as mortals, featured in ancient Egyptian art, while occupying a unique position between the two was the pharaoh, or king, who was believed to be the divine representative of Horus during his lifetime on Earth, and was equated with Osiris after his death. The pharaoh's person is distinguished by various symbolic items in portrayals of numerous kings – notably crowns – some of which alluded to the crucially important maintenance of the harmonious union of Upper and Lower Egypt. Other royal regalia, such as the *nemes* headdress, the *uraeus*, the false beard, the crook and flail, and the bull's tail, symbolised his divine rulership.

Nemes headdress
The pharaoh's *nemes* headdress was fashioned from stiffened, striped linen so that the fabric fell over the front of each shoulder and was gathered at the back. Its symbolic significance lies in its resemblance to a leonine mane, the lion in turn being associated with the sun and Re.

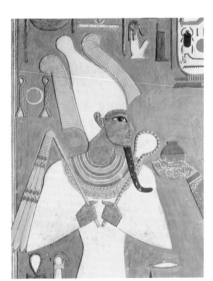

King of the underworld
The mummified figure of Osiris is depicted in a wall painting in the tomb of Pharaoh Horemheb (ruled 1319–1307 BC), in the Valley of the Kings. Shown wearing the *atef* crown and gripping his crook and flail, the underworld ruler's green skin symbolises (vegetal) life and renewal.

Uraeus

The *uraeus*, the cobra that rears up from its position above the pharaoh's eyes, symbolises divine protection, being poised to spit fiery poison at anyone who attacks its royal charge. The *uraeus* generally represents the cobra goddess Wadjet, but may also denote the eye of Re.

False beard

No attempt was made to portray the stiff-looking, strapped-on false beard worn by the pharaoh as natural, for it was a symbol of his sovereign status. When such a beard was depicted with a curved end, the intention was symbolically to link the king with Osiris, divine ruler of the underworld.

Crook and flail

Important symbolic components of the Egyptian royal regalia, the crook (originally used to control livestock) and the flail (which may once have functioned as a whip or flywhisk) represented royal authority. They additionally linked the pharaoh with Osiris, the king of the underworld, who also carried these sceptres.

Bull's tail

Depictions of the pharaoh often show him with a stylised tail attached to his waist. This represents a bull's tail and is intended to symbolise his innate animal strength, aggression and virility, all of which were considered ideal qualities in a ruler who was often referred to as a 'mighty bull'.

Egyptian hieroglyphs: the pharaoh's five names

See also
Horus, page 55

Each ancient Egyptian pharaoh had five 'official' titles: the Horus name; the Two Ladies' name; the Golden Horus name; the throne name, or *praenomen*; and the birth name, or *nomen*. Although the given names themselves varied from individual to individual, the same hieroglyphic symbols were used to denote the type of title, and it is these visual markers that will alert you to the presence of one or more of the king's names when they appear in Egyptian art. Another way of identifying a *praenomen* and *nomen* is to look for the oval cartouches (*shenu*) that enclose them.

Horus name

The pharaoh was identified with the god Horus, who is represented by the falcon standing atop a rectangular frame (a *serekh*) that represents the mud-brick façade of a royal residence and the walls behind it. The pharaoh's Horus name was written within this *serekh*.

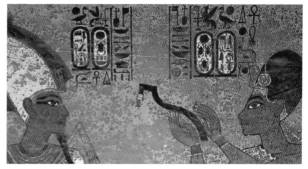

Pharaonic succession

Two pairs of cartouches name the figures seen in a wall painting in the 18th Dynasty tomb of Tutankhamun as Tutankhamun (left) and his successor, Ay (right). Ay is performing the opening-of-the-mouth ceremony on Tutankhamun's mummy, a rite that was believed to restore the deceased's senses.

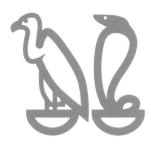

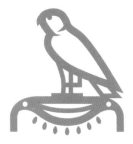

Two Ladies' name

The hieroglyphs of a vulture and a rearing cobra symbolise Nekhbet and Wadjet, the goddesses that respectively represent Upper and Lower Egypt, while the basket (*neb*) on which each is positioned denotes 'lady' (or 'lord'). This grouping identifies the pharaoh's 'Two Ladies', or *nebti*, name.

Golden Horus name

The hieroglyphic label highlighting the pharaoh's Golden Horus name consists of two components: a falcon (signifying the divine Horus) perched on an elaborate-looking stool that is actually the hieroglyph meaning 'gold' (which may symbolically allude to both the sun and indestructibility).

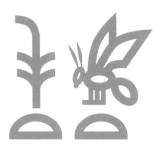

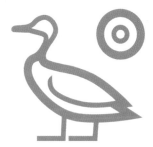

Throne name

The sedge-plant and bee hieroglyphs signal 'He of the Sedge and the Bee', which equates to the pharaoh's throne name (also known as his *praenomen* or *nesu-bity* name). The sedge symbolises Upper Egypt, and the bee Lower Egypt, so that this title means 'King of Upper and Lower Egypt'.

Birth name

The pharaoh's birth name (or *nomen*) was preceded by the goose or duck (*se*) and sun (*re*) hieroglyphs, which is why it is also called the *se-re* name. *Se* means 'son', while *re* denotes Re, the sun god, so this dual symbol proclaims the king's divinity as the 'son of Re'.

Adinkra symbols

See also
Concentric circles,
page 243

Hundreds of motifs make up the *adinkra* collection of symbols evolved by the Ashanti (or Asante) people of Ghana, in western Africa. It is thought that they were originally stamped on cloth used in funerary contexts, but they have since become far more widespread and today adorn all manner of objects, artefacts and architecture, as well as fabrics for festive clothing. Although the original meaning of some *adinkra* symbols has been forgotten, many of the most popular express either universal principles (relating to the divine and death, for instance) or, in symbolic shorthand, a traditional saying.

Owuo atwedee
According to the *adinkra* system of symbolism, the *owuo atwedee* motif represents the ladder of death, which leads us from this world to the next when our time on Earth is up. It consequently reminds us that we all must die, and exhorts us to live a good life.

Reminders of God
A detail from a mural in a traditional shrine in Kumasi, Ghana, displays two *adinkra* symbols. *Gye Nyame* is shown beneath *Nyame biribi wo soro*, which, loosely translated, means 'God is in heaven', suggesting that God will hear and guide those who turn to him.

Mmusuyidee

The *mmusuyidee adinkra* design symbolises sanctity, as well as good fortune. According to some interpretations, this sign evokes the cat's habit of rigorously cleansing itself of dirt and impurities, and consequently signifies purity, the banishment of bad luck, and blessedness.

Adinkrahene

Adinkrahene means 'king of the *adinkra*', and this motif is considered the most significant of the *adinkra* symbols. Thought to have inspired the creation of many of its fellows, the *adinkrahene*'s primary meaning is leadership, its three concentric circles suggesting chiefdom, dissemination and followers.

Mmere dane

The *mmere dane* design tells us that 'time changes' in the *adinkra* language of symbolism. While the mirror-image, triangular elements are reminiscent of a time-measuring hourglass, the circle linking them represents the ever-moving, eternal cycle of time, which ensures that nothing ever stands still or remains the same.

Gye Nyame

One of the most popular *adinkra* symbols is the *gye Nyame* motif, which means 'apart from God' and implies to those who see it that one should not fear anything in life, 'except for God'. This design consequently denotes Nyame's absolute omnipotence and universal supremacy.

Adinkra symbols

See also
St Andrew, page 185
Aries, the Ram,
page 219

As those who are familiar with the proverbs, stories and concepts that they evoke know, *adinkra* symbols are not merely decorative designs, but a source of meaningful messages and sound advice on how best to live one's life.

Yet some *adinkra* symbols are so stylised that it is difficult for the uninitiated to hazard a guess as to what they might signify, particularly when they make use of shapes. More representational symbols – such as the *duafe* design, in which the outline of a comb is easily discernible – are easier to interpret, however.

Ritual comb

The connection between the wooden comb pictured at left, which is thought to have been used in an Ashanti funeral rite, and the *duafe adinkra* symbol is unmistakable. The face at the centre of the comb's handle is reminiscent of an *akuaba* figure, a fertility symbol.

Nyame nnwu na mawu

The *adinkra* symbol that depicts a cross with four oval terminal points is called *Nyame nnwu na mawu*, which conveys the message 'God never dies, so neither shall I'. It therefore denotes immortality: of Nyame, and of the souls of those people who believe in him.

Dwennimmen

Dwennimmen, the 'ram's horns' design, depicts two pairs of curly ram's horns enclosing a white space. Because rams fight with their horns, *dwennimmen* evokes aggression, yet the horns may be deadlocked, and also submit to humans, so humility lies at the heart of the message.

Duafe

The *duafe adinkra* symbol represents the wooden comb used by Ashanti women. It therefore signifies such traditionally prized feminine qualities as pride in one's appearance, good grooming and beauty, as well as more profound 'womanly' virtues, such as selflessness and looking after others.

Akoko nan

Akoko nan means 'the leg of a hen', and this *adinkra* symbol is a reminder of the traditional saying that while a hen may squash her chicks under foot, she will not kill them. It therefore expresses the need for a parent to be firm, but also loving.

Introduction

See also
Plains' warrior symbols,
pages 86–7
The cosmos & the natural world,
pages 10–11

Natural forms and symbols predominate within the Americas' varied art forms, reflecting the holistic connection that humans here have historically felt with their environment. And while stylised representations of crops and rain appear in the art of such agriculturalists as the Hopi and Maya, warriors and hunters like the Aztecs and Plains' Indians identified with animal aggressors, consequently adopting them as emblems and investing these with a spiritual presence that is similarly accorded to Voodoo *veves (see page 82)*. Creatures also signal clan identity (as seen in the crests of the Northwest Coast), and feature strongly in decorative and useful symbolic systems.

Protective power
By painting the imposing figure of a grizzly bear on his deer-hide shield cover in around 1865, a Hidatsa (Plains') warrior hoped to harness the protective power symbolised by this fearsome beast. The eagle feathers hanging from the cover signify sunrays, along with the bird's strength and bravery.

Crow Mother *kachina*

Angwusnasomtaka, or Crow Mother, is regarded as the mother of all *kachinas*, or the spirits that the Hopi people of the North American Southwest regard as their helpers. She is primarily symbolised in masks and dolls by a turquoise headdress flanked by crow wings.

Maize plant

Maize was of such great importance as a staple-food-providing crop in Mesoamerica that this universal symbol of life and prosperity was considered to have divine status. Many depictions of male Mayan maize deities, for example, incorporate ears, or cobs, of this grain into their otherwise human features or headdresses.

Bear

Like most clan animals represented in the Native American art of the Northwest Coast, the bear is portrayed with its ears crowning its head. It also has large paws and claws; many teeth; and a protruding tongue. The bear symbolises strength and skill, be it in hunting or housekeeping.

Rabbit

The rabbit represented day eight (Tochtli) in the cycle of 20 day names that formed part of the Aztec 260-day calendar. In Mesoamerica, the rabbit was particularly identified with the moon and pulque (an alcoholic drink whose cloudy appearance recalled milk, fertility and motherhood).

The Navajo *yei*

See also
Whirling log,
page 91
Rainbow,
page 29

The Navajos' 'holy people', the *yei*, are portrayed in the sand, or dry, paintings (*see page 248*) that are created specially for healing or harmonising ceremonies such as the Holyway. Built up following prescribed patterns and principles, these paintings are both sacred (for they act as vessels for the presence of the *yei*) and ephemeral, being destroyed on the ritual's eventual completion. More permanent, non-sacred approximations of these images are today woven into blankets and rugs, giving non-Navajos an insight into the functions and symbolism of the *yei*. These spirits are represented in stylised, static, frontal human form, with long, straight bodies.

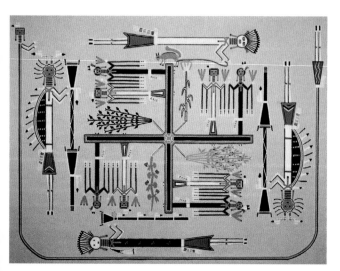

'Whirling logs'
Four pairs of male and female *yei* are included in this Navajo sand-painting design based on the 'whirling logs' story, which is often created for the Nightway Chant. Also visible are the rainbow goddess and Talking God (shown at the top, holding his squirrel-skin bag).

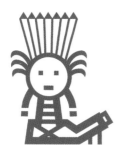

Talking God

Hastseyalti (Talking God or Soft Talker), a leading *yei* associated with the east, dawn and corn, features prominently in the Nightway Chant. This tutelary spirit is represented with a white face; a headdress of erect feathers, symbolising leadership; and a squirrel-skin bag containing corn pollen.

Male *yei*

Rounded heads typically distinguish male *yei* from their female counterparts (both sexes may be portrayed wearing skirts). Among the other features that symbolise a masculine spirit are the use of black and yellow and the depiction of decorative lightning flashes or crooked lines.

Female *yei*

Female *yei* can usually be recognised in Navajo sand paintings and woven fabrics by their square or rectangular heads. In addition, the colours used to symbolise these feminine figures are predominantly blue and white, while straight lines may be included for adornment.

Rainbow goddess

The rainbow *yei* encloses the figures of other *yei* in Navajo art to form a three-sided 'frame', the gap (or 'spirit break') being to the east, or at the top. This guardian goddess symbolises the sky–earth path of the *yei*, and is shown with an elongated, multi-coloured body.

The Hopi *kachinas*

See also
Buffalo, page 87

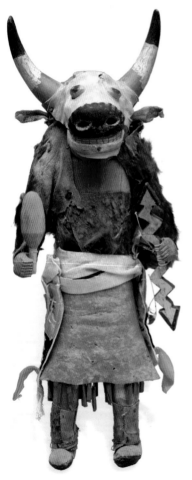

The agriculturalist Hopi, of the North American Southwest, believe that up to 300 *kachinas* (rain-bringing spirits of nature and fertility) live among them from the winter solstice until the summer solstice. During this period, ritual dances are performed, with the spirits' presence being symbolised by the masks and costumes worn by their impersonators and channellers. The symbols and attributes that identify each *kachina* – which are most visible on their *tabletas*, or headdresses – are reproduced on the cottonwood-root *kachina* dolls that were traditionally given to Hopi children as learning aids, and that are now fast becoming an art form.

Zuni *kachina* doll
Kachinas are not exclusive to the Hopi, but are important to other Pueblo peoples, too. This intricately fashioned Zuni *kachina* doll, made in around 1915, was created from wood, paint, rawhide and other materials. Its horned head identifies the *kachina* doll as representing a buffalo (see also opposite).

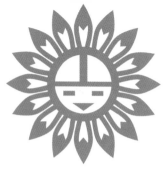

Sun *kachina*

Regarded as the spirit of the sun, Tawa (or Sun) *kachina* consequently denotes warmth, light and happiness. His feather-edged, circular headdress symbolises the sunbeam-radiating solar disc. The bottom half of this circle is painted sky blue, while the top half comprises sunny red and yellow quadrants.

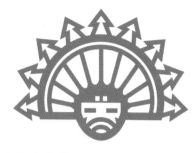

Butterfly Maiden

Although some consider her not a *kachina* at all, but a ceremonial dancer, Palhik Mana (Butterfly Maiden) is represented wearing the *tableta* of a 'respect spirit' (*kachina*). Symbols signifying butterflies and corn (both denoting fertility and life) may decorate this *tableta*, whose shape alludes to a rain cloud.

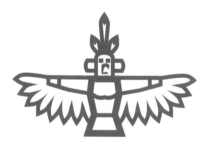

Eagle *kachina*

The costume that identifies Kwahu (or Eagle) *kachina* includes a pair of eagle-feather wings, a turquoise mask with a yellow beak and a feathered headdress. Eagles are cherished and respected by the Hopi, being thought to carry messages between the human and spirit realms.

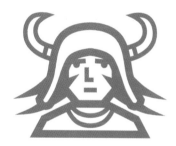

White Buffalo *kachina*

Mosairu (or White Buffalo) *kachina* is portrayed wearing a pair of curved buffalo horns on his head, while his white-trimmed headdress and costume evoke the animal's hide. Because white buffaloes are rare, they are considered sacred beings, and so symbolise blessedness or good fortune.

Aztec deities

See also
Plumed serpents,
page 93.
Rod of Asclepius,
page 29.

The Aztec civilisation that prevailed in Mesoamerica before its destruction by the Spanish conquistadors inherited many of its deities from its predecessors, particularly the Maya. And although the collective and individual characteristics of its gods reflected the concerns and ideals of Aztec society, many of the symbolic attributes that represented them were both derived from previous pantheons and drawn from nature. Indeed, while Aztec art is often highly stylised, it is not difficult to discern in the surviving statues, artefacts and illustrated codices the feathery and serpentine forms, for example, that helped to identify and define their deities.

Xochiquetzal

The quetzal's scarlet and green feathers were highly prized as a natural symbol of beauty. This exquisite bird was equated with Xochiquetzal ('Flower Quetzal'), a goddess of love and fecundity who epitomised the feminine ideal. Xochiquetzal was often portrayed wearing a headdress of quetzal feathers.

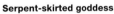

Serpent-skirted goddess

The interwoven rattlesnakes that make up her skirt are evident in the Aztec figure of Coatlicue that was found at Tehuacan, Mexico. Her skull-like face and pendulous breasts further emphasise 'She of the Serpent Skirt's' status as a goddess who symbolises both death and birth.

Quetzalcoatl

Quetzalcoatl can be translated as 'Plumed Serpent' or 'Feathered Serpent', the feathers in question being those of the quetzal bird. This 'good' god (who was associated with the sky and fertility) was consequently often symbolised by a sinuous snake with a striking crest of long, bright-green, male quetzal's tail feathers.

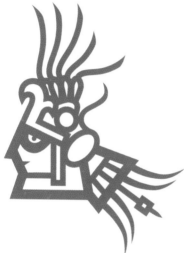

Huitzilopochtli

The Aztecs' most important god was Huitzilopochtli, whose name means 'Hummingbird on the Left' or 'Hummingbird of the South'. Although this solar and martial deity could be represented as a golden eagle, he otherwise wore a hummingbird headdress – the aggressive, sharp-beaked hummingbird being an Aztec symbol of belligerence.

Coatlicue

'She of the Serpent Skirt' – Coatlicue – was the mother goddess who gave birth to Huitzilopochtli at the moment of her murder. The skin-discarding serpents that comprise the skirt of this mutilated goddess symbolise (Coatlicue's) death and (Huitzilopochtli's) birth, or regeneration.

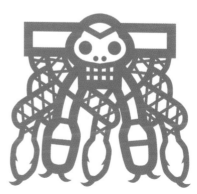

Other Mesoamerican deities

See also
Jaguar God of the Underworld,
page 89
Jaguar Warrior Order, page 89

The individual natures of the gods that were venerated by the peoples of Mesoamerica reflected the different concerns of their worshippers. Being especially interested in the fertility of the land and the growth of maize, the divinities to which the Maya accorded special importance included the rain god Chac. The Aztecs shared these fundamental preoccupations, and therefore perpetuated aspects of such deities in their own pantheon, but the warlike nature of their civilisation is evident in the martial characteristics of many of their gods, which, in the art of the codices, are portrayed in a strikingly complex and dynamic style.

Aztec rain god
His jaguar's fangs and goggle eyes identify the face that stares out of a polychrome ceramic Aztec vase as Tlaloc, the rain god. Worshipped as 'The Provider', Tlaloc was believed to live on the summit of the temple at Templo Mayor, in Tenochtitlan, where he was worshipped.

Manikin Sceptre

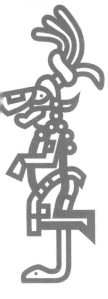

The Mayan deity called the Manikin Sceptre (or God K or GII) may originally have represented lightning, but came to symbolise divinely sanctioned rulership. Portrayed with a snout-like head and serpent-like leg, but otherwise as human, tiny versions of the Manikin Sceptre were depicted being held by rulers.

Tlaloc

Tlaloc, the Aztec god of rain, is represented with goggle eyes and jaguar's fangs, the connection with the big cat possibly having been made because the jaguar's snarling resembles the sound of thunder's rumbling. Thunder and lightning could also be respectively symbolised by the tomahawk and serpent that Tlaloc carried.

Xiuhtecuhtli and Xiuhcoatl

The primary attribute of the Mesoamerican god of fire, Xiuhtecuhtli, was the Xiuhcoatl fire serpent, or turquoise serpent (which was also wielded as a weapon by Huitzilopochtli). A symbol of fire and sunrays, Xiuhcoatl was shown as having a serpent's head and a segmented body.

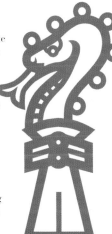

Tezcatlipoca

Tezcatlipoca means 'Smoking Mirror', this being the attribute of the Mesoamerican god of sorcery, symbolising his clairvoyance. Tezcatlipoca wore this round, magical mirror, which was made of polished black obsidian, on the back of his head (and it sometimes also replaced one of his feet).

Voodoo *loas*

See also
Seven Sorrows of the Virgin Mary, page 183

Voodoo, and related sacred beliefs like Voudou, Santería and Macumba, evolved in the Americas where Africans lived in slavery, notably in New Orleans, Louisiana; Haiti; the Dominican Republic; and Brazil. Because most slaves were transported from west Africa, Voodoo's traditions are rooted in that region, also incorporating elements of other faiths, such as Roman Catholicism. Voodoo recognises hundreds of deities, or *loas* (intermediaries between the supreme being and humankind). A *loa*'s presence is ritually invoked in Voodoo ceremonies by the drawing of his or her individual symbol (*vere*); and *reves*, some of which are shown here, are increasingly referenced in art.

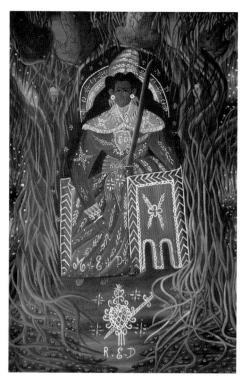

Erzulie Dantor
Haitian artist André Pierre's 1978 painting *La Reine du Vodoun – Maîtresse Erzuly Dantor* (*The Queen of Voodoo – Mistress Erzuly Dantor*), portrays a dark aspect of Erzulie. Her heart-enclosed initials are adorn her bosom, while her *vere* – a heart pierced by a sword – is visible at her feet.

Damballa

Considered the father of them all, the most important *loa* is Damballa (also Damballa-Wedo or Danbhalah-Wedo). As the 'Great Serpent', Damballa is symbolised by such enormous snakes as pythons and boa constrictors. A snake is therefore the crucial component of Damballa's *reve*.

Legba

Although he is associated with the sun, and with sorcery, Legba's most important role is as the doorkeeper between the mortal world and that of his fellow *loas*. He is also called Maître Carrefour ('Master of the Crossroads'), and the basis of his *reve* is a cross, symbol of the crossroads.

Erzulie

The female *loa* Erzulie, or Maîtresse Erzulie, is equated with the moon. Characterised as beautiful, sensual and vain, she is renowned for her fondness for the good things in life, including wealth, material possessions – and love. A heart, the symbol of love, outlines Erzulie's *reve*.

Baron Samedi

Baron Samedi ('Saturday') belongs to the group of *loas* known as the *guedes*, who are regarded as dangerous spirits, having an appetite for sexual excess, but ultimately being linked with death. As a *guede*, Baron Samedi's *reve* is based on such symbols of death as coffins and graves.

Northwest Coast clan crests

See also
Eagle and thunderbolts.
page 163
War goddesses.
page 175

Eagle
The eagle's most recognisable characteristic. according to the form-line conventions of the Northwest Coast. is its downward-curving beak (a primary form line. this is usually black). A principal Haida crest. the eagle represents extraordinary hunting prowess. as well as superior powers of hearing and seeing. and chieftainship.

The Native American peoples of the Northwest Coast (including the Tlingit. Haida and Tsimshian: the Bella Bella. Bella Coola. Kwakiutl and Nootka: and the Coast Salish) have traditionally supported themselves by fishing. establishing permanent settlements in the region's coastal villages. where large. communal wooden houses shelter kindred or clan groups. Such groups have historically expressed their shared identity by means of bold clan crests. typically either carved two-dimensionally in wood or painted – singly or in combination – on house fronts. totem poles and other artefacts. Indigenous creatures feature in many such crests. with each being imbued with different symbolic significance.

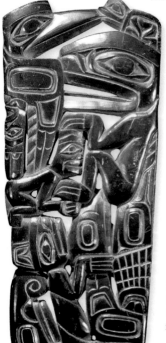

Haida raven totem
Carved during the 19th century from argillite (a type of slate). this Haida raven totem uses the bold form lines characteristic of the art of the Northwest Coast with which to portray the raven. The Haida are noted for their fine argillite artworks.

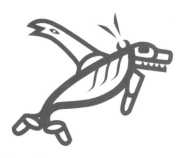

Killer whale

Killer whales are considered by the Haida to be the mightiest of all creatures, and symbols of power. They are generally distinguished in the art of the Northwest Coast by their large dorsal fin and by the blowhole in front of it; a pectoral fin may also be portrayed.

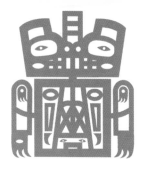

Beaver

The dam-building beaver represents creation, construction and industriousness. It is typically depicted in the art of the Northwest Coast with a pair of oversized incisor teeth; a long, upward-pointing tail; and sometimes also gripping a fish or log in its forepaws.

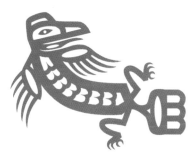

Raven

The raven, perhaps the most popular crest of the Northwest Coast, is represented with a straight, or gently curved, beak. A trickster and culture hero who, it is said, gave humankind the heavenly bodies, and thus light and fire, the carrion-eating raven is also associated with orderliness.

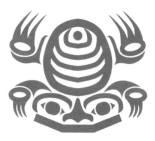

Frog

The frog is usually portrayed with large eyes and a wide mouth in the stylised, symmetrical style typical of Northwest Coast art, which combines block-like forms with ovoid and U-shaped units. The frog is considered a messenger here, as well as a symbol of magic and good luck.

Plains' warrior symbols

See also
Native American shield, page 33
White Buffalo kachina, page 77

As nomadic hunters, the Plains' Indians (including the Sioux, Crow, Blackfeet, Arapaho, Comanche, Cheyenne and Pawnee) traditionally admired such natural predators as the eagle and bear, which became mystical symbols of warriorship. Despite having symbolic links with the eagle, the thunderbird was a mythical being; but, on the mundane level, the buffalo was also accorded respect, for these Native Americans relied on the immense buffalo herds of the Great Plains region of North America for meat and hide, the latter being used for tipis, clothing and as a rawhide canvas for the Plains' people's symbolic pictographs and patterns.

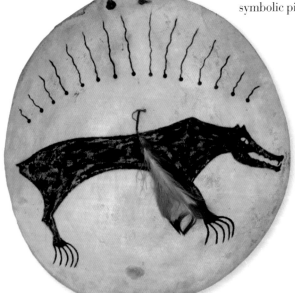

Protective shield
A feather has been attached to this Crow deer-hide shield cover, which dates from around 1860, yet the most significant symbolic element is the terrible-taloned animal whose image dominates it. The creature's symbolic presence by the warrior's side would have been believed to shield him from harm.

Thunderbird

The mythical thunderbird symbolises the ultimate sky spirit and warrior's 'power' creature. Typically portrayed in profile, sometimes in an hourglass shape, with fanned-out tail feathers, outspread wings and a curved beak, it is so huge that thunder rumbles when it moves its wings, while lightning flashes from its eyes.

Bear paw

The sheer strength, size and ferocity of the bear made it a favoured 'power' animal among Plains' warriors. By depicting its paw on, for example, buffalo-hide shields and shield covers, warriors symbolically summoned, and benefited from, the bear's spiritual presence, power and protection in battle situations.

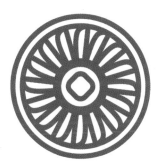

Buffalo

Not only did the buffalo provide the hide for warriors' buffalo robes and shields (which were painted with depictions of war exploits or protective 'power' symbols), but as a hunted animal and a symbol of strength, abundance and wisdom, it was itself portrayed either in pictographic or box-and-border-pattern form.

Feathered circle

A circle comprising stylised feathers is often seen in Plains' warrior-related art. While its circular shape and radiating pattern denote the sun, the feathers make various symbolic allusions. As eagle feathers, they may signify communication with higher spirits, mastery of the sky, protection and a feathered war 'bonnet'.

Aztec symbols of military identity

See also
Roman military standard, page 33
Eagle and thunderbolts, page 163

Surviving reliefs and codices featuring heavily armed and armoured, martial-looking men attest to a sophisticated Mesoamerican warrior culture. Particularly striking is the prominence accorded to reptile, animal and avian forms, notably serpents (which appear as stylised weapons and helmets), jaguars and eagles, the respective emblems of the Aztec jaguar (or tiger) and eagle knights. All predators have additional symbolism in the context of warfare. The serpent, for instance, represents lightning bolts and fire, with the jaguar signifying mastery of the earth and the sun by night, and the eagle domination of the sky and the daytime sun.

War Serpent
The War Serpent is represented in Mayan art alongside weaponry or as part of a warrior's headdress or helmet. Possessing the scaly skin and dark, round eyes of a snake, it is also equipped with fearsome-looking jaguar's teeth, denoting aggression and the ability to wound and kill.

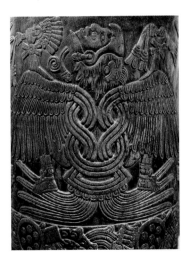

Eagle knight
A stylised portrayal of a knight of the Eagle Warrior Order has been carved on this wooden Aztec drum. Look closely, and you'll see a man's head framed by the eagle's beak – his helmet – and his hands and feet protruding above and below its wings.

Jaguar God of the Underworld

Feared for their sharp claws and teeth and predatory nature, nocturnal jaguars were also associated, in Mesoamerican minds, with the underworld realm of death. The image of the Mayan Jaguar God of the Underworld (and night-time sun) – in full jaguar form or with jaguar-like facial features – therefore symbolised deadly ferocity.

Eagle Warrior Order

The high-flying, keen-eyed, cruel-beaked, razor-taloned eagle was viewed by the Aztecs as the king of the sky, furthermore being equated with the daytime sun. This powerful bird was therefore a natural choice to symbolise an Aztec warrior order, whose members could be portrayed wearing beaked helmets and armour resembling feathered wings.

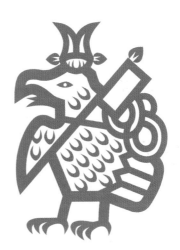

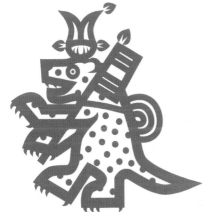

Jaguar Warrior Order

As the Mesoamerican 'top cat', the jaguar (*Panthera onca*) represented lordship. Its association with physical superiority, earned by its prowess as a strong, skilled and ruthless hunter, and with death, led to the jaguar also being accorded the symbolic position of patron of a noble Aztec warrior order.

Symbolic systems of the Southwest

See also
'Whirling logs',
page 74
Swastika,
page 111

Native American artistic traditions of the Southwest, home to the Pueblo, Hopi, Navajo, Apache and Zuni peoples, among others, include sand painting, basketry, weaving and pottery. The inclusion of intricate or complex details being ineffective in such art forms, they instead rely on simple symbolic motifs with which to communicate abstract concepts or narratives. Being heavily dependent on the weather's vagaries has given the people of the Southwest an exceptional awareness of natural cycles and of all that is in, and descends from, the sky, which is why stellar, solar and meteorological symbols feature prominently in their art.

Zia
The Southwestern sun is typically symbolised by means of a circle (the solar disc), from which four groupings of ray-like lines may radiate towards the north, south, east and west (as exemplified in the Zia symbol shown above). Such motifs also represent the centre and the four cardinal directions.

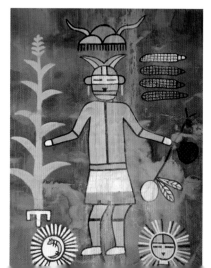

Hopi *kachina*
Fred Kabotie's painting of a Hopi *kachina* is packed with symbolic details, such as the circular image at bottom right denoting the Sun *kachina*. *Kachinas* are believed to bring rain, which is why the composite symbol above this figure's head represents a rain cloud and rain.

Morning Star

The four-pointed star is often the central focus of Apache basketwork. Stars generally represent spirits in the symbolism of the Southwest, with the Morning Star (the brightest star visible from the Earth at dawn) having particular significance in the sacred traditions of the Native Americans of this region.

Whirling log

A four-armed cross with hooked ends is a common motif in the art of the Southwest, where it may have a number of names (the whirling log is one) and meanings, usually associated with the sun, the cosmos or water. Most symbolise concepts relating to movement and dynamic cycles.

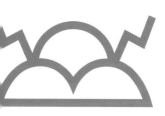

Rain cloud

Rain clouds may be depicted as a pyramidal collection of semi-circles from which protrude jagged lines denoting the lightning flashes that often precede rainfall. According to Pueblo belief, clouds are the spirits (or breath) of worthy people who have died.

Rain

Rain is vital to the peoples of the arid Southwest – without it, crops would not grow. Rainfall may be symbolised by a semi-circle (signifying a cloud), with a series of short lines (representing rain) projecting from its baseline.

Snow

In the art of the Southwest, the motif that is frequently used to symbolise the falling of snow comprises a pyramid made up of dots, which is a simple, but elegant, expression of the way in which snowflakes accumulate to blanket the ground below.

Symbolic systems of the Southwest

See also
Kangaroo tracks,
page 236

The reptiles, animals and birds that inhabit the American Southwest are generally all-important to the peoples who share their habitat, even if their significance is limited to the danger that they pose, or their usefulness as a source of food or clothing. Most, however, have more profound symbolic associations, which is why they feature repeatedly in the Native American art of this region. The symbols selected here, which can be seen decorating basketware, textiles and pottery, evoke the presence of such creatures in a form that is minimalistic, understandable and eloquent.

A bowl of blessings

The art of the Southwest's characteristically spare lines have transformed a simple bowl into an elegant artwork. Dating from between 1375 and 1475, this polychrome artefact was discovered at Hawikku, New Mexico, an ancestral Zuni town. The macaw or parrot adorning it may signify affluence or summer.

Snake and lightning

The shapes of a snake's body and a lightning bolt are similar, which is why both may be symbolised by a jagged line, tipped by a triangular head. This symbol generally represents water, rain and fertility.

Deer tracks

Deer have traditionally provided the Native Americans of the Southwest with meat for food and deerskin for clothing, and may therefore represent sustenance, well-being and security. Deer, or the direction in which they have travelled, may be symbolised in the art of the Southwest by their distinctive, cloven-hoofed tracks.

Plumed serpents

Plumed serpents, such as Kolowisi and the Avanyu, make appearances in the Native American art of the Southwest in the form of creatures with undulating, serpentine bodies (representing water) and feather-crested or horned heads (often signifying the sky). Such hybrid snakes may represent storms and seasonal changes.

Wolf tracks

Wolves are regarded with ambivalence by the Southwestern peoples, for on the one hand they may prey on humans and, on the other, they are admired for their hunting prowess. The motif that is typically used to symbolise a wolf is its paw prints.

Macaw and parrot

The motifs denoting a macaw (seen here) and parrot essentially comprise a triangle that extends at the top into a curved line at one end, and into a straight line at the other, describing a bird's body, beak and tail. Macaws and parrots symbolise the sun, summer and prosperity.

The Aztec *tonalpohualli*

See also
Water, page 11

Aztec day names
The four glyphs
depicting a skull,
streams of water,
a flint stone and a
dog that symbolise
the Aztec day
names Miquizli,
Atl, Tecpatl and
Izcuintli are all
discernible in this
detail from the
15th- or 16th-
century Codex
Borgia.

Various calendars have been used in Mesoamerica over the
millennia, the most important, and widespread, being the
260-day almanac (called the *tonalpohualli* by the Aztecs).
Consisting of two intermeshing cycles comprising 20 day
names and 13 day numbers, the 260-day calendar had
particular significance for divinatory purposes, for all of
the 20 day names had different symbolic associations –
some auspicious and others inauspicious, resulting in
lucky and unlucky days. The glyphs that represented the
individual components of the *tonalpohualli* (a few of
which, symbolising day names, are featured here) were
carved into stone and survive in codices.

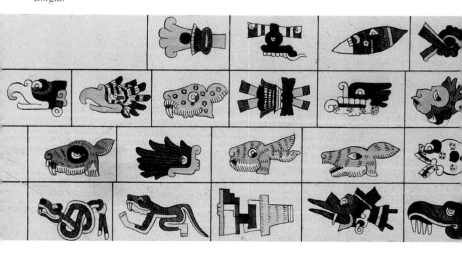

Death

The glyph that represents death, day six (Miquizli) of the Aztec day names, takes the form of a human skull. a universal symbol of death – this being all that remains of a person's head when the flesh has rotted away. Being born on this day augured a short life.

Water

Day nine (Atl) of the 20 day names was designated by the Aztecs the day of water, streams of which can be discerned in the glyph that symbolises it. Water being of great importance for agriculture, and thus for the well-being of the people, Atl was an auspicious day.

Flint

The flint stone was accorded divine status by the Aztecs on account of its hardness, its sharpness and its ability to create sparks of fire. Its versatility and usefulness in everyday life help to explain why flint symbolised day 18 (Tecpatl) in the Aztec cycle of 20 day names.

Dog

Izcuintli, day ten in the Aztec cycle of 20 day names, was symbolised by the dog. Admired for their loyalty and prowess as scavengers, canines were, perhaps more importantly, highly regarded as psychopomps, who were believed to guide their owners to the underworld after death.

Introduction

See also
The Hindu *Trimurti*,
pages 104–5
**The Chinese *tai-chi*
symbol & *pa-kua*
trigrams,**
pages 148–51

Some of the most sophisticated systems of sacred and societal belief, ordering and enrichment evolved in Asia, with the art expressing them figuring among the most eloquent – and elegant – anywhere. From the dynamic pantheons and the supernatural beings of ancient Mesopotamia, Hinduism, Buddhism, Taoism and Shintoism to the monotheism of Judaism and Islam, profound beliefs are embodied in symbol-rich art that ranges from the incredibly complex to the breathtakingly simple. And while the Japanese turned emblems of identity into an art form (known as *mon*), the Chinese perfected the art of conveying macrocosmic–microcosmic ideas using the sparest of symbols.

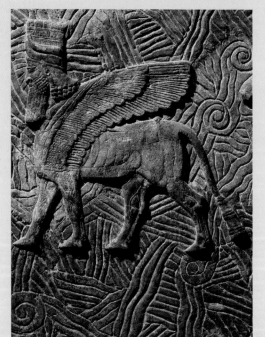

Assyrian guardian
The hybrid figure of a *lamassu* stands proud on an Assyrian gypsum relief dating from the 8th century BC. An evil-averting symbol of protection, its combination of bull's body, eagle's wings and man's head was intended to convey power, monumental strength, and authority.

Kurma

Kurma is the Hindu god Vishnu's second avatar, or manifestation on descending to Earth. As Kurma, Vishnu is symbolised as a man from the waist up, but with a tortoise's lower half, the better to support Mount Mandara during the churning of the ocean to create the intoxicating liquid *soma*.

Bamboo-displaying *mon*

Japanese *mon*, or heraldic badges, take the form of a circle (originally a solar symbol) containing a stylised representation of a plant, animal or object that has positive connotations. The bamboo plant (*sho*) within the *mon* shown above, for example, signifies longevity and resilience.

Tai-chi and *pa-kua* lucky charm

The *tai-chi* (*taiji*, or *yin–yang*) circle surrounded by the eight *pa-kua* (or *bagua*) trigrams symbolises the interaction between *yin* and *yang*, the two fundamental cosmic energies of traditional Chinese belief. This symbol is considered one of the most efficacious charms against harmful influences, including the 'Five Poisons'.

Lamassu

Stone reliefs depicting the *lamassu* – a hybrid creature with the body of a bull, the wings of a bird and a man's head, together representing strength, as well as supernatural and sovereign power – were positioned alongside city gates and doorways in ancient Mesopotamia to protect those within from harm.

Mesopotamian deities

See also
Dragon,
page 229
Zeus/Jupiter,
page 165

The ancient Sumerian, Babylonian and Assyrian civilisations of the southwest Asian region of Mesopotamia portrayed their sophisticated (and related) visions of the cosmos in a simultaneously stately and vivid style, as is evident in surviving reliefs, statuary, murals and other artefacts. The vital elements of this collective vision included deities that symbolised cosmic and natural forces, and patron gods, for the natural replenishment of the rivers Tigris and Euphrates, and humankind's knowledge of the agricultural arts, were of vital importance if the land was to remain fertile, cultivated and consequently productive.

Divine Assyrian symbols
A group of symbols representing the Assyrian gods flank the head of an authoritative-looking figure carved into an Assyrian stele (stone slab). The figure is thought to be that of King Adad-Nirari III (ruled 811–782 BC), and among the symbols are the star of Ishtar and the *marru* of Marduk.

Inanna and Ishtar

The eight-pointed star symbolised the Sumerian goddess Inanna, and her Babylonian and Assyrian counterpart Ishtar, goddesses of sexual love and warfare. The star, often worn as a headdress, represents Venus, the brightest planet, with which they were equated.

Marduk

Marduk had the power to whip up storms, but was particularly venerated as the city god and tutelary deity of Babylon, who vanquished Tiamat and created the sky, earth and humankind. Among his attributes is a triangular spade (the *marru*), which symbolises the agricultural practices that he taught humans.

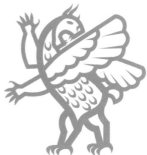

Tiamat

According to the Babylonian tale the *Enuma Elish*, Tiamat was the terrible mother goddess of the salt water, who battled with Marduk following the murder of her husband Apsu, the fresh-water god. Herself a symbol of primeval chaos, Tiamat is depicted as a ferocious-looking dragon- or serpent-like hybrid being.

Adad

A Mesopotamian sky god with rain- and storm-bringing powers, Adad (also known as Hadad or Ishkur) was portrayed in art brandishing a three-pronged, double-ended staff. This symbolised a lightning flash or thunderbolt, and consequently signalled both Adad's authority and his ability to wreak destruction by means of his lethal weapon.

Jewish sacred symbols

See also
Menorah, page 103
**Seraphim, cherubim
and cherubs,**
page 195

Some of the Jewish symbols that appear on the following pages are seen in Christian art, for not only is Christianity a fellow 'religion of the book' (their shared 'book' being the Old Testament), but it is traditionally less averse to representational art than Judaism. You may therefore identify, for example, the tablets of the Decalogue in Western paintings depicting Moses, or an *ephod* with a prominent breastplate being worn by Moses' brother, Aaron (the first high priest). And while these items can consequently be regarded as Moses' and Aaron's attributes, they have symbolic significance in their own right.

Moses and Aaron
Numerous Jewish sacred symbols have been included in this illuminated page from an 18th-century text. They include the *ephod* worn by Aaron (at left) and the tablets of the Decalogue held by Moses (at right). Also visible is a menorah and the Ark of the Covenant.

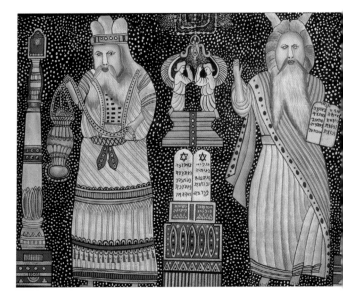

Tablets of the Decalogue

The tablets of the Decalogue symbolise God's renewed covenant with the Israelites following their escape from Egypt. Before giving them to Moses, the Israelites' leader, on Mount Sinai, God inscribed the original pair of stone tablets with the Ten Commandments (in Hebrew), so they also represent God's Law.

Ephod

The *ephod* was a garment worn by Jewish high priests in ancient times. Its most striking – and symbolic – element was the breastplate, which was set with 12 gems, each engraved with the name of one of the 12 tribes of Israel. It therefore represents the 'children of Israel'.

Ark of the Covenant

Hidden since the destruction of Jerusalem's First Temple, the Ark of the Covenant was a sacred symbol of God's presence. It is described as being a gilded wooden casket containing the tablets of the Decalogue (the entire second set, and fragments of the first), surmounted by two cherubim.

Tetragrammaton

Four Hebrew letters – equating to Y, H, W and H – spell out a name that is too holy for Jews to utter (although non-Jews may enunciate it as 'Yahweh' or 'Jehovah'): that of God. This symbol of *ha-shem* ('the name'), called the Tetragrammaton, forms the centrepiece of amuletic images.

Jewish sacred symbols

See also
Conch shell,
page 115
Holy Book,
page 23

'Thou shalt not make unto thee any graven image, or any likeness of any thing that is in heaven above, or that is in the earth beneath, or that is in the water under the earth' (Exodus 20:4), God commanded Moses, and this proscription is reflected in Jewish art. So while naturalistic depictions of living creatures are notably absent, symbols representing mystical concepts may densely illustrate Kabbalistic texts; some are reproduced here. One – the star of David – has become so readily identified with Judaism that it is the primary symbol of Jewish identity, and, indeed, appears on the Israeli flag.

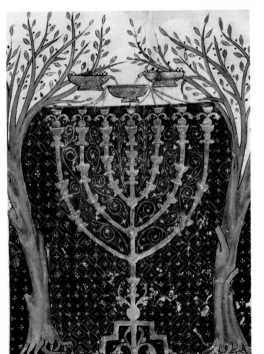

Sacred candelabrum
Joseph Assarfati created this ornate menorah for a Hebrew manuscript in 1299, in Spain. A golden menorah (candelabrum) once burned constantly in the Temple in Jerusalem, thanks to a regular supply of olive oil, perhaps represented here by the two trees and olive-filled bowls overflowing with oil.

Shofar

The *shofar*, a hollowed-out ram's horn, is a ritual trumpet blown on Rosh Hashanah (the Jewish New Year), Yom Kippur and the Day of Judgement, which may variously represent spiritual awakening, repentance and jubilation. It also symbolises the ram that Abraham sacrificed in place of his son Isaac.

Star of David

The star of David (or seal of Solomon) is a six-pointed star, or hexagram, created by two interlocking, upward- and downward-pointing equilateral triangles. Believed to be imbued with protective power, this *magen David* ('shield of David' in Hebrew) may be equated with the shield of God's salvation (as mentioned in Psalm 18:35, attributed to King David.

Sefer Torah

In the context of Jewish art, two scrolls, between which a section of text written in Hebrew characters may be visible, represents the *sefer Torah*, or 'Torah scroll' (the Torah being the Pentateuch, or first five books of the Old Testament). This symbolises the sacred word of God.

Menorah

The seven-branched candelabrum of Judaism – the menorah – encapsulates many facets of sacred meaning linked to the symbolism of both light and the number seven. For while the flames of its candles collectively represent spiritual illumination and God's wisdom, its branches may denote, for instance, the seven days of creation.

The Hindu *Trimurti*

See also
***Trimurti*,** page 13
Kurma, page 97

The most important Hindu gods are Brahma. Vishnu and Shiva. Collectively, they are known as the *Trimurti* ('Having Three Forms' in Sanskrit), their significance as individuals thus being enmeshed, so that the 'Creator' (Brahma), 'Preserver' (Vishnu) and 'Destroyer' (Shiva) maintain a divine cosmic balance that underpins all existence. Brahma is regarded as a more abstract, harmonising divinity, but may still be represented in art. Vishnu and Shiva are far more popular subjects in painting and sculpture, and are portrayed in their many different aspects, particularly Vishnu, who has had nine avatars (earthly manifestations), with one more still to come.

Vishnu Visvarupa
This 19th-century painting from Jaipur portrays Vishnu as the blue-skinned Vishnu Visvarupa, or 'Vishnu who has the Form of the Universe'. His four hands hold his traditional attributes, read clockwise from bottom left: a mace, a disc, a conch shell and a lotus.

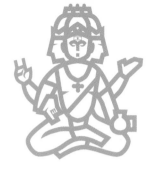

Brahma

Brahma, the god identified with cosmic creative energy, may be represented with four heads, often crowned, all facing in different directions; the quartet may symbolise the world's four ages (*yugas*) and the four most important *Vedas* (sacred texts). Brahma's *vahana* (vehicle) – Hamsa, a swan or goose – represents intelligence.

Vishnu

Vishnu, the 'Preserver', is usually portrayed holding four attributes: a conch shell (which functions as a war trumpet); a mace (*dorje* or *vajra*, simultaneously a weapon and a symbol of authority and knowledge); a lotus flower (denoting creation); and a disc or wheel (*chakra*, a weapon and solar symbol).

Krishna

Vishnu's eighth avatar is Krishna, when he is depicted in fully human form (albeit with blue skin, signalling his celestial origins). The most popular portrayal of Krishna is as a lover playing his flute (a phallic symbol), the entrancing sound of which enraptured all, notably female cowherds.

Shiva

In representational Hindu art, Shiva has many distinguishing features (including a third eye and a crescent moon adorning his hair), all of which have symbolic significance. As the 'Destroyer', this complex god's primary attribute is his trident-topped spear (*trishula* in Sanskrit), which he hurls with devastating effect.

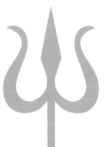

Popular Hindu deities

See also
Third eye, page 123
Lotus *chakra,*
page 140

Many Hindu deities, among them goddesses, inspire great devotion, and are consequently frequently portrayed in art. Some of these representations depict scenes from much-loved myths, such as the image of the goddess Durga (or Devi, the Great Goddess, of whom Kali is similarly a wrathful aspect), vanquisher of the buffalo-demon Mahisha, armed to the teeth astride her big-cat mount. The presence of other deities, such as lady-of-luck Lakshmi, or the prosperity-bringing Ganesh, may be invited into the home or workplace with less elaborate – but no less beautiful – art forms, such as a lotus symbol or an inexpensive divine likeness.

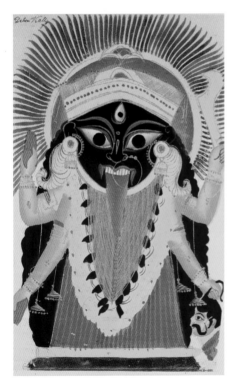

Wrathful Kali
Blood stains the right hands and tongue of the terrifying Kali in this 19th-century Indian portrayal of the goddess of destruction, who grasps a sword and severed head in her left hands. A *shakti* (female energy and consort) of Shiva, Kali is depicted with the third eye associated with the god.

Durga

The goddess Durga, a beautiful, but aggressive, aspect of Devi, was incarnated to battle and overcome Mahisha, the buffalo-demon. She is therefore depicted riding a lion or tiger (symbolising her ferocious energy) and wielding the borrowed weapons (and therefore powers) of the male gods who created her.

Kali

The black-skinned Kali – one of Devi's wrathful aspects – is the burial-ground-inhabiting goddess of death. The bloodthirsty, weapon-brandishing 'Black One' is portrayed with a protruding, blood-dripping tongue and wearing a garland of skulls and a belt of severed hands – all symbols of the death that she brings.

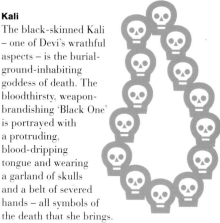

Lakshmi

Lakshmi, Vishnu's consort, exemplifies the perfect wife, being beautiful, benevolent, gentle and loyal. Her primary attribute is the flawless lotus (a symbol of feminine fertility), and because Lakshmi is a fortune-bringing goddess, *rangoli* patterns symbolising lotuses (as above) are drawn in the home during Diwali.

Ganesh

The son of Shiva (whose trident may adorn his forehead), Ganesh is instantly recognisable on account of his elephant's head, symbolising his wisdom. Ganesh has only one tusk, having snapped off the other to write the *Mahabharata*. His mount, the mouse or rat, represents his ability to erode obstacles.

The Buddha & *bodhisattvas*

See also
Eight-spoked wheel, page 115
Bodhisattvas, page 27

Although the Buddha was originally symbolised aniconically (by means of symbols rather than in human form), the power of his personal legacy – encouraged, perhaps, by the representational artistic tradition of Hinduism – led to his increasing portrayal as a man. When shown in human form, he may appear in scenes depicting his princely life as Siddhartha Gautama; as a *sadhu*, or wandering ascetic; or as the Buddha, the 'Enlightened One', when his body may display some of the 32 marks, or *lakshanas*, of a great man, with his hand gestures (*mudras*) and pose (*asana*) all having symbolic significance. Benevolent *bodhisattvas* may be similarly portrayed.

Enlightened One
Portrayed as the sovereign of the world, the Buddha is shown making the *bhumisparsha mudra* in an 18th-century Tibetan painting. The *dharma-chakra*, the eight-spoked wheel that represents the 'Wheel of the Law', is visible at the base of Buddha's lotus throne.

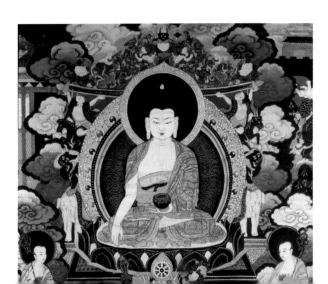

Buddha

The Buddha's person may often be identified by the inclusion of some of the 32 *lakshanas* (physical signs) that are listed in the *Lakshana Sutra*. These include an *urna* (hairy mole) between the eyebrows, which may denote spiritual vision, and a turban-shaped head, surmounted by a topknot-type bump (*ushnisha*), signifying knowledge.

Mudras

Mudras ('signs' in Sanskrit) are symbolic hand gestures seen in the artistic traditions of both Hinduism and Buddhism. There are hundreds, but Buddha is portrayed making only a handful, including the *bhumisparsha* ('touching the earth') *mudra*, when his right hand points downwards, signifying the moment of his enlightenment.

Asanas

Hindu and Buddhist deities may be depicted in various *asanas* (yogic ritual postures), the best-known being the *padmasana*, or 'lotus posture', which is equated with the lotus throne and evokes the lotus's symbolism. On his deathbed, Buddha is portrayed lying on his side, in the *parinirvanasana*, or reclining position.

Bodhisattva Avalokiteshvara

Bodhisattvas ('Those whose essence is enlightenment') are Buddhist beings who act as humankind's helpers, whose relative worldliness may be signalled by their costly clothes and relaxed *asanas*. Avalokiteshvara, the *bodhisattva* of compassion, is frequently portrayed with 11 heads (denoting virtues) surmounted by the image of the Buddha Amitabha.

Buddhist symbols

See also
Buddha's footprints,
page 114
**Vajrayaksha or
Kongoyasha Myo-O,**
page 119

Buddha may be represented aniconically in art – that is, by means of symbols rather than in human form. Indeed, such symbols as the *Buddhapada* and fiery pillar, among others, were used to signify Siddhartha Gautama long before the now-familiar figure of the Buddha entered the iconography of Buddhist art. Some such symbols, like the swastika (symbolically associated with the Hindu gods Vishnu and Shiva) and the *vajra* (the attribute of the Vedic deity Indra before becoming the Vajrayana sect's emblem), were furthermore 'borrowed' from older religious traditions of the Indian subcontinent before being imbued with sacred Buddhist significance.

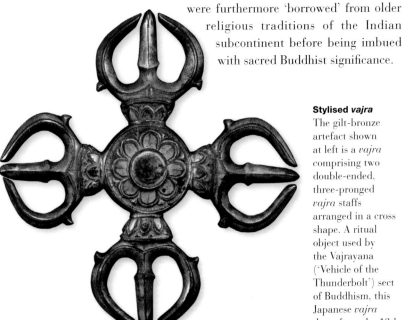

Stylised *vajra*
The gilt-bronze artefact shown at left is a *vajra* comprising two double-ended, three-pronged *vajra* staffs arranged in a cross shape. A ritual object used by the Vajrayana ('Vehicle of the Thunderbolt') sect of Buddhism, this Japanese *vajra* dates from the 13th or 14th century.

Buddhapada

The original *Buddhapada* (Buddha's footprints), it is said, were formed when Buddha stood on a stone at Kushinagar. These representations may be adorned with other Buddhist symbols, notably the *dharma-chakra* (*see page 115*), the implication being that following in his footsteps will lead believers to enlightenment.

Flames

Flames represent concentrated energy: all-consuming and destructive, yet also illuminating and a power for good. The Buddha may be portrayed as a fiery pillar, while Buddhist deities and symbols may be depicted ablaze, so that flames can symbolise divinity, as well a purifying and enlightening spiritual force.

Swastika

When its hooked ends give a cross the appearance of revolving in a clockwise direction, they identify it as a swastika, an ancient Indian symbol of the sun and good fortune (anticlockwise signifies a *sauvastika*). In Buddhist art, the swastika denotes Buddha's heart (and mind).

Vajra

Often seen in the hands of revered Buddhist characters, the *vajra* ('thunderbolt' or 'diamond') staff – which may be single- or double-ended, with three or more points – represents a devastating weapon with all-illuminating, all-shattering powers. As such, it symbolises the Buddhist Law's supremely authoritative, unyielding and enlightening qualities.

Buddhism's Eight Auspicious Symbols

See also
Asanas, page 109
Lotus, page 123

Alternatively called the Eight Symbols of Good Augury or Eight Lucky Emblems (*Ashtamangala* in Sanskrit, and *Pa chi hsiang* in Chinese), the Eight Auspicious Symbols (or Signs) of Buddhism comprise the parasol (or umbrella); the two golden fish; the treasure vase or jar; the lotus; the conch shell; the endless knot; the victory banner or flag (or canopy); and the eight-spoked wheel. The first four symbols listed here are discussed in a little more detail on the facing page, while the significance of the last four is explained overleaf, on page 115.

Flower of Buddhism

Crafted in fine porcelain, this exquisite 18th-century *objet d'art* sets the Buddha at the centre of a white lotus flower. The lotus is a profound and multi-faceted symbol in Asia. In a Buddhist context, it may, for example, allude to enlightenment, the Buddha and the Dhyani-Buddha Amitabha.

Parasol

Held by underlings, the parasol or *chattra* was used in India to protect the heads of important personages from the sun or rain. A symbol, therefore, of elevated social status, the parasol's function furthermore implies a link between heaven and Earth. It therefore denotes spiritual power.

Two golden fish

While a golden fish may signify riches, two fishes denote fertility (through their ability to generate numerous offspring together), so that two golden fish (*suvarnamatsya*) represent an abundance of good things. The fish may also symbolise the freedom to leave behind earthly ties and concerns.

Treasure vase

The symbolic significance of the treasure vase (or jar), *kalasha*, lies both in it being a vessel and in its contents. For while the vessel may be equated with the human body (particularly when shown with a lid), the treasure that lies within may signify spiritual wealth and blessings.

Lotus

A sacred flower in many Asian religions (through the contrast between its beauty and muddy habitat), in the context of the Eight Auspicious Symbols the white lotus (*padma* in Sanskrit) symbolises spiritual purity and enlightenment. It may also represent the Buddha, and the Buddhist Law.

Buddhism's Eight Auspicious Symbols

See also
Buddhapada,
page 111
Parasol,
page 113

The collective significance of the Eight Auspicious Symbols lies in the traditional belief that their first manifestation was on the soles of Buddha's feet, which is why they are frequently depicted adorning his footprints (the *Buddhapada*). The eight symbols appear on Buddhist buildings and prayer flags, and the motifs are often also used to decorate Chinese ceramics and enamelware. They may be represented individually (particularly the eight-spoked wheel), although the luck-bringing, misfortune-averting potential of the Eight Auspicious Symbols is considered to be greatly enhanced when they are portrayed as an octet.

Buddha's footprints
Sketched in watercolour on paper by Dr H A Oldfield, a European visitor to Nepal during the mid-19th century, this set of Buddha's footprints (*Buddhapada*) displays symmetrical, stylised versions of the Eight Auspicious Symbols upon the soles. A lotus *chakra* (wheel) encircles the sacred footprints.

Conch shell

The conch shell produces a loud, resonant sound when blown into, and was used in Asia to summon people to gatherings or in rituals. As one of the Eight Auspicious Symbols, the conch shell (*sankha*) symbolises the voice of Buddha and the spread of his teachings.

Endless knot

The origins of the symbol of the endless, or infinite, knot (*shrivasta*) are uncertain: some say that it represents two tangled serpentine bodies, and others, intestines. Its significance is clearer – it represents longevity, the interconnectedness of all that is in the universe and Buddha's infinite wisdom.

Victory banner

The victory banner or flag (*dhvaja*) signals Buddhism's victory over ignorance and malign forces. When the victory banner is instead identified as a canopy, its symbolism is similar to that of the parasol, signifying as it does protection (in this case, offered by the Buddhist Law) and power.

Eight-spoked wheel

The eight-spoked wheel (*dharma-chakra*) is one of the most important symbols of Buddha and Buddhism. Buddha is said to have set this 'Wheel of the Law' turning when he first began preaching, and its eight spokes symbolise Buddhism's Noble Eightfold Path (to enlightenment).

SACRED

Buddhism's Seven Treasures

See also
Elephant, page 51
Horse, page 145

An Indian myth tells of a perfect king of the universe called Chakravartin, 'He Who Turns the Wheel', who became identified with Buddha, who turns the 'Wheel of the Law' (*dharma-chakra*). Chakravartin possessed Seven Treasures, or Seven Jewels of Royal Power (*Saptaratna* in Sanskrit), four of which – the elephant, horse, light-giving jewel and queen – are introduced here, the remaining three being the wheel, the minister (or treasurer) and the general (or military leader). The Seven Treasures – symbols of the ideal ruler – may be depicted around the Chakravartin or else appear as decorative elements in Buddhist art.

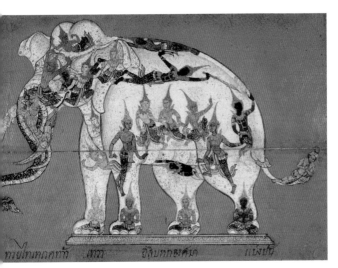

Buddhist jewel
Stately elephants are so greatly respected in Asia that they have come to signify both spiritual authority and temporal power. This fanciful Thai depiction of an elephant, which dates from 1850, emphasises such symbolic connections by incorporating the images of various Buddhist deities and figures.

Elephant

Sometimes portrayed carrying the light-giving jewel on its back, the elephant is associated in Asia with wisdom, patience, strength and sovereignty. Because his mother dreamed of a white elephant before conceiving Siddhartha Gautama, this creature may symbolise the Buddha.

Horse

The horse – the mount of high-ranking men – was valued in Asia for its speed and endurance. Its association with Buddha arose from the legend that when he fled his princely life, it was on a horse named Kantaka, whose hooves did not touch the ground, so they made no sound.

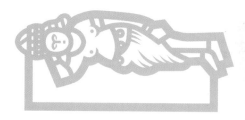

Light-giving jewel

The light-giving (or wish-granting) jewel – which may be equated with a lustrous pearl and can be depicted as oval or tear-shaped, ringed or enclosed by flames – represents the priceless gift of clarity of vision or illumination. It therefore symbolises insight, understanding, and the spiritual riches offered by Buddhism.

Queen

The queen (or maiden) symbolises Chakravartin's ideal consort, and is consequently envisaged as the epitome of womanly beauty and virtue. The mother of Siddhartha Gautama, the future Buddha, was just such a queen (Queen Maya gave birth to him from her side, dying of bliss seven days later).

Buddhism's Five Kings of Mystical Knowledge

The Five Kings of Mystical Knowledge, or Wisdom Kings, are the irate-looking, weapon-wielding, and wrathful manifestations of the five Dhyani-Buddhas ('Buddhas of Meditation') who battle against passions, ignorance and all that is evil in the world, aided by the all-consuming flames that surround them. Venerated in the Himalayan region and in Japan, the Vidyaraja and Myo-O, as they are collectively called in Sanskrit and Japanese, may be worshipped individually or as a group. Similarly, in art, they may be portrayed singly (often as sculpted figures) or collectively, when they are typically shown in mandalas (symbolic circles), with each having cosmic significance.

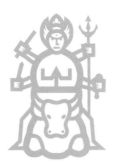

Yamantaka or Daiitoku Myo-O

Yamantaka, the 'Terminator of Death', is revered in Tibet for killing Yama, the black-buffalo-headed 'Lord of Death', which is why he is usually depicted with a buffalo head or accompanied by a white buffalo. Called Daiitoku Myo-O in Japan, he equates to Amitabha (or Manjushri) and the west.

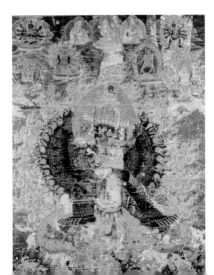

Death's terminator

A dark, dynamic portrayal of Yamantaka dominates this 18th-century Tibetan *thangka* ('flat' painting). The painting has faded, but Yamantaka's horned buffalo's head remains visible (he has nine heads in all here). This wrathful, 34-armed, 16-legged figure is surrounded by flames.

Acalanatha or Fudo Myo-O

Acalanatha (Vairocana's furious-looking emanation), or Fudo Myo-O ('The Immovable One') in Japan, is portrayed at the centre of mandalas. In his right hand he may hold a (serpent-entwined) sword with which to vanquish greed, anger and ignorance, and in his left a rope, with which to immobilise evil forces.

Trailokyavijaya or Gozanze Myo-O

Trailokyavijaya, the 'Conqueror of the Three Worlds' who corresponds to Akshobhya and the east, is called Gozanze Myo-O in Japan. He is represented stamping on Shiva and Parvati, his numerous hands holding weapons, with two intertwined to form the distinctive *mudra* that is associated with him.

Kundali or Gundari Myo-O

Known as Gundari Myo-O in Japan, and corresponding to the Dhyani-Buddha Ratnasambhava, Kundali is the king of the south. Less frequently depicted than the other Vidyarajas, his identifying symbolic attributes are typically the venomous serpents that coil themselves around his neck, arms and ankles.

Vajrayaksha or Kongoyasha Myo-O

The king of the north is Vajrayaksha, a manifestation of Amoghasiddhi, whose name is Kongoyasha Myo-O in Japan. He may be portrayed wielding a five-pointed *vajra* in one right hand, sometimes with a bell in the corresponding left hand (respectively masculine and feminine symbols that imply generative power).

Buddhism's Four Heavenly Kings

See also
Bishamon,
page 133
Dragon,
page 159

According to Buddhist tradition, the Four Guardian Kings (*Lokapala* in Sanskrit), Celestial Kings or Heavenly Kings guard the four quarters of the cosmos (or the Buddhist Law) from evil. Each of the four is consequently associated with a cardinal direction (and season), and each brandishes a different weapon with which to fend off malign forces. As a group, they are typically represented guarding Buddhist stupas (domed shrines) and altars and at the periphery of mandalas. Less ferocious-looking in Chinese portrayals than in Indian art, it is on the Chinese vision of the kings that the illustrations on these pages are based.

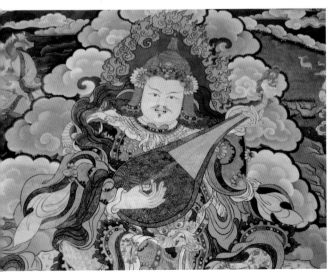

King of the east
The names and representations of the Four Heavenly Kings may vary in different countries' Buddhist traditions. In Tibet, it is the guardian king of the east, Dhritarashtra (or Dhrtarashtra), pictured here in a painting at Lhakhang Karpo Temple, Litang Chode Monastery, who plays a stringed musical instrument.

Vaishravana or Mo-li Shou

Vaishravana, 'He Who is Knowing' –
equated with the Japanese Bishamon and
the Chinese Mo-li Shou – is the only
heavenly king to be singled out for
veneration. The guardian of the north and
winter, he may hold a vicious dragon or
mongoose, and a pearl (symbolising wealth).

Dhrtarashtra or Mo-li Qing

The protector of the east and spring,
Dhrtarashtra ('He Who Maintains the
Kingdom of the Law'), who is called Mo-li
Qing in China, is the oldest of the fraternal
quartet. When swung, his sword raises a
devastating black wind, followed by lethal
manifestations of fire and smoke.

Virupaksha or Mo-li Hai

The protector of the west and autumn,
Virupaksha ('He Who Sees All in the
Kingdom') is called Mo-li Hai in China.
In Chinese art, Mo-li Hai is usually shown
holding a four-stringed lute, which, when
played, causes the camps of his foes to
catch fire and be annihilated.

Virudhaka or Mo-li Hong

'He Who Enlarges the Kingdom',
Virudhaka is the guardian king of the south
and summer. As the Chinese Mo-li Hong,
he may be portrayed holding an umbrella.
When opened, this 'Umbrella of Chaos'
causes the universe to be plunged into
darkness; when lowered, it generates
earthquakes and storms.

Sacred Asian 'crossover' symbols

See also
Krishna,
page 105
Buddha,
page 109

A number of 'crossover' symbols feature in the sacred art of Asia, and particularly in the artistic traditions of Hinduism and Buddhism – Buddhism having adopted many of the attributes and iconography associated with Hindu deities, for example, with which to convey similar concepts (albeit with Buddhist significance). Some of the most obvious include the many pairs of arms with which divine or spiritually superior beings may be equipped; the 'third eye', or eye-like mark, that may be visible at the centre of the forehead; Sanskrit calligraphy spelling out the sacred syllable *Om*; and the exquisite lotus flower.

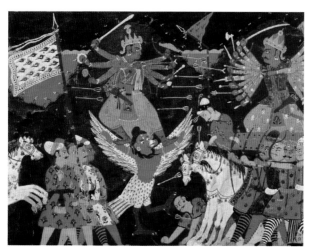

Krishna battles Banasura
Multiple weapon-wielding arms abound in this Nepalese gouache painting dating from 1795, which depicts an epic battle drawn from the Hindu tale of Banasura, a 1,000-armed *asura*, or demon. In this battle Banasura was pitted against Krishna – and was defeated.

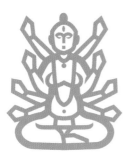

Multiple arms

The extra pairs of arms with which many Hindu and Buddhist deities are depicted are a general symbol of their supernatural natures or divinity. The symbolic objects or gestures (*mudras*) that are held or made by each hand additionally represent an aspect of that specific god's or goddess's powers or character.

Third eye

Certain Buddhist divine beings may be depicted with numerous eyes adorning their hands, but the 'third eye' is typically portrayed turned on its side above, or between, a figure's conventional pair of eyes. A symbol of spiritual vision, in Hinduism a fiery third eye is especially associated with Shiva.

Om

The symbol shown above represents the Sanskrit characters that symbolise the sound *Om* (or *Aum*), which is thought to have divine resonance in the sacred traditions of India. In Hindu belief, for example, it represents the combined cosmic powers of Brahma (creation), Vishnu (preservation) and Shiva (destruction).

Lotus

One of the Eight Auspicious Symbols, the lotus has additional meaning in Buddhism as a sign of divine origins, for it was believed to generate itself spontaneously from the water. In Hinduism, it is also a symbol of the divine feminine principle – that is, of the cosmic womb or creation.

Popular Taoist figures & symbols

See also
Fukurokuju,
page 131
Taoism's Eight Immortals,
page 126–9

Many of the scenes and symbols that have traditionally been the subjects of Chinese brush painting – also appearing on ceramics, as well as in other art forms – are drawn from Taoism. Originally a philosophy established by Lao-tzu (or Lao Zi), over the centuries Taoism came to incorporate certain religious features, notably a divine pantheon, which included the Eight Immortals. In the artistic context, popular Taoist images include the figure of Lao-tzu himself, along with the legendary Hsi Wang Mu, the Queen Mother of the West, and such symbols of eternal life as the peach and the plant of immortality.

Fruit of immortality
A delicately painted, naturalistically depicted, fruit-laden branch of a peach tree embellishes an enamelled porcelain bowl dating from 1723 to 1735, the Yung Chen period of the Ch'ing Dynasty in Chinese history. In Chinese eyes, the peach is a Taoist symbol of immortality and renewal.

Lao-tzu

Always portrayed as an old man (he was supposedly born with white hair in around 604 BC), Lao-tzu's (or Lao Zi's) attributes include an S-shaped *ju-i* sceptre (a symbol of fulfilment) and a scroll representing the *Tao-te Ching*. His most distinctive attribute is the water buffalo that he rides.

Hsi Wang Mu

Two female attendants (one carrying a fan, the other peaches) alongside a regal-looking woman identify their mistress as Hsi Wang Mu (or Xi Wang Mu), the immortal Queen Mother of the West. Another of her attributes is a white crane, a symbol of longevity and a divine messenger.

Peach

One of the most potent symbols of immortality, and renewal, in Chinese eyes, the peach (*t'ao*, which also means 'marriage') was said to grow in the Queen Mother of the West's palace gardens. Although the tree blossomed only every 3,000 years, its fruit contained the essence of eternal life.

Plant of immortality

Although stylised and cloud-like, its portrayal in Chinese art has linked the legendary plant of immortality (*lingzhi*, or *ling-chih*) with *Polyporus lucidus*. Believed to bestow eternal life (which it symbolises) on all who eat it, the 'sacred fungus' is a general attribute of Taoist immortal beings.

Taoism's Eight Immortals

See also
Hsi Wang Mu,
page 125

The Eight Immortals (*Pa hsien* or *Baxian*) of Taoism – or the symbols (their attributes) that represent them – are frequently portrayed in Chinese paintings, notably on porcelain. Eight is an auspicious number in China, and a symbol of wholeness, and while this magical number of *Pa hsien* has remained constant, the individual immortals have varied. Those that are introduced on the following pages – six of them male, and two of them female – have, for centuries, been accepted as part of the divine octet, however. All are said once to have been human beings whose exceptional Taoist qualities won them an eternal existence.

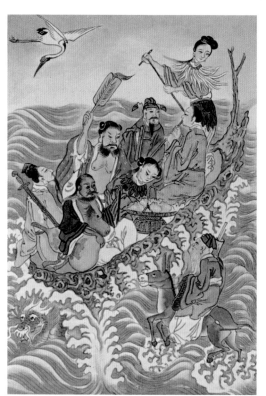

The Eight Immortals
Edward T C Werner's illustration for the book *Myths and Legends of China* shows seven of the Eight Immortals crossing the sea in a boat, while the eighth, Chang Kuo, travels alongside it on his mule. The crane that is flying overhead is a symbol of longevity.

Li T'ieh-kuai

Li T'ieh-kuai (or Li Tieguali) is typically portrayed leaning on an iron crutch (signifying lameness) and holding the double gourd (*hu-lu*) that Chinese travellers once used as a water bottle, from which smoke may rise, denoting the union of Earth with heaven.

Chang Kuo

The attribute that Chang Kuo (or Zhang Gualao) grasps may puzzle Western viewers: it is, in fact, a musical instrument: a hollowed-out bamboo tube that is beaten like a drum with the two sticks shown stored inside it. Chang Kuo may also ride a white mule (backwards).

Lu Tung-pin

The primary attribute of Lu Tung-pin (or Lu Dongbin, the patron of Chinese barbers) is a sword; the second is a flywhisk. When portrayed with Lu Tung-pin, his weapon is shown strapped across his back. No ordinary sword, it has the power to despatch evil monsters.

Lan Ts'ai-ho

The female immortal Lan Ts'ai-ho (or Lan Caihe) carries a basket full of flowers (which is why she was adopted by Chinese florists as their patron). She may also be readily identified in portrayals of the Eight Immortals by the single shoe that she wears.

Taoism's Eight Immortals

See also
Krishna,
page 105
Lakshmi,
page 107

When represented as men and women, the Eight Immortals are often depicted within a scenic landscape, for a basic tenet of Taoism is that longevity – and immortality – can be attained through being in harmony with the forces of nature, this being best achieved by living a life of passive contemplation among the mountains, far from society. In addition, immortals ('the blessed') were said to live on the 'Three Islands of the Blessed' in the Eastern Sea, or, more specifically, in the 'Hills of Longevity' (*Shou Shan*), denoted in artistic representations by mountains rising above the sea.

Chief of the Eight Immortals
His beard, bare chest and flat fan all help to identify the imposing figure carved in ivory by a Chinese artist during the 17th century as Chung-li Ch'uan. Regarded as the head of the Eight Immortals, Chung-li Ch'uan is thought to have discovered the elixir of life.

Chung-li Ch'uan

The leader of the Eight Immortals is Chung-li Ch'uan (or Zhongli Quan). Typically portrayed as an older man with a beard and exposed chest, his symbol is the long-handled flat fan (*shan* or *shanzi*) that he holds, with which he fans life into the souls of the dead.

Ts'ao Kuo-chiu

The two identical objects held by, and symbolic of, Ts'ao Kuo-chiu (or Cao Guojiu) are a pair of castanets – attention-grabbing percussion instruments – that have also been linked with writing tablets. This older, bearded immortal is the patron of all those who work in the Chinese theatre.

Han Hsiang-tzu

The flute is the attribute of the young Han Hsiang-tzu (or Han Xiangzi), the patron of Chinese musicians. Han Hsiang-tzu was said to wander the land playing his flute, attracting and enchanting all who heard his sweet music, which even prompted flowers to burst into bloom.

Ho Hsien-ku

The immortal Ho Hsien-ku (or He Xianghu) presents a graceful figure, and holds the stem of a lotus plant in her hand. Both the lotus flower (a symbol of summer and natural fecundity) and its seedpod (signifying offspring) may be depicted at the stem's end.

The leading gods of Japanese Shintoism

See also
Jurojin,
page 133
Peach,
page 125

The primary deity of Shintoism – Japan's indigenous religion – is Amaterasu, the sun goddess who is also considered the divine ancestor of the Japanese emperors. The three relics (a mirror, sword and jewels) that they are said to have inherited from her are kept at Ise-Jingu, the royal shrine at Uji-Yamada, and Amaterasu may be depicted holding these sacred items in Japanese art. Shintoism's *Shichi Fukujin*, or Seven Happiness Gods, are regarded as less remote, luck-bringing deities. Six are male (Hotei, Fukurokuju, Ebisu, Bishamon, Daikoku and Jurojin), while one – Benten – is female; all may be identified by their individual attributes.

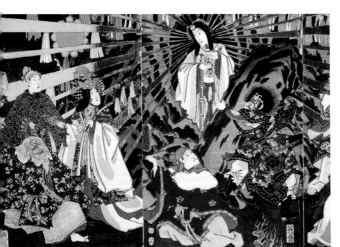

Shinto sun goddess
Amaterasu is here portrayed emerging from the cave into which she once retreated by Utagawa Kunisada (1786–1865), a master of the *ukiyo-e* genre. The radiant Shinto sun goddess is shown holding her sword and looking towards the mirror whose reflection entranced her.

Amaterasu

Amaterasu, the Shinto sun goddess, is typically portrayed with halo-like rays emanating from her head, signifying sunbeams, and holding the three sacred imperial relics. These are the mirror (pictured above), which is said to encapsulate her *shintai*, or spirit; a sword, denoting power; and jewels, symbolising beauty and riches.

Hotei

Hotei is depicted as a bald, chubby, laughing monk, as befits a god associated with happiness and contentment, as well as abundance. His attribute is a sack (on which he may sit), which is said to contain rice and the *Takara-mono* (treasures); he may also be pictured with children.

Fukurokuju

As a deity who represents longevity, Fukurokuju is usually portrayed with Japanese symbols of a long life, which include a deer, a tortoise and a crane, as well as a peach. He may also carry a staff from which a scroll or two (signalling wisdom) may dangle.

Ebisu

The god of fishermen, and of merchants, the beaming Ebisu is usually shown holding a fishing rod in one hand and clutching a huge fish in the other. Ebisu represents the happiness that comes from occupational success, and also natural abundance (symbolised by the fat fish).

The leading gods
of Japanese Shintoism

See also
Vaishravana or Mo-li Shou, page 121
Fukurokuju, page 131

The *Shichi Fukujin*, or Seven Happiness Gods, are typically portrayed as a group, sailing in their treasure ship (*Takara-bune*). Also on board this magical vessel are the *Takara-mono*, or treasures – 21 in total – associated with the gods. These symbolise different aspects of wealth and good fortune, and may be taken out of the treasure-ship context to serve as auspicious decorative motifs. Images of the *Takara-bune*, complete with its divine passengers, are prevalent during the Japanese New Year, for it is said to arrive in Japan on New Year's Eve. It also features frequently on *netsuke*, or intricately carved toggles.

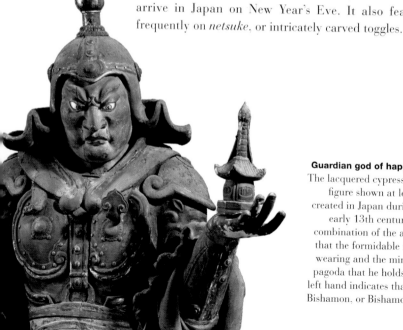

Guardian god of happiness
The lacquered cypress-wood figure shown at left was created in Japan during the early 13th century. The combination of the armour that the formidable man is wearing and the miniature pagoda that he holds in his left hand indicates that he is Bishamon, or Bishamon-ten.

Bishamon

Because Bishamon corresponds to Vaishravana (one of Buddhism's Four Heavenly Kings), the guardian of the north, he is regarded as a god of happiness with a martial aspect. The armour-clad Bishamon may hold a spear, as well as a tiny pagoda (symbolising Buddhism's preciousness).

Daikoku

The earthly riches that Daikoku represents are symbolised by his hammer and sack. Because the mallet-shaped hammer is a miner's hammer, it denotes the mineral wealth that may be hacked out of the ground. The sack, by implication, is full of treasures, such as rice and precious stones.

Benten

Benten is usually depicted playing a lute, signifying her patronage of the arts (literary, representational and dramatic, as well as musical), and the happiness that they can bring. As a goddess, Benten is also regarded as a deity of love (other attributes may refer to further of her aspects).

Jurojin

Like his fellow god Fukurokuju, Jurojin is portrayed as an older man, alongside such symbols of a long life as a deer, crane and tortoise. Jurojin is considered a deity of learning, represented by the scroll, or scrolls, that hang from his staff (again like Fukurokuju).

The sacred art of Islam

See also
Holy Book,
page 23
Hamsa **or**
hamesh, page 43

The central tenet of Islam is that there is no God but Allah, and it is this that underpins a proscription on the portrayal of living beings – human and animal – lest such images become the focus of idolatrous worship. In addition, it is held that any attempt realistically to represent Allah's flesh-and-blood creations would be tantamount to blasphemy. With figurative art therefore not being an option for Muslim artists, over the centuries they have been instrumental in developing the aniconic arts of calligraphy and abstract ornamentation (particularly using geometric and vegetal forms) into exquisite vehicles for spiritual contemplation.

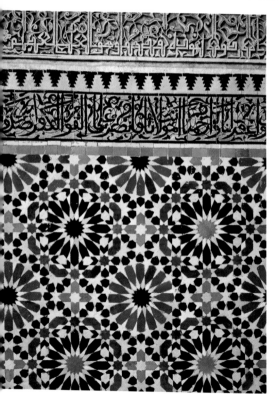

Moroccan *zellij* tiles
Intricate calligraphy spelling out verses from the Qur'an border an elaborate repeating pattern of floral and geometric forms in a detail showing decorative earthenware *zellij* tiles at the Saadian Tombs. Dating from the 16th century, this necropolis in Marrakesh, Morocco, was constructed for Sultan Ahmed el Mansour.

Arabic calligraphy

Arabic calligraphy, which incorporates numerous styles of scripts, is regarded with reverence in the Islamic world, for it embodies and conveys the divine word of Allah (whose name is written above), as contained in the Qur'an, Islam's sacred book. Many artistic media, notably ceramics, display its flowing forms.

Ka'bah

The Ka'bah ('cube' in Arabic) is the cubic shrine within the al-Haram Mosque in Mecca, Saudi Arabia, that contains the Black Stone that Adam is said to have been given by the Archangel Gabriel. The Ka'bah's image may be woven into the prayer rugs (*sajjada*) that are used by Muslims.

Arabesque patterns

The gracefully curving, intricate vegetal patterns that have become a defining characteristic of Islamic art are known in the West as 'arabesques' (or 'in the Arab style'). Typically incorporated into textiles, ceramics and fretwork, they celebrate the beauty of Allah's earthly creation, also alluding to the Garden of Paradise.

Geometric patterns

Based on such forms as the circle, square, triangle and especially the star, the symmetrical, repeating geometric patterns that decorate the structure of Islamic mosques and palaces, for example, make reference to the dynamic qualities of order, harmony and unity that characterise the laws of nature regulating Allah's universe.

Japanese *mon*

See also
**Bamboo-displaying
mon,** page 97

The *mon*, or heraldic badges, of Japan are thought to have
evolved from battlefield banners signalling the identity of
warlords and their men. Over the centuries, the symbols
emblazoned on these flags – many featuring blooms, as
illustrated on these pages – migrated to the *mon* that were
displayed on a samurai or military retainer's person. *Mon*

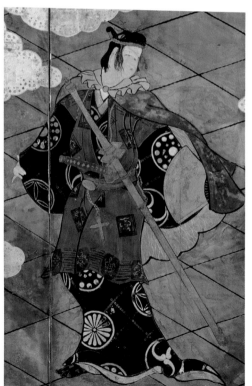

were then adopted for
peacetime wear by members
of noble families and their
retainers, when they were
either attached to, or woven
into, the fabric of their
clothing. Clans had at least
one *mon*, the *jo-mon* ('fixed
badge'), alternatives being
the *kae-mon*.

Badges of identity
A variety of large *mon* adorns
the garb of the sword-carrying
samurai, or warrior, depicted
on this 18th-century Japanese
painted screen. Prominent
among them at the bottom
of his robe is a *mon* based on
the 16-petalled chrysanthemum,
or the *kiku-mon*.

Kiku-mon

The *kiku-mon* is the *kae-mon* of the Japanese emperor, as well as a Japanese national emblem. Based on a stylised chrysanthemum (*kiku*), the bloom at the centrepiece of this *mon* comprises 16 petals, with the hint of 16 more behind. The chrysanthemum symbolises a long life and happiness.

Paulownia

Mon based on the blooms and foliage of the paulownia (*kiri*), an indigenous Japanese plant with clusters of purple-hued or white flowers and heart-shaped leaves, serve as the Japanese emperor's *jo-mon*, the imperial family's *kae-mon* and the Japanese prime minister's *mon*.

Peony

The spectacularly beautiful flower of the peony (*botan-kwa*) may be represented surrounded by its verdant leaves in *mon*. This plant is rich in symbolic meaning in Japan, where it signifies such concepts as the season of spring, as well as marriage, fertility and abundance.

Plum

Because its flowers blossom above bare, or dead-looking, branches, the plum symbolises victory over difficult situations, and was therefore favoured for samurai *mon*. It may also denote spring and good fortune. The plum blossom may furthermore refer to the deified Kitano Tenjin, a revered Shinto artistic patron.

Japanese *mon*

See also
Ogi-displaying mon, page 35

Mon are circular in shape, alluding to the sun – a potent symbol in Japanese culture. Within the circles are stylised representations of plant and animal forms, and of other patterns and objects that, in Japan, are imbued with positive meaning (some examples are shown opposite). Some were chosen for their generally auspicious significance; others as an allusion to a significant event in a clan's history. Hundreds of *jo-mon* were historically officially registered by clans, whose members wore them as a sign of identity and allegiance, but they survive today as less formal symbols of family (and even of corporate) identity.

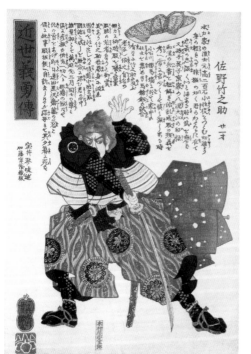

Military insignia

The samurai, or warrior, portrayed by Utagawa Toyokuni (1769–1825), a Japanese artist also known as Toyokuni I, who was renowned for his woodblock prints, displays a typically single-coloured *mon* on his sleeve. While an ordinary samurai generally had one *mon*, his *daimyo* (feudal overlord) could use three.

Pine tree

Because the pine tree is a resin-producing evergreen, the Japanese associate it with incorruptibility and longevity (and in Japanese art, two Scots pines may signify a long-lasting marriage). Therefore a positive symbol that is also believed to attract good luck, the pine's branches make a popular *mon* motif.

Dragonfly

Although the dragonfly's erratic flight path has caused it to be linked with unreliability, it also has positive symbolism, which is why this insect may be accorded a starring position in some *mon*. Its similarity in shape to the Japanese archipelago has resulted in the dragonfly becoming an emblem of Japan: 'Dragonfly Island'.

Butterfly

One butterfly (*cho*) may not be such an auspicious symbol in Japan, suggesting as it does feminine vanity (and the geisha) and short-lived happiness, for example, while a white butterfly is associated with the soul of a dead person. Two butterflies, however, represent a happy marriage.

Tortoise

As a Japanese symbol of longevity, the wrinkled, long-living tortoise (*kame*) is an auspicious subject for a *mon*. In some Japanese traditions, the tortoise has additional significance as a bearer of the cosmos, which is why it also symbolises support, strength and endurance.

Hindu & Buddhist mandalas & *yantras*

See also
***Vajra**, page 111*

Lotus *chakra*
A circle ringed by petal shapes (of which there are typically eight) represents the lotus *chakra* (circle or wheel), a symbol of cosmic creation, for the lotus was believed to have arisen spontaneously from the primeval waters. It also signifies the cosmic womb, mother goddess, or female creative power.

They may look like exquisite pieces of abstract art to the uninitiated, Western eye, but although they are indeed art forms, the primary purpose of a Hindu or Buddhist mandala or *yantra* (Sanskrit for 'circle' and 'instrument' respectively) is to serve as a tool for meditation and consequently spiritual advancement. Often painted on Tibetan and Nepalese *thangkas* ('flat' paintings), the meanings underlying the beings and shapes (some of which are explored here) that make up a mandala or geometric *yantra* – overall, symbols of the cosmos and consciousness like stupas, their three-dimensional counterparts – encourage ascent to a higher spiritual plane.

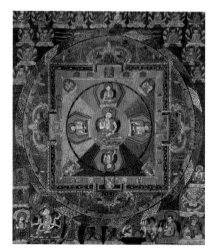

Vajrasattva mandala
The figure at the centre of this Tibetan mandala is the Buddha or *bodhisattva* Vajrasattva ('Diamond Essence' or 'Thunderbolt Essence'). The cross shape that emanates from him is reminiscent of two crossed *vajra* staffs; his mandala also comprises circles and squares.

Circle

The circle generally symbolises the universe or self. Concentric circles, an important feature of most mandalas and *yantras*, typically represent the cosmic worlds contained within the round of existence, or successive, higher levels of understanding, with the centre symbolising perfection.

Centre

The middle of a mandala or *yantra* represents the end of the successful spiritual journey or the centre of the universe. Depicted here may be Mount Meru, the cosmic mountain; Buddha (symbolising the attainment of enlightenment); or the *bindu* ('dot'), which denotes spiritual illumination or the absolute.

Square

Although the specific symbolism of a square within a mandala or *yantra* may vary, depending on the type of cosmic model that it depicts, the square generally denotes the Earth, the mundane and the material. Gateways at the centre of each side signify access by means of the cardinal directions.

Upward-pointing triangle

The upward-pointing triangle signifies the phallus, or *lingam*, a symbol of (Shiva's) active masculine energy. When they cross, the fusion of the female–male generative powers is denoted, as portrayed in representational art by the *yab–yum* ('father–mother') posture.

Downward-pointing triangle

The downward-pointing triangle symbolises the *yoni* ('vulva' in Sanskrit), which in turn represents the *shakti*, or cosmic female creative energy. The *shakti* may in turn be depicted or envisaged as a goddess (especially as the female partner of the Hindu god Shiva).

The Chinese zodiac

See also
Chinese zodiac,
page 41
***Tai-chi* and *pa-kua*
lucky charm,** page 97

The 12 Terrestrial Branches may be called the 'Chinese zodiac' in the West, and, like the Western zodiac, they comprise 12 'signs' – the rat, ox, tiger, rabbit, dragon, snake, horse, goat, monkey, cock, dog and pig being outlined over the following five pages – each of which is said to exert a powerful influence over those born under its sway. But the two systems are otherwise very different. For rather than corresponding to a solar month, each of the 12 Terrestrial Branches is equated with a two-hour period within the 24-hour daily cycle, as well as with a lunar month and an entire year.

The 12 Terrestrial Branches

The 12 creatures that symbolise them are portrayed in a circle in this Chinese paper-cut-style representation of the 12 Terrestrial Branches. At the centre is the *tai-chi* symbol enclosed by the eight *pa-kua* trigrams, and surrounding them are the individual Chinese calligraphic characters that correspond to each animal.

Rat

The first creature in the cycle of the 12 Terrestrial Branches is the rat, a wild animal whose cardinal direction is the north, and whose hours are 11pm–1am. When portrayed in art, the rat may symbolise the qualities of industriousness, accumulation, parsimony and prosperity.

Ox

The ox, a domesticated animal, comes second in the cycle, and corresponds to north-northeast and 1–3am. Often shown in Chinese art bearing respected historical and mythological figures on its back, the ox signifies strength and solidity, as well as agriculture and the spring season.

Tiger

The third Terrestrial Branch, the tiger, is linked with east-northeast, 3–5am, and with such wild-cat characteristics as aggression, bravery and unpredictability. It has extra significance in art, symbolising *yang* and warriorship, with the white tiger being one of the Four Supernatural Creatures (of the west and autumn).

Rabbit

Also called the hare, the wild rabbit represents the fourth of the Terrestrial Branches; its direction is the east, and its hours are 5–7am. A symbol of longevity, sensitivity and *yin*, it may be portrayed performing its celebrated mythical function: mixing the elixir of immortality on the moon.

The Chinese zodiac

See also
Horse, page 117
Dragon, page 159

Chinese people traditionally use the name of the creature that was in the ascendant when referring to the year in which they were born ('the year of the dragon', for instance), the New Year inaugurating it falling on the second full moon after the winter solstice. The sequence of the 12 Terrestrial Branches, beginning with the rat and ending with the pig, forms a constantly repeating 12-year cycle. In the calendrical context, this cycle is intermeshed with that of the Ten Heavenly Stems – which, when grouped into pairs, correspond to the five elements – to form another 60-year cycle.

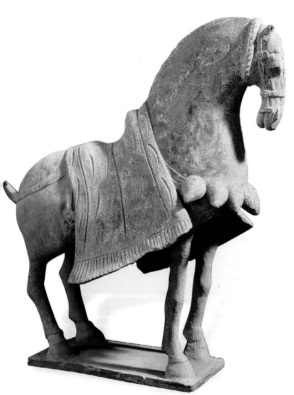

The seventh animal
The saddle and bridle with which a terracotta figure of a 5th- or 6th-century Wei Dynasty horse has been equipped is testimony to the early date of the horse's domestication in China. The horse is the seventh creature of the 12 Terrestrial Branches.

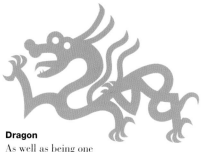

Dragon

As well as being one
of the Four Supernatural Creatures, and a
popular symbol of benevolent supernatural
power in Chinese art, the dragon is the
fifth (wild) animal of the 12 Terrestrial
Branches. As such, it is associated with
east-southeast and 7–9am, and also
with confidence and ambition.

Snake

The sixth Terrestrial
Branch is that of the
snake, or serpent,
which is in turn
linked with
south-southeast and
9–11am. Although
this wild, venomous creature is generally
feared and distrusted in China, the slyness
with which it is equated may also be
interpreted more positively: as shrewdness.

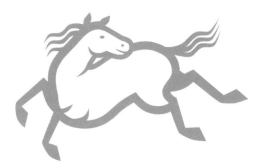

Horse

A domesticated animal, the horse canters
into view as the seventh creature in the cycle
of the 12 Terrestrial Branches. The horse
corresponds to the south, to 11am–1pm, and
to qualities like determination, perseverance
and enthusiasm. Its year may be marked by
wide-ranging and rapidly evolving events.

Goat

The (domesticated)
goat, or sheep, is the
eighth of the 12 Terrestrial Branches, and
while its direction is south-southwest, its
hours comprise 1–3pm. When it makes
a symbolic appearance in Chinese art, it
may signify gentleness and leisure, and
may consequently denote retirement.

The Chinese zodiac

See also
Dog, page 95
Sacred sow, page 25

Although the 12 Terrestrial Branches date back for millennia, the 12 animals that symbolise them are considered Buddhist in origin. Indeed, there is a tale that Buddha named them after the 12 creatures – six wild, and six domesticated – that responded to an invitation to visit him. As a group, the 12 animals may be portrayed sheltering under the 12-branched 'year tree'. They may also form part of traditional mirror backs that, in effect, represent a symbolic map of the cosmos, when they may be depicted forming a circle, ringed in turn by the 28 creatures associated with the constellations.

Symbol of faithfulness
The terracotta funerary statuette glazed with white lime at left dates from the later Han Dynasty, that is, from between the 3rd centuries BC and AD. It is fashioned in the form of an alert dog, the 11th symbolic animal of the 12 Terrestrial Branches, denoting faithfulness.

Monkey

The ninth creature of the 12 Terrestrial Branches' cycle is the monkey, or ape, to which is allocated responsibility for west-southwest and 3–5pm. The wild monkey is regarded – and represented – ambivalently in China, typically as an intelligent and dextrous, but curious and unpredictable, trickster figure.

Cock

The cock, or domesticated rooster, is the tenth of the 12 creatures that symbolise the Terrestrial Branches, and denotes the west, as well as 5–7pm. Considered a solar bird (due partly to its golden plumage, and partly to its habit of crowing at dawn), it represents *yang* qualities.

Dog

The 11th Terrestrial Branch is the province of the domestic dog (which is generally regarded positively in China as a symbol of faithfulness and straightforwardness). This canine creature is consequently considered the guardian of the direction of west-northwest and of 7–9pm.

Pig

The last (domesticated) creature in the cycle of the 12 Terrestrial Branches is the pig, or boar, which is equated with north-northwest and the hours of 9–11pm. Numbering among the qualities that the pig may represent – including in art – are sensuality, fecundity and honesty.

The Chinese *tai-chi* symbol & *pa-kua* trigrams

See also
Chinese zodiac,
page 41
Jurojin, page 133

The ancient Chinese belief in the duality that underpins the existence and functioning of the universe is symbolised by the *tai-chi* (*taiji*, or *yin–yang*) circle. This simple, graphic symbol elegantly encapsulates and conveys the concept that the cosmos – and everything in it – consists of two opposing dynamic energies, *yin* and *yang*, and that both macrocosmic and microcosmic harmony is achieved when they are perfectly balanced. The eight *pa-kua* (or *bagua*) trigrams – three-line symbols – that are used in divination also symbolise the varying relationship between *yin* (denoted by the broken lines) and *yang* (shown by unbroken lines).

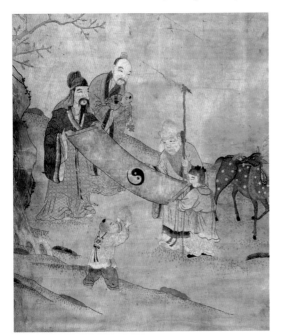

Harmony and longevity
A 17th-century Chinese artist has portrayed the *tai-chi* symbol being studied by a group of travellers in the countryside. Among them is the dome-headed Shou Hsing, the god of longevity (and one of three stellar gods of happiness), accompanied by his deer, a symbol of long life.

Qian trigram

The *qian* trigram consists of three unbroken lines, each of which signifies the *yang* energy. *Qian*'s various symbolic associations include the sky; the southern cardinal direction; and the horse. The qualities that it may denote include animal strength and tirelessness.

Dui trigram

The combination of a broken (*yin*) line above two unbroken (*yang*) lines identifies the *dui* trigram. *Dui* corresponds to still water, or bodies of water; to the southeast; and to the goat (or sheep). It embodies the possibility of contentment and pleasure.

Yin and yang

The black half of the *tai-chi* symbol represents *yin*: the cosmic energy that is passive, negative, feminine and equated with darkness, night, the moon, coldness, moisture and the Earth. The black dot represents the seed, or presence, of *yin* within *yang* (and *vice versa*), and thus their interdependence. The *tai-chi* symbol's sinuous white half denotes *yang*, *yin*'s conflicting polar opposite, being active, positive and masculine, and corresponding to light, day, the sun, heat, dryness and the heavens. The circle that contains both energies signifies the cosmos (and cosmic egg), unity and the ever-revolving cycle of life.

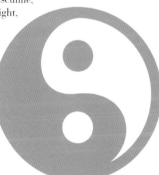

Li trigram

The *li* trigram, which consists of a broken (*yin*) line sandwiched between two unbroken (*yang*) ones, is interpreted as signifying lightness, radiance and grace. It is linked with heavenly manifestations of fire (such as lightning and the sun); the east; and the pheasant.

The Chinese *tai-chi* symbol & *pa-kua* trigrams

See also
Tai-chi and *pa-kua* lucky charm, page 97
The 12 Terrestrial Branches, page 142

In Chinese art, the *tai-chi* symbol is often surrounded by the eight *pa-kua* trigrams, which were said to have manifested themselves in a tortoise's shell to the legendary Emperor Fu Hsi (who may also be portrayed). As well as decorating chinaware and scrolls, printed, carved and woven representations of this good-luck charm are traditionally worn on the person and hung in the home.

Once formed using yarrow sticks, the eight different, horizontally oriented, three-line trigrams – each with a set of symbolic associations – form the basis of the 64 hexagrams that comprise the divinatory system of the *I Ching* (*Book of Changes*).

Emperor Fu Hsi
Fu Hsi is depicted displaying a *tai-chi* symbol circled by the eight *pa-kua* trigrams in an 18th-century engraving. Said to have introduced his people to the trigrams, this emperor lived so long ago that mythical origins (and sometimes ox's horns) are ascribed to him.

Zhen trigram

Two broken (*yin*) lines balanced above one unbroken (*yang*) line describe the *zhen* trigram. This particular combination of three lines corresponds to thunder, as well as to the northeast and to the mythical dragon. *Zhen*'s potential meanings include excitement, movement and forcefulness.

Xun trigram

The *xun* trigram is formed by placing two unbroken (*yang*) lines above one broken (*yin*) one. Signifying such concepts as the ability to yield and be accommodating, adaptability and penetration, *xun* is also associated with the wind and wood; the southwest; and the cock (or rooster).

Kan trigram

An unbroken (*yang*) line between two broken (*yin*) ones identifies the *kan* trigram. *Kan* is linked with moving water – be it in the form of rain and clouds or streams and rivers – and the moon, and with the west and the pig (or boar). It denotes danger and difficulties.

Gen trigram

In the *gen* trigram, an unbroken (*yang*) line is positioned above two broken (*yin*) ones. This symbolic configuration signifies hills or mountains, along with the northwestern direction and the dog. It may suggest a pause in activity or the taking of a rest.

Kun trigram

Three broken (*yin*) horizontal lines make up the *kun* trigram. As well as symbolising the earth, the cardinal direction of the north and the ox, *kun* may represent a number of concepts identified with *yin*, among them submission and spaciousness.

The Five Chinese Elements

See also
Chinese medicine,
page 41
**The Four Elements
& Humours,**
pages 224–5

The Chinese calligraphic characters seen here, which may be reproduced on decorative scrolls, spell out the names of the five elements – water, fire, wood, metal and earth – that, according to Chinese tradition, make up all cosmic matter, and whose dynamic interaction regulates the workings of the natural world. The five elements may be symbolised collectively in representational art by five tigers, or by different creatures. They may also be signified by an appropriate natural feature or manufactured object: a river (denoting water), for instance; flames or lanterns (fire); trees (wood); metal tools or gold (metal); and the ground or earthenware (earth).

Earth
Rather than any cardinal direction, the element of earth is equated with the centre, and also with the human stomach. It is said to produce metal (metal ore being mined from it), but has a negative relationship with water, which it can prevent from flowing freely.

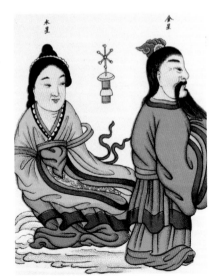

Spirits of the five planets
The spirits of Mercury and Venus are depicted in a detail from a 19th-century representation of the spirits of the five planets. Reflecting the theory that each element is associated with a planet, the Chinese characters for water and metal are visible above Mercury and Venus's heads.

Water

Water (which is regarded as a *yin* or passive, negative element) is symbolically linked with the north and with winter, and, in relation to the human body, with the kidneys. It is considered to generate wood (trees), but to put out fire.

Fire

Fire's cardinal direction is the south, and its associated season is summer; its seat within the human body is the heart. While it is said to create earth with its ashes once it has burned itself out, it has a destructive relationship with metal, which it can melt.

Wood

Wood is the element that is linked with the east, with the season of spring, and, of the human organs, with the liver. Although it feeds the element of fire, wood has a negative effect on earth, which it depletes by drawing nourishment from it.

Metal

Associated with the west, and with autumn, within the human body the element of wood is said to correspond to the lungs. Despite being regarded as giving rise to water (which it contains), metal may destroy wood, for metal implements are used to cut down trees.

Auspicious Chinese calligraphy & symbols

See also
Harmony and longevity,
page 148
Chinese character,
page 39

Chinese (and Japanese) calligraphy is as much an art form as it is a tool for recording and communicating using the written word, not least because the categories into which its characters fall include pictograms and ideograms. Some characters and character combinations are valued so highly for the positive concepts that they convey (you'll see some on the opposite page) that they are singled out for special treatment. Their highly ornamental qualities, combined with their meaning, may consequently cause them to be reproduced on ceramics, textiles, doorways and on decorative scrolls, for example, for the enjoyment – and benefit – of all who see them.

Long life and happiness

The circular *shou* character that symbolises longevity can be seen on the yellow sleeve of Shou Hsing, the god of longevity, in a 19th-century Chinese colour lithograph. Shou Hsing, holding a peach, is accompanied by Lu Hsing (right) and Fu Hsing (centre), his fellow gods of happiness.

'Five Blessings' symbol

According to Chinese tradition, the 'Five Blessings' are longevity (*shou*), wealth, health, virtue and a natural death. The luck-bringing symbol that represents this concept comprises a *shou* (seal) character encircled by five stylised bats, which themselves denote joy ('bat' being a homonym for 'good fortune') and a long life.

Double-happiness symbol

The Chinese character *xi* means 'happiness', so that when two *xi* characters are written side by side, 'double happiness' is signified. Ornate versions of the double-happiness symbol are traditionally presented to newly-weds, but may wish anyone, whether married or not, a double dose of joy.

Good-luck symbol

The Chinese character *fu* means 'felicity' or 'good fortune', and is therefore a symbol of good luck, and of all that it may entail, like prosperity, happiness and satisfaction. This character is attached to doorways during the New Year period in the hope that it will exert a positive influence.

Good-health symbol

The *kang* character of Chinese calligraphy represents healthiness or vigorousness. The well-being that is signified is not merely physical, however, but holistic in nature, suggesting a healthy and happy mind, body and spirit, as well as contentment with one's lot in life.

Indian fantastic creatures

See also
Eagles *versus* snakes,
page 27
Triton, page 45

Fabulous creatures populate the myths of Hinduism – a religion in which certain deities are visualised in part-human, part-animal form – also featuring in the faiths that subsequently sprang up in the Indian subcontinent. Traditional tales the world over tell of fantastic beings, whose bizarre, symbolic build magically equips them to dominate the skies, seas or subterranean realms, and those of Hinduism are no exception. In art, some of these, such as Garuda, Ananta and the *makara*, may be explicitly associated with particular gods, often acting as their mounts or vehicles (*vahana*). Not all of these creatures are as co-operative or benign, however.

Sheltering serpent
In his portrayal of Ananta, Khandesh – an Indian artist who was at the height of his artistry in around 1780 – has depicted the cosmic *naga* with six heads. Ananta supports the sleeping Vishnu as he floats on the lotus-dotted primeval ocean, watched over by his wife, Lakshmi.

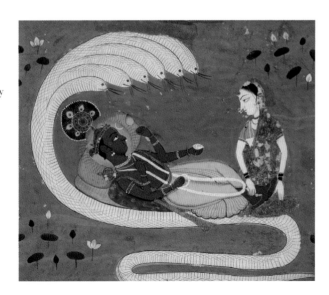

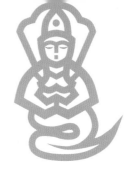

Garuda

Typically portrayed as a man whose enormous pair of eagle's wings gives him mastery of the skies, Garuda's golden plumage equates him with the sun, and with Vishnu, the Hindu god whose *rahana* (mount) this 'sunbird' is. As a solar creature that battles vicious *nagas*, Garuda symbolises light and life.

Nagas

The *nagas* are a race of serpentine beings, often portrayed with jewel-studded human heads, torsos and arms and the bodies of snakes. Described as living in opulent underwater palaces, and as guarding the treasures of the ocean, the *nagas* symbolise the fertility, abundance and riches of the sea.

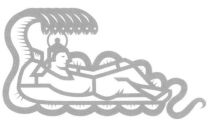

Ananta

Ananta (also called Shesha, or Ananta-Shesha) is the cosmic *naga*, or snake, upon whose coiled body Vishnu is depicted slumbering as he floats on the primeval waters, protected by the canopy formed by Ananta's heads (of which there may be six, seven, nine or even a thousand). Ananta symbolises infinity.

Makara

Depictions of the sea-inhabiting *makara* (the *rahana* of Varuna, 'Lord of the Deep [Ocean]') vary, but usually have fish-like or reptilian physical features in common. The *makara* may therefore be part-fish and part-crocodile, and sometimes has an elephant's head. It takes the place of Capricorn in the Hindu zodiac.

Chinese & Japanese fantastic creatures

See also
Dragon, page 145
Unicorn, page 229

While many Western fantastic creatures threaten humankind – notably the dragon – their Eastern counterparts are generally more benign, the dragon included. Dragons and phoenixes commonly appear in Chinese art; when depicted together, they represent the emperor and empress. They also feature among China's Four Supernatural Creatures (portrayed on ancient bronze mirrors), with the azure dragon protecting the cosmic eastern quarter (and denoting spring), and the vermilion bird (phoenix) being associated with the south and summer. (The white tiger, or unicorn, is linked with the west and autumn, and the 'black warrior', a snake-entwined tortoise, with the north and winter.)

Duelling dragons

A green and a red dragon confront each other on an 18th-century Chinese porcelain plate. The circle at the design's centre represents a flaming pearl, which dragons are often shown chasing in Chinese art. This may symbolise the sun, moon, rolling thunder or potentiality.

Dragon

In Chinese belief, there are three main dragon species: the *lung*, which live in the sky; the ocean-inhabiting *li*; and the *jiao*, which lurk in caves. All have long, thin bodies and represent the fertility-giving powers of water, consequently symbolising good fortune, as well as protection.

Phoenix

Descriptions of the gentle phoenix (*feng huang* in China, and *ho-oo* in Japan) vary, but most agree that this exotic-looking, avian-type creature has a cock-like head. This, along with its guardianship of the south and summer, imbues it with solar (*yang*) symbolic significance and thus with fertility-promoting powers.

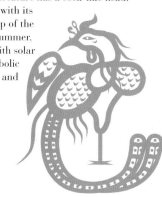

Unicorn

Celebrated for its gentleness, the Asian unicorn (*qilin* or *kylin* in China; *kirin* in Japan) was considered to be androgynous, and therefore to symbolise the harmonious union of *yin* and *yang* and thus longevity. It was envisaged with a stag's body and a dragon's head crowned by a horn.

Lion-dog

The sculpted figures of lion-dogs (*fo* in Chinese) positioned in male–female pairs outside Asian Buddhist temples symbolise protection against evil. The male rests a front paw on a globe (symbolising the sun or Buddhist light-giving jewel), while the female shelters a cub under one of hers.

The Four Arts of the Chinese scholar

See also
The Seven Liberal Arts, page 234–35

In ancient times, it wasn't enough for Chinese scholars to have passed their exams to be considered educated and cultured individuals. For a scholar was also expected to be proficient in the Four Arts (*Siyi*), in skills that would help to maintain a well-balanced personality and would also act as aids to relaxation. These Four Arts – music, literature, painting and 'sport' – are symbolised by the pieces of equipment traditionally used to practise them. They may be collectively depicted on ceramics, and, in paintings, in the hands of those (such as the 'Ten Learned Women') engaged in the *Siyi*.

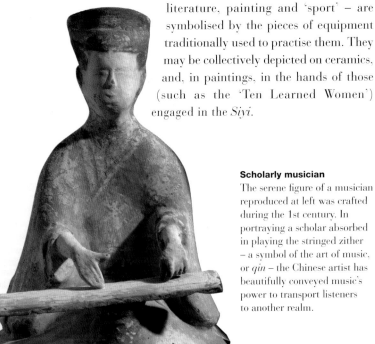

Scholarly musician

The serene figure of a musician reproduced at left was crafted during the 1st century. In portraying a scholar absorbed in playing the stringed zither – a symbol of the art of music, or *qin* – the Chinese artist has beautifully conveyed music's power to transport listeners to another realm.

Qin, the art of music

A Chinese zither (an ancient Chinese stringed instrument that may sometimes be referred to as a lute) symbolises the art of music (*qin*). Proficiency in musicianship requires dexterity and practice, making it a demanding skill to acquire, but was also considered to lift the musician to a higher spiritual plane.

Shu, the art of literature

Sets of books encased in protective decorative covers, tied with ribbons, and sometimes with brush pens depicted alongside, symbolise the art of literature, or calligraphy (*shu*). (Note that the curving fillets or ribbons, which, in art, often adorn such Chinese symbols, denote their special or sacred qualities.)

Hua, the art of painting

Hua, or the Chinese art of brush painting, is typically symbolised by a pair of rolled-up scrolls, the canvases on which the scholar-artist could create exquisitely considered, composed and executed paintings. Such scrolls were typically made of rice paper or silk.

Qi, the art of 'sport'

The art of 'sport' (*qi*) is represented by the board on which an ancient Chinese board game is played, along with two pots containing the black and white pieces. Although often described as a chessboard, this is the board for the game of *weiqi* ('surrounding chequers').

EUROPE Introduction

See also
Hindu & Buddhist mandalas & *yantras*, pages 140–1
The symbolism of warriorship & initiation, pages 32–3

Europe's ancient, highly developed artistic heritage embraces myriad areas of everyday life, spiritual belief and esoteric thought. The cultural legacy of ancient Greece and Rome, revisited during the Renaissance, has arguably been seminal in shaping European art, providing symbolic blueprints with which to represent sacred concepts and a visual vocabulary that has contributed profoundly to the development of the heraldic, symbolic and allegorical systems and themes that still inform our understanding of the world. Christian subjects and symbols have similarly dominated European art, and yet the enduring influence of deep-rooted pagan instincts has created some uniquely life-affirming, symbol-rich styles.

Stained-glass rose
This spectacular rose window was installed during the 19th century in the north transept of the Basilique Saint-Denis, France, by architect Eugène Emmanuel Viollet-le-Duc. It is based on a Rayonnant Gothic design by the abbey church's 12th-century abbot, Abbot Suger.

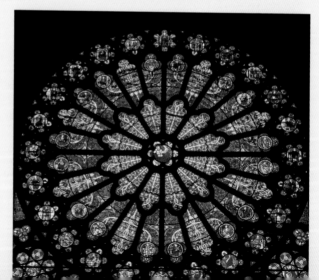

Eagle and thunderbolts

An eagle gripping thunderbolts in its talons symbolises Zeus/Jupiter, the Graeco-Roman sky god and supreme divinity. Together, this fearsome bird of prey and its divine master's lethal natural weapons represent such a powerful image that it became the emblem of ancient Rome, and later of the French Empire.

Rose window

The rose windows whose stained glass illuminates Christian churches are so called because their shape resembles that of a many-petalled, open rose. Their symbolism combines that of the circle (perfection and paradise), wheel (eternity), red rose (love and martyrdom) and the Virgin Mary (the unsullied 'rose without thorns').

Arms of the duchy of Cornwall

Heraldry and its now elaborate system of symbols originally developed in medieval Europe as a way of identifying noble individuals in battle. At the centre of the duchy of Cornwall's armorial bearings is a shield with a black (sable) field emblazoned with fifteen bezants (golden roundels).

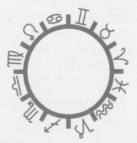

Signs of the zodiac

The 12 signs of the Western zodiac that represent the solar year are each symbolised by a glyph. The zodiacal symbolic system is thousands of years old and extremely complex, incorporating planetary, elemental and other influences, and also having macrocosmic-microcosmic significance.

The Graeco-Roman Olympian deities

See also
Adad, page 99
Shiva, page 105

Written works, such as the Greek poet Hesiod's *Theogony*, have helped us to understand how the gods of the Graeco-Roman pantheon were believed to have come into being, but it is the depictions of them that have survived the millennia – notably in the form of statues, paintings, mosaics and decorated vases – that have brought them to life. The most important were the 12 *Olympioi*, who lived on Mount Olympus; these deities are described on the following pages, as are the attributes that aid their recognition in art.

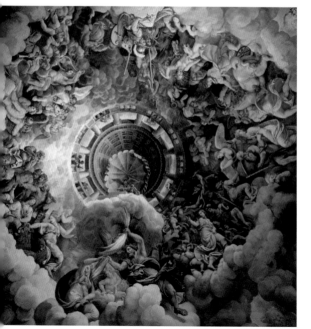

Olympian gods

A fresco by Giulio Romano (1499–1546) for the Room of the Giants in the Palazzo del Tè, Mantua, Italy, presents a Mannerist's vision of Olympus. Certain Olympians can be identified by their attributes, including Zeus/Jupiter, clutching his thunderbolts, and Poseidon/Neptune, wielding his trident.

Zeus/Jupiter

Zeus/Jupiter, first and foremost among the Olympians, may be portrayed as an imposing, crowned, mature man, although as a shape-shifting seducer he assumes a variety of forms. His primary attributes are the eagle and thunderbolts (or lightning flashes, often shown as a sceptre), symbolising his mastery of the sky.

Hera/Juno

As Zeus/Jupiter's wife, Hera/Juno was the queen of heaven and is consequently frequently depicted wearing a crown. She was also known for her vanity, making the majestic, strutting peacock – whose tail feathers were said to bear Argus Panoptes' eyes – a fitting attribute. Peacocks are often portrayed pulling her chariot.

Demeter/Ceres

The Graeco-Roman deity most closely linked with agriculture was Demeter/Ceres, a mature, mother-earth figure, who is consequently usually identifiable by the ears of corn with which she may be crowned, or the wheat sheaf or harvester's sickle that she may carry.

Poseidon/Neptune

Poseidon/Neptune ruled over the watery realms, especially the sea, and he is represented as a powerful older man with a long beard, usually accompanied by mermen and hippocampi (seahorses, which draw his chariot). He is symbolised by the sceptre that he holds: a three-pronged fisherman's spear, or trident.

The Graeco-Roman Olympian deities

See also
Eros/Amor or Cupid,
page 171
**Marriage
and maturity,**
page 233

One of the most popular themes from Graeco-Roman mythology to be depicted in art – particularly during the Renaissance era – was the passionate affair between Ares/Mars, the virile god of war, and Aphrodite/Venus, the seductive goddess of love and fertility (who was actually married to Hephaestus/Vulcan). Symbolising as they did such opposing, yet mutually attractive principles as masculinity and femininity and aggression and pacifism, the physical relationship between the god and goddess lent itself beautifully to allegorical paintings, also offering artists the chance to portray a pair of near-nude bodies as the epitome of physical perfection.

Love and war
The Graeco-Roman deities of war and love are easily identified in French artist Pierre Mignard's painting *Mars and Venus* (1658). In this work, Ares/Mars is characteristically armour-clad as he embraces Aphrodite/Venus, who is accompanied by a pair of doves and the cherubic Eros/Amor/Cupid.

Hermes/Mercury

Hermes/Mercury acted as an airborne divine messenger, and his speedy pace is signalled by his winged hat (the petasus) and sandals. The young god's most recognisable attribute is the caduceus, his winged messenger's staff, around which are wound two snakes to symbolise healing and peace.

Hephaestus/Vulcan

The small, lame Hephaestus/Vulcan is not often represented in art, but when he is, he may be portrayed with a crutch. Otherwise, the god of fire and metalworking is typically shown at a fiery forge with his attributes: tools of the smith's trade, such as an anvil, hammer and pincers.

Aphrodite/Venus

Aphrodite/Venus's loveliness, sensuality and sexuality are emphasised in art by her nudity and languorous pose. This self-regarding goddess of beauty may be symbolised by a hand mirror, while her connection with love and fertility may be represented by Eros/Amor/Cupid, red roses and white doves and other flowers and birds.

Ares/Mars

As a god of war, Ares/Mars is usually portrayed with a weapon, helmet and armour, which may be discarded when with Venus/Aphrodite. The wolf is also his attribute (for a she-wolf suckled Romulus and Remus, his sons), as is the woodpecker, on account of its supposed aggression and destructiveness.

The Graeco-Roman Olympian deities

See also
Krishna, page 105
Moon, page 215

The rediscovery of Classical literature and the development of the humanist outlook that helped to spell the end of the medieval mindset in Europe were exhilaratingly mirrored in the art of Italy, in particular, between the early 15th and 16th centuries. Although inspired by the thrilling adventures and questionable morals of the Graeco-Roman gods, Renaissance artists tended to portray their subjects with faces and bodies that conformed to contemporary ideals, often placing them in contemporary settings, too. The inclusion of the old pagan deities' traditional attributes was consequently a vital aid in identifying them.

Olympian twins

Apollon/Apollo and Artemis/Diana are pictured in the upper reaches of a dramatic painting by the French artist Nicolas de Platte-Montagne (1631–1706). *The Children of Niobe* portrays the divine twins punishing the boastful Niobe on behalf of their mother, Leto.

Apollon/Apollo

The twin brother of Artemis/Diana.
Apollon/Apollo was the Graeco-Roman
sun god, whose dazzling radiance may be
implied in art by his golden hair or aura.
while arrows may symbolise his sunrays.
A lyre represents his love of music, and a
laurel wreath alludes to his loss of Daphne.

Artemis/Diana

Artemis/Diana, the moon goddess, is
symbolised by the silvery lunar crescent
that adorns her hair. Because she was an
athletic huntress, this virgin deity may
additionally wear a short robe and carry
a bow and quiver full of arrows; she may
be accompanied by hunting dogs, too.

Athena/Minerva

Athena/Minerva was the tutelary goddess
of reason, crafts and warfare. As the patron
of heroes, she wears a helmet and a cloak
(the *aegis*) or breastplate bearing Medusa's
head. Having given Athens the olive, this
plant may represent her, but her primary
attribute is the owl, symbolising wisdom.

Hestia/Vesta

Hestia, who is not always counted among
the Olympians, tended the flame that
burned in the hearth on Mount Olympus,
while that of Vesta, her Roman counterpart,
was kept constantly alight in her temple in
Rome. Her flame symbolises the continuity
of life and harmonious relationships.

SACRED

Minor Graeco-Roman gods & characters

See also
Durga, page 107
Basilisk, page 201

Many minor Graeco-Roman deities and mythical characters are portrayed in art, often because they are attractive or symbolic figures. The Greek Eros, for instance, who was equated with the Roman Amor or Cupid, is seen as a cheeky cherub alongside his mother, Aphrodite/Venus, or as the lover of the beautiful Psyche. Other deities provide colourful subjects, such as Dionysus/Bacchus, the god of wine, who, like Cybele, was the focus of a powerful mystery cult. Cybele had a terrible aspect, but the visual epitome of horror was the Gorgon Medusa, whose snake-haired, decapitated head is depicted as the gorgoneion.

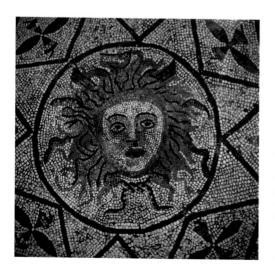

Gorgoneion
The skilfully arranged tesserae (small tiles) visible in the detail reproduced at left of a Roman mosaic from the ancient North African city of Volubilis (in modern-day Morocco) portray the severed head of the Gorgon Medusa. This gorgoneion was thought to have the power to frighten away malign forces.

Eros/Amor or Cupid

The winged Eros/Amor or Cupid, the young god of love and desire whose portrayal inspired Renaissance *putti* or *amoretti* (*see page 248*), is usually depicted carrying a bow and arrows that inflame amorous feelings. He may also be shown blindfolded (for love is blind) or with a fiery torch (denoting burning passion).

Medusa

Greek myth relates that Medusa was one of three Gorgon sisters with serpents for hair and petrifying glares. Having been tricked into gazing at her own reflection by Perseus, she was beheaded, her head then being set on Athena/Minerva's *aegis*, or shield. This symbol, the gorgoneion, was believed to avert evil.

Dionysus/Bacchus

Grapes and vine leaves identify Dionysus/Bacchus, the Graeco-Roman god of wine and fertility, who sometimes numbers among the Olympians. His primary attribute, the thyrsus, is also a phallic symbol, being a vine- and ivy-encircled staff with a pine cone at its apex.

Cybele

Originally a Phrygian goddess, Cybele was venerated as the *Magna Mater* ('Great Mother Goddess') in ancient Rome. As such, she may be depicted enthroned, wearing a turreted crown and flanked by the lions that symbolise her ferocity and that may also pull her chariot.

Graeco-Roman heroes & heroines

See also
Hero, page 17
Spider, page 13

Graeco-Roman myths are bursting with tales of larger-than-life heroes, like Herakles/Hercules and his 12 labours, whose portrayal in art through the ages is testament to the enduring and inspirational appeal of such archetypal figures and the apparently insuperable challenges that they managed to overcome regardless.

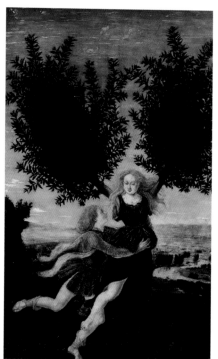

Other heroes depicted at moments of supreme danger or triumph include Theseus, Perseus and Jason and the Argonauts. And although heroines are more incidental figures in these ancient accounts, the stories of Arachne and Daphne, for instance, address and symbolise equally eternal human themes, and have inspired some unforgettable images.

Apollo and Daphne

Apollo and Daphne, a painting by the Italian artist Antonio del Pollaiuolo (*c*.1432–98), depicts Apollo – the god is dressed as a Renaissance prince here – at the moment that he catches up with Daphne. Daphne's transformation into a laurel tree is already well advanced, however.

Herakles/Hercules

Herakles/Hercules is first portrayed as a baby, be it being breastfed by Hera/Juno or strangling two snakes, but his exploits as a flawed adult hero have greater resonance in art. As such, his primary attributes are his weapon – a club – and the (Nemean) lion skin that he may wear.

Jason

Jason, the leader of the Argonauts, is described as having long blond hair and as being clad in a leopard skin, which is how he is generally portrayed. His most significant attribute, however, is the Golden Fleece, whose retrieval from Colchis was the aim of the Argonauts' heroic quest.

Daphne

The lovely Daphne aroused the passion of Apollon/Apollo, but fled his advances and begged her father, a river, to save her from his clutches, whereupon she was transformed into a laurel tree. The tree now symbolises the nymph, who is commemorated in the laurel wreath worn by the god.

Arachne

In Greek mythology, Arachne was a young woman who was the most gifted weaver in the world, proving herself better even than Athena/Minerva (or Pallas Athena), who transformed Arachne into a spider in punishment for her impudence. The spider, or spider's web, therefore symbolises the creative Arachne.

Celtic deities & sacred symbols

See also
Latin cross,
page 196

A powerful connection with the natural world is evident in Celtic art. The intricately decorated metalwork of the La Tène style, for instance, displays the abstract, flowing, vegetal forms that have become synonymous with Celtic artistry. These are thought to signify fertility, as do triple mother goddesses and horned gods. But just as divine trios could represent birth, life and death, so certain goddesses were worshipped within this warrior culture for their association with death and the Otherworld. The animals that could symbolise them are often represented, as are circles, originally denoting the solar wheel and eternity.

Celtic cross
The Celtic cross – a cross with a circle superimposed on its four arms – was adopted as the symbol of Christianity when it spread to the Celtic fringes of Europe, notably Ireland. Yet it is a far more ancient Celtic sacred symbol, which represents the solar wheel, space and the cardinal directions.

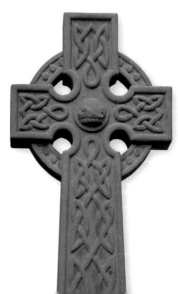

Sacred wheel and cross
A Celtic cross from the British Isles combines Celtic and Christian symbols, and consequently represents a profound fusion of the mystical pagan and Christian mindsets. The stone cross has been carved in relief with the fluid, interlaced patterns that are typical of Celtic art.

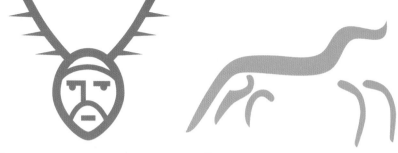

Cernunnos

Cernunnos ('Horned One') is believed to have been a shape-shifting fertility god, for he is depicted – on the Gundestrup Cauldron, for example – as a man with antlers, surrounded by animals. The stag that partly represents him symbolises virility, and because its tree-like antlers are renewed each year, also regeneration.

Epona

The Celts venerated many horse deities, the most important being Epona, represented as a woman with a horse or two. Thought to have been a goddess of equine fertility, Epona's appearance in funerary art suggests that she was also believed to accompany the dead (on horseback) to the Otherworld.

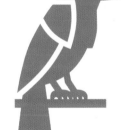

Matronae or *deae matres*

Many stone figures and reliefs labelled *matronae* or *deae matres* ('mothers' or 'mother goddesses' in Latin) have survived from Romano-Celtic times. They portray three seated women bearing such fertility symbols as infants, fruit, bread and corn, and other manifestations of the earth's great bounty.

War goddesses

Their jet-black feathers, taste for carrion and consequent presence on battlefields resulted in crows and ravens being linked with death, while their raucous cries caused them to be regarded as prophesiers. These birds therefore symbolised many shape-shifting Celtic war goddesses, including the Irish Macha, the Badbh and the Morrígán.

Norse sacred symbols

See also
Tree, page 9
Pegasus, page 229

Yggdrasil, the world or cosmic tree, is central to Norse mythology. The worlds enclosed by Yggdrasil included, it is said, Asgard, home of the gods (Aesir); Midgard, that of humans; and the underworld realm of Niflheim. The Aesir, led by Odin, were allied with the Vanir (fertility spirits), but were at war with numerous hostile forces, including the trickster Loki; all, it was said, would perish in the apocalyptic battle of Ragnarök. This dual emphasis on nature and warfare is reflected in the stylised vegetal and animal forms and battle scenes seen, for example, in Norse metalwork and picture stones.

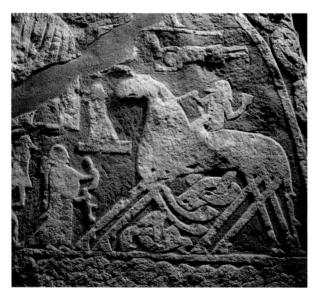

Supernatural steed
His eight legs ensure that the horse shown galloping across a 9th-century picture stone from Tjängvide, on the Swedish island of Gotland, is unmistakably Sleipnir. Because Sleipnir was Odin's horse, it is likely that the figure portrayed riding him is the chief of the Norse Aesir.

Yggdrasil

The worlds of the Norse cosmos were envisaged as being supported by Yggdrasil, an ash tree. Yggdrasil nourished the stags of the four directions, while an eagle lived at its apex, and a dragon at its base. A symbol of protection and eternal life, Yggdrasil would survive the battle of Ragnarök.

Sleipnir

The offspring of Loki and the horse Svadilfari, Sleipnir was the grey, eight-legged steed ridden by Odin. Horses generally represented wealth and fertility to the Norse, and Sleipnir was hailed as the epitome of equine excellence, being able to travel smoothly and speedily between the heavens and the underworld.

Geri and Freki

Along with two ravens, Odin was accompanied by two wolves, named Geri and Freki. Known for their ravenous appetite (Odin was said to feed them food from his plate in Valhalla), these wolves symbolise the ferocious and devouring forces under the warrior Odin's command, and thus victory in battle.

Gullinbursti and Hildisvini

Freyr and Freyja were said to ride golden-bristled boars (Gullinbursti and Hildisvini), animal symbols of the fertility that these Vanir represented. Boars are strong and aggressive creatures, which may be why helmets bearing boar-like images or crests were worn by Norse warriors seeking to enlist the Vanirs' life-giving protection.

The Christian Holy Trinity

See also
Triangle, page 19
Latin cross, page 196

Having inherited Judaism's Old Testament-inspired aversion to figurative representations of the divine, the Christian Holy Trinity (God, the Father, the Son and the Holy Spirit) was originally shown symbolically, often as a triangle. A triangle enclosing an eye, or a hand emerging from a cloud, could denote God, the Father; Greek characters spelling out his name could allude to God, the Son; and a white dove, or flame, could signify the Holy Spirit or Ghost. Later 'Throne of Grace' depictions showed God, the Father, as an enthroned heavenly ruler supporting the crucified Christ, with the dove hovering overhead.

Throne of Grace
The Trinity (1471), a 'Throne of Grace' or 'Mercy Seat' painting by the Master G H, portrays God, the Father, who is seated on an angel-flanked throne and holding the cross bearing the crucified figure of God, the Son. The white dove symbolising God, the Holy Spirit, is visible above Christ's head.

Alpha and Omega

In the New Testament (Revelation 21:6). God, the Father, states, 'I am Alpha and Omega, the beginning and the end', which is why these first and last characters of the Greek alphabet symbolise him. They may be written on the pages of an open book, alluding to the Bible.

Holy Spirit

The Holy Spirit (or Holy Ghost) is most frequently symbolised by a white dove, particularly in paintings representing the Annunciation and Christ's Baptism, when the New Testament Gospel of St Mark, 1:10, describes 'the Spirit like a dove descending upon him'.

Trefoil

Triangular motifs, such as three interlocked fish, symbolise the Holy Trinity in Christian art. These include the trefoil, which represents three conjoined leaves and echoes the shamrock used by St Patrick to explain the divine three-in-one to the Irish. It is often incorporated into church windows.

IHS

The letters 'IHS' or 'IHC' (often depicted elaborately entwined) may be seen in a Christian context, be it in a painting or church or on a heraldic shield. This emblem is derived from the first letters of Jesus Christ's name in Greek, and consequently symbolises God, the Son.

Jesus's Nativity & Crucifixion

See also
Crown, page 21

Scenes from Christ's life were popular subjects in medieval, Renaissance and Counter-Reformation Christian art, and were often commissioned by pious secular patrons, as well as by religious bodies and office-holders, to hang above the altars of chapels, churches, abbeys and cathedrals. None were more popular than portrayals of Jesus's Nativity in Bethlehem and Crucifixion at Golgotha, and while the New Testament gospels provided artists with many details of the circumstances surrounding the birth and death of Christ, artistic licence was frequently used to add depth and drama to these scenes. Some common symbolic details are considered here.

Magi

The Gospel of St Matthew (2:1) tells us only that wise men (*magi* in Latin) travelled in search of Jesus from the east. Artists depict them as three crowned kings of different ages and complexions, bearing gifts of gold (symbolising royalty), frankincense (divinity) and myrrh (death).

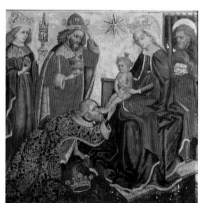

We three kings

Leonardo di Bressanone has portrayed the Magi as three kings paying homage to the infant Jesus in his *The Adoration of the Magi* (1460), a painting on a wooden panel. His star of Bethlehem, which shines above the child's head, has six points.

INRI

In scenes of Jesus's death, a sign may be seen above the cross on which he hangs, bearing the letters 'INRI'. They stand for *Iesu Nazarenus Rex Iudaeorum*, Latin for 'Jesus of Nazareth, King of the Jews'. Luke 23:38 recounts that this was written in Greek and Hebrew, too.

Star of Bethlehem

The 'star in the east' (Matthew 3:2) that led the wise men to Bethlehem is usually shown shining above the stable in which the newborn Jesus lies. It is typically drawn as either a five- or eight-pointed star, respectively denoting the eastern star or Venus (the Morning Star).

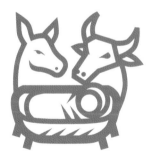

Ox and ass

St Luke's gospel relates that the baby Jesus was laid in a manger, yet there is no mention of the ox and ass depicted gazing at him. Their presence is explained in the Old Testament: 'The ox knoweth his owner, and the ass his master's crib' (Isaiah 1:3).

Instruments of the Passion

The instruments of the Passion, or *arma Christi* ('instruments of Christ') are often seen in Crucifixion paintings. They include the nails driven through Christ's hands and feet, the spear that pierced his side and the ladder used at the Deposition.

The Virgin Mary

See also
Lotus, page 123
Lotus plant,
page 61

Christians do not worship a goddess, but do venerate the Virgin Mary, Christ's mother. Certain episodes from the Virgin's life are portrayed in art, including her presentation at the temple, marriage, dormition (death), assumption into heaven and coronation. She is also, of course, present in Nativity and Crucifixion scenes. Among the most beautiful paintings of the Madonna ('My Lady' in Italian) are those of the Annunciation and the Virgin and Child – often in enclosed-garden (*hortus conclusus* in Latin) settings, alluding to her virginity and fertility – as well as *La Pietà*, in which the 'Lady of Pity' cradles the corpse of her crucified child.

The Annunciation
A white lily, the lovely symbol of innocence, occupies a prominent position between the Archangel Gabriel and the Virgin Mary in this glowing depiction of the Annunciation, painted by Martino di Bartolomeo for a 15th-century altarpiece. The authoritative figure of God presides over the touching scene below.

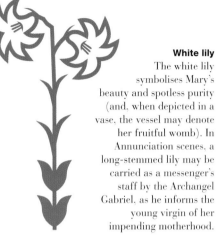

White lily

The white lily symbolises Mary's beauty and spotless purity (and, when depicted in a vase, the vessel may denote her fruitful womb). In Annunciation scenes, a long-stemmed lily may be carried as a messenger's staff by the Archangel Gabriel, as he informs the young virgin of her impending motherhood.

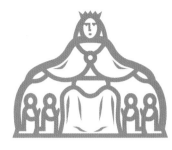

Mary's blue mantle

Mary is typically portrayed wearing a mantle of blue, a colour symbolising heaven, baptismal waters, devotion, compassion and other positive qualities. As the Virgin of Mercy (*Misericordia*), she is depicted sheltering a huddled mass of people as a symbol of protection.

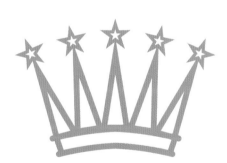

Mary's crown

A crown signals Mary's status as a heavenly queen. A starry crown or halo may allude to her as the woman crowned with 12 stars of the Book of Revelation (12:1), or as the Virgin of the Immaculate Conception. (She is also *Stella Maris*, the 'Star of the Sea'.)

Seven Sorrows of the Virgin Mary

A flaming heart pierced by seven swords symbolises the Seven Sorrows of the Virgin of Sorrows (*Dolorosa*). These represent Simeon's prophecy; the flight into Egypt; losing her son in Jerusalem; meeting Jesus carrying the cross; standing below the cross; receiving Jesus's body; and his burial.

Christianity's Twelve Apostles

See also
Papal arms,
page 211

Last Supper
Certain clues help
to identify the
treacherous Judas
Iscariot in *The Last
Supper*, a fresco by
Maestro Lienhart
Scherhauff. The
moneybag slung
over his back is one,
another is the
absence of a halo.

The apostles were the disciples whom Jesus selected to preach the Christian gospel. They are portrayed in narrative scenes illustrating events from Jesus's life – particularly the Last Supper – and, after his Crucifixion, from their own. Although the total number of apostles remained a constant 12, membership of the band varied, with Judas Iscariot being replaced by Matthias. All have symbolic attributes, those of four being described here; for two more, the evangelists Matthew and John, *see pages 186–7*; the remaining apostles were Bartholomew, James the Less, Simon the Zealot, Thomas, Jude (or Thaddeus) and Philip.

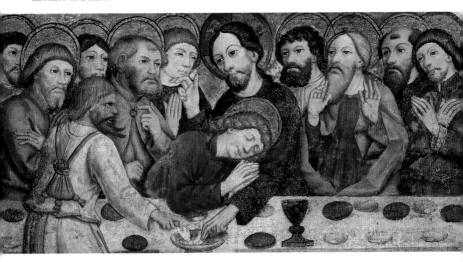

St Peter

As a fisherman, St Peter is symbolised by a fish; a cock signifies his denial of Christ. As the first pope, crossed gold and silver keys (to the heavenly gates) represent him, or a rock. He may also be denoted by the inverted cross of his crucifixion.

St James the Greater

Because the shrine of Santiago de Compostela in Spain claimed to house the relics of St James the Greater (or Great), it became an important pilgrimage destination, and the emblems of a pilgrim in turn became his attributes. These include a scallop shell and a pilgrim's staff and hat.

St Andrew

St Andrew, like his brother Peter, was once a fisherman, and may therefore be represented by a fishing net. More usually, however, St Andrew is symbolised by the X-shaped cross (called a saltire or St Andrew's cross) on which he was crucified.

Judas Iscariot

Judas Iscariot betrayed Christ with a kiss in the Garden of Gethsemene, so he is often portrayed performing this act. He is also visible in Last Supper scenes, clutching his moneybag. Further of his attributes are 30 pieces of silver, a yellow cloak and a rope.

Christianity's Four Evangelists

See also
Christianity's Twelve Apostles, pages 184–5
Lamb and flag, page 197

Matthew, Mark, Luke and John – the saintly writers of the four gospels that open the New Testament – are collectively called the Four Evangelists. Two of them, St Matthew and St John, were apostles, or personal followers, of Christ, and they may therefore be portrayed in art in scenes presenting aspects of their lives prior to Jesus's death and after it. As a quartet, the four are most frequently symbolised by the tetramorphs, or Apocalyptic beasts described in the biblical books of Ezekiel and Revelation, alongside which may be shown scrolls or books, representing their gospels.

Four beasts of the Evangelists
The arms of a cross divide the eagle, winged ox, winged man and winged lion that represent the Four Evangelists in an illustration from a 9th-century Carolingian manuscript from Saint-Amand, France. Each creature holds the gospel associated with it; at the centre stands the Lamb of God (*Agnus Dei*).

St Matthew

As an evangelist, St Matthew's symbol is a winged man, allocated to him, it is speculated, because his gospel emphasises Jesus's humanity. As an apostle, Matthew may be represented by a moneybag (he was a tax collector) or by a spear or sword (instruments of his martyrdom).

St Mark

St Mark's symbol is a winged lion, a possible explanation for this match between gospel and creature being that the former focuses on Christ's divine majesty and the latter is traditionally king of the beasts. (The winged lion is an emblem of Venice, too, where Mark's relics were interred.)

St Luke

The winged ox represents St Luke (a disciple of St Paul) and his gospel. It is thought that the ox was chosen as this evangelist's symbol because it was a sacrificial animal in ancient times, and Luke's account dwells on the sacrificial aspects of Christ's death.

St John

An eagle represents St John the Evangelist, maybe suggesting a symbolic link between his spiritually uplifting gospel and Christ's Ascension. As an apostle, the clean-shaven John is portrayed leaning on Christ at the Last Supper or standing by the cross. A chalice with a snake also symbolises him.

Christian saints

See also
Treasure vase,
page 113
Lamb and flag,
page 197

In Christian belief, saints are individuals whose holiness has earned them a place in heaven. They include contemporaries of Christ, such as St John the Baptist, St Mary Magdalene and the apostles; the evangelists; those who dedicated their lives to the Christian Church (popes, bishops, priests, monks and nuns, for example); as well as martyrs who died for their faith or people who performed exceptional Christian deeds. Saints may be pictured

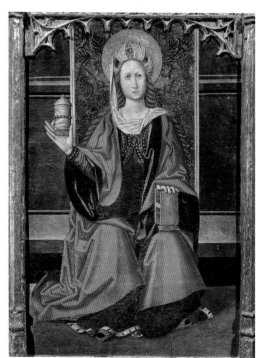

individually, often for devotional purposes, or collectively – be it in heavenly depictions or surrounding the Virgin and Child in *Sacra Conversazione* ('Holy Conversation') scenes.

From sinner to saint
A painting from the Aragonese School created for a retable during the late 15th century portrays St Mary Magdalene holding aloft her ointment pot, the attribute with which she is most commonly depicted. As an erstwhile sinner, Mary is often portrayed with long locks and wearing costly clothes.

St John the Baptist

St John the Baptist was an ascetic desert-dweller, so he is typically portrayed with a shaggy beard and hair and (if not decapitated) wearing a camel skin – when, for example, baptising Jesus. His usual attributes are the reed cross that he may hold and a lamb (representing Christ).

St Mary Magdalene

St Mary Magdalene, the sister of Lazarus and Martha, is known as the reformed sinner who anointed and then dried Christ's feet with her hair. She may be symbolised by her rich (sometimes red) dress, flowing hair and lidded alabaster jar containing perfumed ointment.

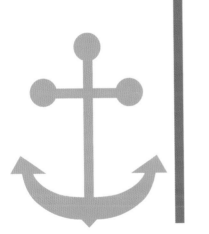

St Nicholas

St Nicholas is the patron saint of children, being said to have resurrected three murdered boys. This 4th-century bishop of Myra, Turkey, also saved sailors, which is why one of his attributes is an anchor, while three golden balls represent the money that he gave three dowry-less girls.

St George

A few attributes identify St George, the Roman soldier martyred for his Christianity. They include the armour that he wore when rescuing a princess from a dragon – also his attribute, and a symbol of Satan – and the cross of St George (red, on a white field, representing victory).

Christian saints

Virginal martyrs
A 16th-century German painted-wood altar portrays two saints wearing martyrs' crowns. A dragon identifies the saint on the left as St Margaret of Antioch, while the tower that her companion supports reveals that she is St Barbara.

Most saints have a devoted following, and many works of art that feature single saints were commissioned by individuals or bodies who felt a special spiritual connection with them. This may be because it was believed that the saint would intercede with God on their behalf (perhaps if the saint was associated with a certain ailment); because their church was dedicated to the saint on its foundation; because the saint established their order of monks or nuns; or because the saint was an appropriate patron saint – of a country, city, society, occupation, profession or condition, for instance.

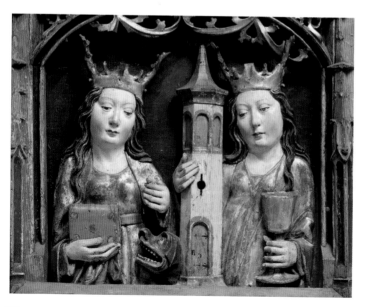

St Eustace and St Hubert

Both St Eustace and St Hubert (of Liège, in Belgium) may be alluded to in art by a stag whose magnificent antlers enclose a cross or crucifix, which therefore represents Christ. An encounter with this stag converted both men to Christianity while they were out hunting.

St Cecilia

In Renaissance art, St Cecilia is typically depicted holding a portative organ, comprising graduated pipes and a keyboard. The patron saint of musicians, this reluctant bride was said to have (silently) sung her loyalty to God to the accompaniment of organs.

St Barbara

St Barbara's attribute is a tower, often with three windows (symbolising the Holy Trinity), which represents the building in which her pagan father imprisoned her. Because he was killed by a lightning strike, St Barbara is the patron saint of miners, gunners and others at risk from explosions.

St Ambrose, St John Chrysostom and St Bernard of Clairvaux

A beehive is the shared attribute of St Ambrose (bishop of Milan), St John Chrysostom (archbishop of Constantinople) and St Bernard of Clairvaux (a Cistercian abbot), all of whom were renowned for their honeyed way with words.

Christian martyrs

See also
Wheel of Fortune,
page 43
Eight-spoked wheel,
page 115

The saints that are classified as martyrs are those who were willing to die rather than renounce their faith. And because many consequently suffered a truly agonising, gruesome death (and because, in many cases, little more is known about them), the instruments of their demise then became their attributes, which is why numerous saintly martyrs may be symbolised by weapons. In 'All Saints' or 'City of God' (*Civitas Dei* in Latin) representations of heaven, martyrs may also be distinguished by their crowns, denoting their victory over death, and the palm branches that they may hold.

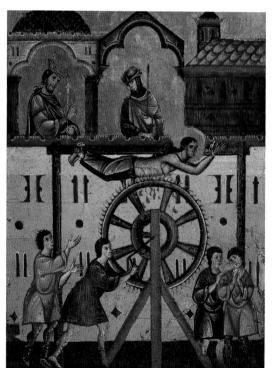

**The original
Catherine wheel**
An illustration created for a *History of Four Saints* (1280), from the School of Guido da Siena, shows a gruesome scene of the martyrdom of St Catherine of Alexandria. She is pictured here impaled upon the knife-studded wheel that has become her identifying symbol.

St Ursula and St Sebastian

The attributes of both St Ursula and St Sebastian include one or more arrows. For while Ursula (along with her virgin companions) is said to have been martyred by the Huns with a single arrow, Sebastian was used as target practice by Roman archers before being clubbed to death.

St Agatha

A virgin saint who had dedicated herself to Christ, Agatha was martyred in Sicily in punishment for her rejection of the Roman consul Quintinian. Her attributes include the pincers with which she was tortured and her breasts, which were severed and may consequently be depicted on a platter.

St Catherine of Alexandria

The virgin St Catherine of Alexandria died on the order of the Roman emperor Maxentius, whom she refused to marry. Her attributes are the (Catherine) wheel, a spiked or knife-embedded wheel that was broken by an angel before it could break her, and the sword that eventually beheaded her.

Palm branch

In ancient Rome, the palm branch originally represented a military victory (perhaps because it had solar symbolism). The symbol that signified triumph to their persecutors was subsequently adopted by early Roman Christians to symbolise victory over death, or resurrection, which is why it is an attribute of Christian martyrs.

Christian angels

See also
Angels, page 27
Justice (*Justitia*),
page 205

Despite having a Jewish, Old Testament origin, angels are frequently represented in Christian art. Nine angelic choirs, or orders, are said to cluster around God's throne, the first hierarchy (counsellors) comprising seraphim, cherubim and thrones; the second (governors), dominions, virtues and powers; and the third order (messengers), princedoms (or principalities), archangels and angels. In art, this heavenly host may be depicted making music, symbolising divine harmony, while archangels and angels may be portrayed on Earth acting as God's messengers and instruments of justice and protection. Only three archangels are usually portrayed: Gabriel (typically in scenes of the Annunciation), Michael and Raphael.

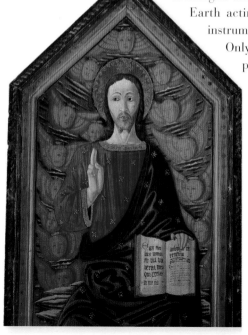

Scarlet seraphim
Although they each have only two wings, their red hue indicates that the disembodied angels that surround the enthroned figure of God, the Son – or Christ – are seraphim. This striking 15th-century image, from a church in Chia, Italy, was painted by the Master of the Chia Triptych.

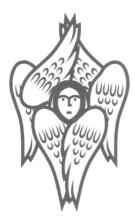

St Michael

St Michael is the warrior archangel who enforces God's will (chasing Adam and Eve from Paradise, for instance) and ensures that justice is done. In art, he may wear armour and carry a sword; alternatively, in Last Judgement scenes, he holds the scales in which the resurrected are weighed.

Seraphim, cherubim and cherubs

Seraphim and cherubim, which symbolise divine wisdom, are portrayed surrounding God as faces enclosed by six wings. While seraphim are red, cherubim are blue, being respectively associated with day and night. Child-like cherubs (*putti* or *amoretti*) are Classical in origin, their inspiration being depictions of Eros/ Amor or Cupid.

Raphael

Raphael, the archangel associated with healing and protection, is commonly portrayed in scenes from the Apocryphal Book of Tobit – for example, as a traveller accompanying the young Tobias. He may carry a moneybag and water vessel, and hold a pilgrim's staff, fish or small box containing a healing unguent.

Angels

Being spiritual creatures of light, goodness and beauty, angels are depicted with lovely and serene faces, and may furthermore radiate a glowing aura or be crowned by a halo. Their feathered wings symbolise their heavenly nature, as well as the messenger's role that they perform on God's behalf.

Christian sacred symbols

See also
Instruments of the Passion, page 181

Some of the most commonly seen Christian symbols are also the most ancient. The elegant outline of a fish, for instance, can be traced back to at least the 1st century AD, when Christians were persecuted, and when they inscribed this secret symbol in the Roman catacombs. And the use of the *chi-rho* to represent Christianity dates from at least 312, being superseded by the cross around a century later. Although the cross remains the ultimate symbol of Christianity, others – including the lamb and flag and the sacred heart – allude equally profoundly to Christ's self-sacrifice for the love of humankind.

Latin cross
The cross evokes the cross on which Christ was crucified and died, and is now the foremost symbol of Christianity. It has numerous variants, but the Latin cross shown above is the one most commonly portrayed in art, and is also the inspiration for the ground plan of Western churches.

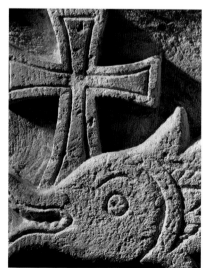

Ancient expressions of faith
A cross and fish – the symbols of Christianity and Christ – have been carved into a stone relief dating from the 4th or 5th century. This was discovered in a Coptic Christian cemetery in the ruins of the ancient city of Hermonthis (also known as Ermant or Armant), in Egypt.

Chi-rho

As one of its names – the *chi-rho* – suggests, the symbol also known as the chrismon, christogram and monogram of Christ comprises two Greek characters, *chi* and *rho*, the first two letters of Christ's name in Greek. As the *labarum*, it adorned the shields of Constantine I's Roman army.

Fish

One reason why a fish symbolises Christ and Christianity is that fish may allude to the Last Supper and the Eucharist. Another is that the Greek word for fish, *ichthys*, is an acrostic of *Iesous Christos, Theou Yios, Soter* ('Jesus Christ, Son of God, Saviour').

Lamb and flag

In art, the lamb symbolises Christ, who sacrificed himself to redeem humankind and was consequently equated with the paschal lamb traditionally sacrificed on the first day of the Jewish Passover. As the Lamb of God (*Agnus Dei*), the lamb often carries the flag of victory or resurrection.

Sacred heart

A heart depicted encircled by a crown of thorns and sometimes pierced by nails (these numbering among the instruments of the Passion), with a flame burning above it, symbolises Christ's burning love for humankind and the terrible self-sacrifice that he made to redeem its sins.

Christian symbols of sanctity

See also
Crown, page 21
Wandjina spirits,
page 239

From the 5th century, the nimbus, or halo, has been the most visible symbol of sanctity or sainthood in Christian art, taking as it typically does the form of a golden or radiant circle, disc or ring, either encircling the head of a holy person or hovering above it. Inspired by sunbeams radiating from clouds, and by the similarly depicted crowns of sun gods like the Graeco-Roman Helios/Sol and Apollon/Apollo, the halo's simplest form is the plain, unadorned circle. Various types of haloes with subtly differing symbolism evolved over the centuries, including triangular, cruciform and square versions.

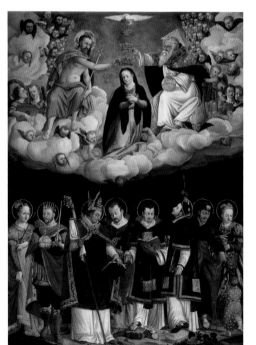

Heavenly haloes
Different haloes can be discerned in 16th-century Italian artist Paulo Naurizio's painting *Coronation of the Virgin and Saints*. The stylised cruciform halo on the left distinguishes Jesus Christ, while the triangular halo opposite it glorifies God, the Father; the saints below are highlighted by round haloes.

Round halo

Christ and the Lamb of God were the first holy beings to be distinguished by a round halo – the circle symbolising heaven – but it eventually became an attribute of angels and saints, too, be it as a solid disc framing the head or a ring tilted above it.

Triangular halo

With its three points, the triangular halo represents the Holy Trinity of God, the Father, God, the Son, and God, the Holy Spirit. Although it is sometimes depicted glorifying the head of the baby Jesus (God, the Son), God, the Father, is otherwise exclusively seen wearing the triangular halo.

Cruciform halo

While the cross symbolises Christianity, it was Jesus Christ who was crucified upon it, which is why a circular halo within which is described a cruciform shape is typically worn by him alone in Christian art. That said, it can occasionally be spotted in portrayals of God, the Father.

Square halo

The square symbolises the Earth, so when an individual wears a square (or rectangular) halo, this signals that the person was still alive – of the Earth – when the artwork was created. Sainthood is implicit in the square halo, which appears most frequently in papal portrayals.

Christian symbols of sanctity & damnation

See also
Weighing-of-the-heart ceremony, page 56
St Michael, page 195

The Christian concepts of sanctity and salvation, on the one hand, and evil and damnation, on the other – as represented by Jesus and the heavenly angels and Satan and the demons of hell – stand in stark opposition to one another. And while golden aureoles and haloes and exquisitely feathered wings may identify the forces of goodness, goatish horns and haunches, serpentine tails and leathery black bats' wings may characterise the monstrous representatives of evil. The contrast is vividly illustrated in scenes of Christ's Temptation and of the 'Four Last Things': a person's death, the Last Judgement, heaven and hell.

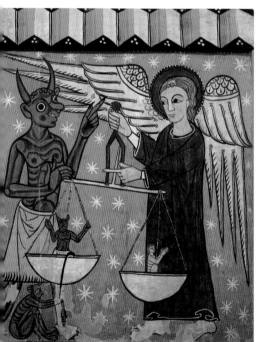

The Last Judgement
A clear distinction between damnation and sanctity is made in the Master of Soriguela's *Last Judgement*, a 13th-century altar panel from Vall de Ribes, Spain. For ranged alongside the infernal figures on the left is a damned soul being weighed by St Michael against a heaven-bound counterpart.

Aureole and mandorla

The aureole – a cloud-like 'body halo' – is also known as the *vesica piscis* ('fish bladder' in Latin), while the stylised, almond-shaped aureole is called a mandorla. These symbols of divine potency usually enclose the bodies of Christ at his Ascension and Transfiguration and of the Virgin Mary at her assumption.

Satan

Satan, or the Devil, embodies evil. Although a master of disguise, his hybrid body – perhaps featuring a goat's horns and legs, the wings of a fallen angel, talons or cloven hooves and a scaly tail – reveals his horrible nature. A dragon, serpent or basilisk may also symbolise him.

Basilisk

The monstrous basilisk symbolised Satan in medieval art, also denoting various sins. Usually portrayed with a cock's head and feet, a bat's wings and a dragon's or serpent's body, the basilisk had a second head at the tip of its tail. Its evil-eyed stare was said to be fatal.

Demons and imps

Demons and imps are infernal creatures that are the busy servants of Satan and are represented in their master's image, albeit significantly smaller than him. They are generally portrayed with black skin, horns, claw-like hands and feet and an arrow-tipped tail.

Christianity's Seven Deadly Sins

See also
Bear paw,
page 87

Avarice (*Avaritia*)
Avarice's primary attribute is money, which is symbolised by coins or a moneybag: a treasure chest (or its key) may additionally signify a blind greed for riches, to which a blindfold may allude. Avarice may also be represented by a vulture or raptor, which feeds off others.

The Seven Deadly (or Cardinal) Sins, which were first listed in the 6th century by Pope Gregory the Great, are transgressions that, it was believed, would condemn those who indulged in them to eternal damnation and endless torments in hell at the hands of Satan's imps. The sins were Lust (*Luxuria* or *Libido* in Latin), Gluttony (*Gula*), Avarice (*Avaritia*), Sloth (*Acedia* or *Pigritia*), Wrath (*Ira*), Envy (*Invidia*) and Pride (*Superbia*), and the seven were often depicted as allegorical figures (frequently female, sometimes horned) in medieval and Renaissance art.

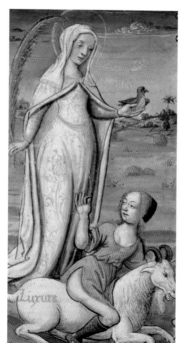

Chastity vanquishes Lust
Chastity is portrayed standing over Lust in this 16th-century illustration. Lust wears an indecently revealing red dress and rides a lusty goat, which Chastity has, however, brought to its knees.

Lust (*Luxuria* or *Libido*)

Lust may be identified by her encircling flames of passion, or by a companion animal. For such creatures as the goat (or, alternatively, a bull or bear, boar or pig, cock or dove or rabbit or hare) were especially noted for their unbridled 'animal passions'.

Wrath (*Ira*)

The figure of Wrath may be portrayed wielding a weapon in anger, and sometimes preparing to fire three arrows at once. Ferocious, aggressive animals may also denote Wrath in art, with the bear, lion and wolf being first and foremost among these.

Gluttony (*Gula*)

The porcine habit of gobbling food caused boars and pigs to become associated with Gluttony. Gluttony – usually depicted with a porky body – may therefore be portrayed riding these creatures, or alongside a supposedly greedy wolf or bear.

Sloth (*Acedia* or *Pigritia*)

Sloth may be represented alongside a slow-moving creature, such as a snail, or with one that is supposedly lazy or reluctant to move (the ass, pig and ox fall into this category). Time-wasting games, like cards or draughts, may symbolise Sloth, too.

Envy (*Invidia*)

Envy may be depicted as a haggard woman with serpentine locks of hair, clutching a venomous snake in one hand, while eating the intestines or heart that she holds in the other. Envy may be accompanied by a snarling, skeletal dog, or by a scorpion.

Pride (*Superbia*)

Medieval representations of Pride often show a rider who has fallen off his horse — pride comes before a fall. Later allegorical figures may be shown holding a mirror or trumpet, alongside a peacock, lion or eagle, all of which have a reputation for being self-regarding.

The Seven Christian Virtues

During the Middle Ages, female personifications of Christian virtues could be portrayed trampling various vices underfoot, or otherwise defeating them, demonstrating the triumph of good over evil. Seven virtues were portrayed particularly often, and sometimes in opposition to the Seven Deadly Sins. Four of these were classified as the cardinal virtues: Prudence (*Prudentia*), Justice (*Justitia*), Fortitude (*Fortitudo*) and Temperance (*Temperantia*), all named by Plato, in *The Republic*, as being qualities that the ideal citizen should have. And the remaining three – Faith (*Fides*), Hope (*Spes*) and Charity (*Caritas*) – were the theological virtues originally specified by St Paul.

Fortitude (*Fortitudo*)
Fortitude is typically portrayed as a helmet-clad female warrior armed with a weapon, such as the club carried by the Graeco-Roman hero Herakles/ Hercules, whose lion skin she may wear, too. She is usually shown alongside a pillar, in allusion to Samson, the biblical strongman.

Prudence in perspective
Their skilled use of perspective assisted Italian artist Antonio del Pollaiuolo (*c.*1432–98) and his brother, Piero del Pollaiuolo (1443–96), in creating the remarkably lifelike allegorical figure of Prudence shown at left. In her right hand, Prudence holds a mirror, and, in her left, a serpent.

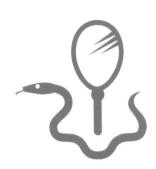

Prudence (*Prudentia*)

Prudence may be shown as a woman with three heads – representing memory, wisdom and foresight – gazing into a mirror and holding a snake, or snakes. Further of her attributes include a book, a pair of compasses, a sieve and a stag.

Justice (*Justitia*)

The female allegorical figure of Justice may be depicted wearing a blindfold, and usually holds a sword in one hand and a pair of scales in the other. Among her other attributes are sometimes seen a lion, a globe, a set square and compasses, and the Roman *fasces*, or bundle of rods.

Temperance (*Temperantia*)

A number of attributes may represent Temperance, including a sword in its sheath, a bridle, a torch and a timepiece. This virtue is most commonly represented, however, as a woman pouring water from one vessel into another, suggesting that she is diluting a jug of wine.

Faith, Hope and Charity (*Fides, Spes et Caritas*)

Faith, Hope and Charity are collectively symbolised by a cross, an anchor and a heart. Along with the cross, a chalice denotes Faith; like the anchor, a ship, crow and flowers represent Hope; while Charity (love) can be signified by a heart, a flame, fruit, infants or a pelican.

British heraldic symbols of birth order & sex

See also
European heraldic shield, page 33
Knight's spurs, page 33

The origins of British (and European) heraldry, the tightly regulated system of armorial bearings, lie in the early medieval period, when it was essential for friends, followers and foe to be able to identify an individual knight on the battlefield. This is why heraldic symbols (called 'charges' in blazon, heraldry's language – *see page 246*) are placed on men's shields (or women's lozenges), and why, when arms became hereditary, various brisures (or marks of cadency, three of which are shown here) were used to difference the arms so that the bearer, and his position within a family, could be identified.

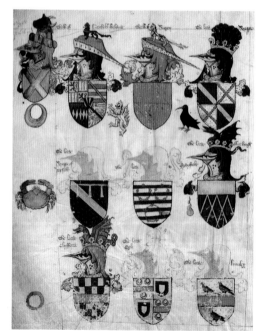

Roll of arms
A label, distinguishing an eldest son, is visible at the top of the shield on the left-hand side of the central row of badges, shields and crests of Yorkshire lords. These were recorded in manuscript form by herald William Ballard, March King of Arms, in around 1483.

Crescent

A heraldic crescent (which takes the form of a lunar crescent whose 'horns' point upwards) is the mark of a second son in a family. This brisure, like its fellows, is typically placed in the middle of a shield, below the top edge.

Mullet

A third son is symbolised by a centrally positioned mullet (a five-pointed star) at the top of his shield. The mullet (or molet) evolved from a knight's spur rowel, or spiked disc, which is also depicted as a star with five points, the difference being that it is pierced in the middle.

Lozenge

According to the conventions of heraldry, only the arms of married noblewomen are displayed on a shield, alongside those of their husband. Unmarried and divorced women bear their father's arms on a diamond-shaped lozenge instead, while it is their marital arms that widows bear on a lozenge.

Label

A label (a horizontal bar from which three vertical 'points' are suspended) is the mark of cadency that signifies an eldest son. A three-pointed label (differenced as appropriate) may now also denote a child, including a daughter, of a British monarch, while a five-pointed label may identify a royal grandchild.

British heraldic achievements of arms

See also
Crown, page 21
Unicorn, page 229

In the language of heraldry (blazon, *see page 246*), a shield's background colour (field) is a specific tincture ('gules', 'azure', 'sable', 'vert' or 'purpure') or metal ('or' or 'argent'). The field may be divided by lines of partition, 'ordinaries' describing any geometric shapes on it, and 'charges' denoting symbols or emblems. In an achievement of arms (*see page 246*), a helmet is positioned above the shield, indicating the bearer's rank, on top of which a crest wreath or coronet holds the mantling in place; a crest surmounts the entire achievement. Two supporters flank the shield, and a motto often appears below.

Royal arms
A detail from an ornate chair used at Queen Victoria's coronation in 1838 displays the royal arms (quarterly England, Scotland, Ireland and England), with lion and unicorn supporters. The shield of arms is surmounted by a crest of a crowned lion standing on a crown.

Tilting helm

An achievement of arms that shows a steel tilting helm, facing the dexter – towards the bearer's right – signifies that the bearer is an esquire or a gentleman (or a corporation). Such helmets, which once provided protection during tilting tournaments, have eye slits, but no visor.

Barriers helm

When the shield in an achievement of arms is topped by a steel helm, or helmet, with a raised visor (called a barriers helm), either facing the dexter (to the right of the bearer) or affronty (looking at the viewer), this symbolises a baronet or knight.

Supporters

A pair of supporters flanking a shield denotes that the bearer is a peer or knight of a chivalric order. Supporters are usually animals, birds, heraldic beasts or people: pictured above are King Henry VIII of England's supporters, a golden lion and red dragon, symbolising England and Wales.

Crest

A heraldic crest is a three-dimensional emblem set atop the helmet. It does not usually feature in women's achievements of arms because females were non-combatants. Female monarchs are an exception, and Queen Elizabeth II's crest (above) is a 'crowned lion 'statant guardant' on a crown.

Continental European heraldic symbols

See also
White lily,
page 183
St Peter, page 185

The heraldic systems that developed within Europe's different countries have much in common, but also notable differences: Italian heraldry's shield shapes, for instance, often resemble a horse's head rather than a combatant's shield. Although they may feature in arms across Europe, certain heraldic emblems have become so synonymous with a particular country, kingdom, family or office that they have come to symbolise it, notable examples being the fleur-de-lys (France), the Maltese cross (Malta) and the papal tiara and crossed keys (the pope). Punning – as demonstrated by the castle and lion, rebuses that denote Castile and León – is pan-European, too.

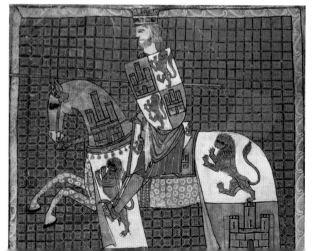

Heraldic lion and castle
King Alfonso X of León and Castile is pictured in the Index of Royal Privileges, a Spanish manuscript dating from the 12th or 13th centuries. His shield and horse's caparison display the lion of León and castle of Castile, which today feature in the royal arms of Spain.

Fleur-de-lys

The fleur-de-lys (French for 'flower of the lily') represents a stylised lily. This heraldic charge, or emblem, was once synonymous with the French royal family (and appeared in the arms of English monarchs who claimed the French throne), but also represents the Italian city of Florence.

Maltese cross

The Maltese cross is a cross whose four arms bear eight points. Originally the badge of the Knights of St John of Jerusalem, it became associated with Malta after the Knights Hospitaller, as they were also called, based themselves on the island in 1529.

Papal arms

The papal arms shown above are those of Paul VI (who was pope between 1963 and 1978). They include the crossed gold and silver keys that symbolise St Peter; the papal tiara, or triple crown; and, at the centre, an Italian horse-head-shaped shield emblazoned with fleur-de-lys and stylised hillocks.

Arms of Spain

The arms of Spain display quarterings symbolising the kingdoms of Castile (the castle), León (the rampant lion) and Navarre (an 'orle', or border, of chains), as well as the pallets (thin vertical bands) of Aragon. Also included are a pomegranate, denoting the kingdom of Granada, and the House of Bourbon's fleur-de-lys.

Heraldic badges &
Renaissance *imprese*

See also
Rose window,
page 163
Aphrodite/Venus,
page 167

Heraldic badges are freestanding symbols that represent and identify an individual, household or family, corporate body or office. During the medieval period, they were often worn by retainers or allies as a visual proclamation of allegiance to a person, family or dynasty. Although they are not classified as heraldic badges, the *imprese* (Italian for 'devices') that can often be spotted in Renaissance art are also personal or dynastic emblems. An *impresa* comprises a pictorial *corpo* ('body' in Latin) accompanied by a motto, or *anima* ('spirit'), both of which were carefully chosen to express a particular quality or characteristic.

Elizabeth Tudor
As a granddaughter of Henry VII, one of Elizabeth I's badges was the Tudor rose. The inner casing of the Armada Jewel (*c.*1585–90), which was painted by Nicholas Hilliard before being enamelled, contains a portrait of the queen; the outer casing displays a Tudor rose.

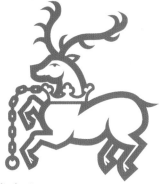

White hart

The white hart (or male deer) was the badge of King Richard II of England (1367–1400). Described as being 'gorged with a gold coronet', the hart's noble association is symbolised by the golden coronet encircling its neck.

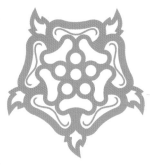

Tudor rose

The Tudor rose is the badge of the House of Tudor, which ruled England and Wales from 1485 to 1603. A fusion of Lancaster's red rose and York's white rose, it symbolises the resolution of the Wars of the Roses, which ended with Henry VII's coronation.

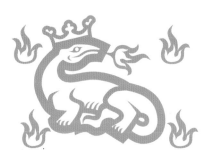

Crowned salamander

The crowned salamander encircled by flames was an *impresa* of the French king François I (1494–1547). The accompanying motto was 'I nourish [the good] and extinguish [the bad]', referring to the flames that cold-blooded salamanders could reputedly extinguish with their bodies.

Medici *impresa*

The Medici family dominated Florence from 1434 until the 18th century. Patrons of the arts, many of the paintings that they commissioned incorporate such Medici *imprese* as three interlinked, diamond-set rings, sometimes alongside the Latin word *Semper* ('Always').

The Western zodiacal planets

See also
Hermes/Mercury,
page 167
Virgo, the Virgin,
page 221

In astrological belief, the planets play a vital role in governing the zodiacal signs. When looking at their depictions in art, whether personified as Roman deities or symbolised by glyphs, remember that the planets of astrology and astronomy differ, for although Mercury, Venus, Mars, Jupiter, Saturn, Uranus, Neptune and Pluto are common to both, astrology includes the sun and moon, but excludes the Earth. Uranus, Neptune and Pluto were not discovered until 1781, 1846 and 1930 respectively, which is why these planets are absent from older artistic representations.

Mercury's chariot
A 16th-century fresco in the Old Library's cupola at the University of Salamanca, in Spain, portrays Mercury, holding his caduceus (represented by his glyph), driving his chariot across the sky. Mercury is the ruling planet of Gemini and Virgo, which are represented within the chariot's wheels (Virgo also appears above Mercury).

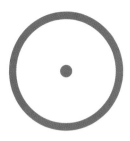

Sun

Personified as the Graeco-Roman Helios/Sol or Apollon/Apollo, as an astrological 'planet', the sun governs the zodiacal sign of Leo, infusing it with its fiery brightness and warmth and producing creative, energetic, egotistic and self-confident characters. The glyph symbolising the sun is a dot within a circle.

Moon

The many-phased moon is associated with such virgin, mother and crone goddesses as the Graeco-Roman Artemis/Diana, Selene, Luna and Hecate, and also with the triple goddess. This 'planet', whose glyph is a crescent moon, rules the zodiacal sign of Cancer, to which it imparts sensitivity and receptiveness.

Mercury

Mercury, the planet that orbits the sun the fastest, was equated with the Roman messenger god (the Greek Hermes), and its glyph represents his winged hat, head and caduceus. Mercury rules Gemini and Virgo, to which it imparts intelligence, versatility and communicativeness.

Venus

The sparkling beauty of the brightest planet caused it to be equated with Venus, the Roman goddess of love, and its glyph represents her hand mirror or necklace. Venus rules Taurus and Libra, giving each feminine qualities such as sociability and self-indulgence.

Mars

Mars's glyph – also the biological symbol for masculinity – depicts a shield and spear, befitting the blood-red planet whose namesake is the Roman god of war. Mars rules the zodiacal sign of Aries (and traditionally Scorpio, too), to which it transfers such macho characteristics as assertiveness, competitiveness and determination.

The Western zodiacal planets

See also
Poseidon/Neptune,
page 165

Saturn
The planetary ruler of the zodiacal sign of Capricorn (and traditionally also of Aquarius) is Saturn, the Roman god of agriculture whose Greek counterpart was Cronos, and whose sickle is sketched in the planet's glyph. Saturnine characteristics include tenacity, conservatism, prudence and diligence.

There was a time when astrology and astronomy were indistinguishable, when all stargazers believed that the planets orbited the Earth, and when they included the sun and moon among these seven planets. Diagrammatic maps of the heavens based on the Ptolemaic system reflect this geocentric arrangement, in which glyphs symbolising the sun, moon, Mercury, Venus, Mars, Jupiter and Saturn are shown orbiting the Earth. These 'planets' may also be portrayed as the gods and goddesses for which they were named, sometimes driving their chariots across the sky, and sometimes alongside their particular zodiacal sign, or sun signs (or signs).

A Ptolemaic planisphere
The 'seven orbs' are shown encircling the Earth, seen at the centre of this engraved Ptolemaic planisphere from Andreas Cellarius's *Harmonica Macrocosmica* (1660). While the sun blazes around it, the moon, Mercury, Venus, Mars, Jupiter and Saturn are represented both driving chariots and in the form of glyphs.

Jupiter

Named for the leader of the Roman gods, the planet Jupiter imparts expansionist, exuberant and liberal tendencies to Sagittarius, the zodiacal sign ruled by the 'Great Benefic' (along, traditionally, with Pisces). Jupiter's glyph may represent a Greek Z (for Zeus, Jupiter's Greek equivalent) or else the god's eagle.

Uranus

The planet Uranus became the ruler of Aquarius following its discovery in 1781 by William Hershel, who is commemorated in the H – his surname's initial letter – of its glyph. It is Uranus that is said to be responsible for the eccentric, experimental and innovative behaviour associated with Aquarians.

Pluto

Pluto's existence was unproven until 1930, but its discovery was anticipated by Percival Lowell, whose initials are represented by its glyph (which also spells out the first two letters of the name of the Roman underworld god). Recently downgraded to a 'dwarf planet', the transformational, enigmatic Pluto rules the sign of Scorpio.

Neptune

Neptune, today the planetary ruler of Pisces, remained undiscovered until 1846. Its glyph represents the trident of the Roman sea god (whose Greek counterpart was Poseidon), while the qualities with which it imbues the zodiacal sign of the Fishes, including unconscious urges, intuitiveness and dreaminess, are associated with water.

The Western zodiacal signs

See also
Chinese zodiac,
page 41
Western zodiac,
page 41

Although the origins of the Western zodiac lie in Mesopotamia, the ancient Greeks developed the astrological system with which we are familiar today. Mirroring the solar year, the zodiacal yearly cycle begins at the time of the vernal equinox – Aries, the Ram, being the first of the 12 constellations, or signs, of the zodiac, followed at approximately monthly intervals by Taurus, Gemini, Cancer, Leo, Virgo, Libra, Scorpio, Sagittarius, Capricorn, Aquarius and Pisces. In art, each sign may be symbolised by its representational depiction – a ram denoting Aries, for instance – or by its glyph.

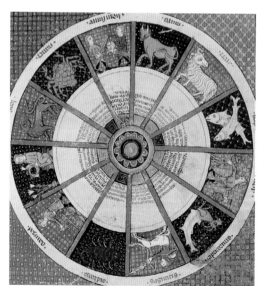

The zodiacal circle
As is traditional, the 12 signs of the Western zodiac are arranged in a circle or wheel, representing the eternal cycle of time, in the 13th-century illustration reproduced at left. The original appears in a Provençal codex: *Le Bréviaire d'Amour* (*The Breviary of Love*), by Ermengol de Béziers.

Aries, the Ram

Aries kicks off the zodiacal cycle on around 21 March. The Ram's ruling planet is Mars, its element is fire, and it has a cardinal quadruplicity and masculine polarity, a combination whose influence is forceful, energetic and positive. Aries's glyph represents a stylised pair of ram's horns.

Taurus, the Bull

The glyph that symbolises Taurus – which takes over from Aries on about 21 April – represents a bull's head and horns. The Bull's planetary ruler is Venus; its element, earth; its quadruplicity, fixed; and its polarity, feminine. Their overall effect produces placid, practical, steady people.

Gemini, the Twins

The zodiacal sign of Gemini, the Twins, is in the ascendant from 21 May, and its glyph symbolises two connected individuals. Mercury is Gemini's ruling planet, and air, its element, while its quadruplicity is mutable and its polarity, masculine. Together, they exert a curious, restless, versatile and active influence.

Cancer, the Crab

It is not certain what Cancer's glyph denotes, but ideas include a crab's claws, lunar phases or two breasts. For with a lunar ruling 'planet', watery element and feminine polarity, the zodiacal Crab (whose quadruplicity is cardinal) signifies motherhood and nurturing. Cancer's period begins on about 22 June.

The Western zodiacal signs

See also
Leo's physical correspondences,
page 41
St Michael,
page 195

According to astrological belief, the relationship between the zodiacal signs and life on Earth is macrocosmic-microcosmic in nature: 'As above, so below'. A number of influences are contained within each sign – those of its ruling planet (*see pages 214–17*), element (*see pages 224–5*), quality, mode or quadruplicity (cardinal, fixed or mutable) and polarity (masculine or feminine) – with it, in turn, bringing its complex influence to bear on the Earth below. More specifically, each sign is believed to affect the fundamental personalities of those born 'under it', as well as a part of the body.

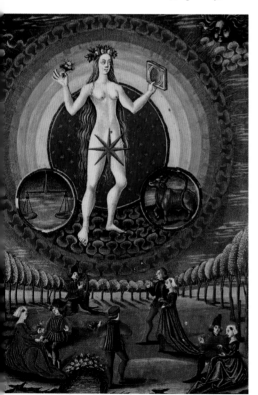

The ruling planet Venus
Pictured in the 15th-century manuscript *De Sphaera* (*Of the Spheres*). Venus is flanked by Libra and Taurus, the zodiacal signs governed by this planet. Venus imparts a love of beauty – and of love – to 'her' signs, as suggested by her flowers, and by the courting couples below.

Leo, the Lion

Leo, the zodiacal Lion, enters the spotlight on around 23 July. Its ruling planet (the sun), element (fire), quadruplicity (fixed) and polarity (masculine) create a commanding personality with a sunny nature (and fiery side), stamina and energy. Leo's glyph may symbolise a lion's mane or tail, or a heart.

Virgo, the Virgin

Virgo's glyph may represent the female reproductive organs or an M for 'Mary'. The sign of the Virgin – in the ascendant from 23 August – is ruled by Mercury, with its earthy element, mutable quadruplicity and feminine polarity all producing an intelligent, practical character.

Libra, the Balance or Scales

Libra, which comes into its own from 23 September, is the sign of the Balance, or Scales, which its glyph symbolises. Venus is Libra's planetary ruler, its element is air, its quadruplicity is cardinal and its polarity is masculine, producing a dispassionate, assertive and extrovert disposition.

Scorpio, the Scorpion

The sting in the Scorpion's tail is visible in its glyph, helping to distinguish it from Virgo's. Scorpio takes over on around 23 October, with the influences generated by its ruling planet, Pluto (or Mars), watery element, fixed quadruplicity and feminine polarity including caution and compassion.

The Western zodiacal signs

See also
Two golden fish,
page 113
Goat, page 145

Portrayals of the 12 signs of the zodiac, or their glyphs, have traditionally featured in the star maps created by astrologers and astronomers, when the zodiacal constellations may be shown forming a circle. Because every one is associated with a period of around 28 days (roughly a month), the zodiacal signs, which together comprise a full year, may also be depicted in works of art that have a calendrical focus, with each – often with seasonal correspondences – representing the appropriate time of year (as in books of hours). Medical and esoteric diagrammatic drawings may additionally incorporate the zodiacal symbols.

Piscean month
Two joined fishes represent Pisces, in an illustration from a mid-15th-century French book of hours. The month ruled by this zodiacal sign begins on around 19 February – wintertime in northern Europe – which is why a man is warming his feet by the fire.

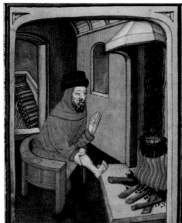

Sagittarius, the Archer

The influence of Sagittarius permeates the Earth from about 22 November, and because its ruling planet is Jupiter, its element is fire, its quadruplicity is mutable and its polarity is masculine, this is expansive, vital, changeable and energetic. Envisaged as a centaur, the zodiacal Archer's glyph symbolises an arrow.

Capricorn, the Goat

Capricorn is sometimes portrayed with a fishtail; its glyph may include this detail, and a pair of goatish horns, too. Saturn is Capricorn's ruling planet, and it has an earthy element, a cardinal quadruplicity and a feminine polarity. Ascendant from about 22 December, Capricorn's nature is sober and ambitious.

Aquarius, the Water-carrier

Aquarius is the Water-carrier, underlined by the wave-like lines that comprise its glyph. Coming to the fore from 20 January, Aquarius's ruling planet (Uranus or Saturn), element (air), quadruplicity (fixed) and polarity (masculine) make for an analytical and determined character.

Pisces, the Fishes

The glyph that symbolises Pisces, the sign of the Fishes, represents two bound fishes. The Piscean period starts on 19 February, and the combination of Neptune or Jupiter (Pisces's ruling planet), water (its element), a mutable quadruplicity and a feminine polarity infuses it with idealistic qualities.

The Four Elements & Humours

The theory of the Four Elements – fire, water, air and earth – which originated in ancient Greece, is symbolised in medieval and Renaissance medical illustrations and in alchemical and astrological diagrams, for it was once believed that this quaternity made up everything in the universe. Each element, or principle, is said to comprise two qualities (hot, dry, cold or moist), and is associated with three zodiacal signs (trigons or triplicities). And while each sign of the zodiac is linked with part of the human body, the elements were additionally thought to influence human health through the Four Humours.

The four zodiacal elements
The central circle of a zodiacal wheel depicted in a 15th-century French manuscript has been divided into four quarters. Each quarter represents one of the four elements: fire, water, air and earth.

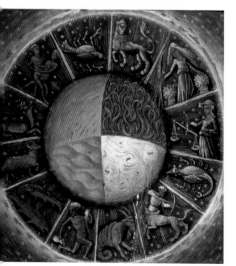

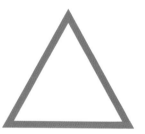

Fire
Hot and dry, fire stands in opposition to water, this masculine element's trigon being Aries, Leo and Sagittarius. In alchemical tracts, fire is symbolised by an upward-pointing triangle; it can also be denoted by the salamander or, in art, by the Graeco-Roman god Hephaestus/Vulcan.

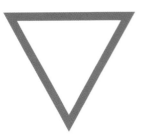

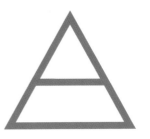

Water

A feminine element whose trigon comprises Cancer, Scorpio and Pisces, water's qualities are cold and moist. The opposite of fire, it is signified by a downward-pointing triangle in alchemy, but may alternatively be symbolised by undines, its elemental spirits. The Graeco-Roman sea god Poseidon/Neptune can denote water, too.

Air

Air is a hot, moist, masculine element, whose trigon consists of Gemini, Libra and Aquarius, and which contrasts with earth. Alchemists represent it with an upward-pointing triangle crossed by a horizontal line, or with its elemental spirits, sylphs. The Graeco-Roman goddess Hera/Juno may symbolise air in art.

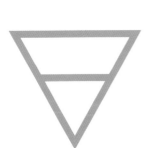

Earth

Earth, air's opposite, is denoted by a downward-pointing triangle divided by a horizontal line, or by gnomes, its elemental spirits, while Graeco-Roman mother goddesses like Demeter/Ceres may represent it in art. Taurus, Virgo and Capricorn form the trigon associated with this cold, dry, feminine element.

The Four Humours

Four Humours – symbolised by a lion, lamb, ape and pig – were once thought to circulate in the body. The fiery humour (yellow bile) created choleric types. The watery humour (phlegm) produced phlegmatic personalities. The airy humour (blood) encouraged sanguineness. And the earthy humour (black bile) caused melancholy.

Occult & secret symbols

See also
Pair of compasses,
page 23
**Lightning-struck
Tower,** page 43

Europe has a rich history of symbol-permeated occult traditions and secret societies, many of which live on today, which means that you are just as likely to see a 21st-century representation of a pentagram as a symbol of Wicca, for instance, as of you are of a medieval necromancer, while the design of Tarot cards is constantly being reinvented. Foremost among these esoteric systems and secret societies are alchemy, Rosicrucianism and Freemasonry, all of which were condemned by the once all-powerful Roman Catholic Church, which is why their symbolic languages evolved, in part, at least, as a form of covert communication to avoid persecution.

Androgyne

Early alchemists sought the elixir of eternal life, as well as a method of transmuting base metals into gold, using an elaborate symbolic system with which to record their theories and chemical experiments. The Androgyne, a hermaphroditic figure combining the male and female principles, represents the ideal totality.

XII
Der GEHÄNGTE

A major-arcana Tarot card

The Hanged Man is a highly symbolic major-arcana Tarot card, but its significance is not necessarily negative. This version is drawn from a German set of cards based on the early 20th-century Rider-Waite Tarot deck designed by Arthur Edward Waite with Pamela Colman Smith.

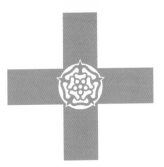

Rosicrucian rose cross

The primary symbol of Rosicrucianism is the rose cross – a cross with a rose at its centre – in fact, a rebus representing the name of the mystical secret society (*Rosae Crucis* being Latin for 'Rose of the Cross') and of its reputed founder, Christian Rosenkreuz (German for 'Rosy Cross').

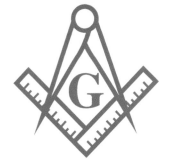

Masonic symbol

The secret society of Freemasons dates from 1717, yet its members claim links with the masons who constructed Solomon's Temple and with the medieval guild of stonemasons who developed their secret signs. Freemasonry's best-known symbol combines a G, for God (and geometry), with compasses and a set square.

Pentagram

The pentagram is a five-pointed star that symbolises the universal or cosmic man – or woman – five being the number of humanity (for humans have five senses and a head plus four limbs). The points also represent the five elements (the conventional four, plus ether, or spirit) and thus wholeness.

Tarot's Hanged Man

Used for divination and meditation, a set of Tarot cards comprises 22 major-arcana cards and 56 minor-arcana cards consisting of four suits of 14

cards. The card pictured is number 12 of the major arcana, and represents the Hanged Man, which symbolises self-sacrifice in exchange for wisdom.

Fantastic creatures

See also
Dragon, page 159
Phoenix, page 159
Unicorn, page 159

The fantastic beings dreamed up by the European imagination have resonated so powerfully in the continent's sacred myths and concepts that they have become engrained in its cultural traditions. Many of these fabulous creatures of the sky, sea and earth were bequeathed by the ancient Greeks and Romans, who illustrated their tales of heroic exploits on, for example, Attic vases and in Roman mosaics. While some beasts symbolised otherwise inexplicable natural phenomena, others represented good or evil supernatural forces, distinctions subsequently reinforced in Christian allegory. Depictions of related heraldic monsters, drawn from medieval bestiaries, often feature in armorial bearings.

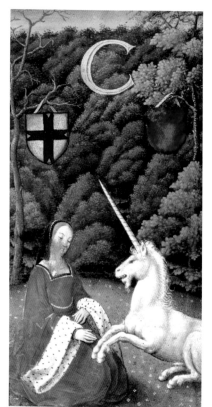

The lady and the unicorn
A snow-white unicorn is depicted resting docilely alongside a noble lady in an illustrated frontispiece to Gilles Hardouyn's printed *Book of Hours for the use of Rome* (published in France in around 1510). Only a virgin was said to be able to tame this wild fantastic creature.

Pegasus

In Graeco-Roman mythology, Pegasus, a winged white horse, was said to be the offspring of Poseidon/Neptune, the god of the sea, and the Gorgon Medusa. The mount of such heroes as Perseus, the high-flying Pegasus represented spirituality and nobility (and, in Renaissance allegory, fame).

Unicorn

Descriptions of the Western unicorn vary – it may have an antelope or horse's body, for instance – but all agree that a purifying horn grows from its head. In Christian tradition, this white symbol of purity is only tameable by a virgin, and can consequently denote Christ.

Phoenix

The golden Western phoenix was said to expose itself voluntarily – and fatally – to the sun's fiery rays every 500 years, before rising reborn from the ashes of its funeral pyre. To the Romans, it symbolised the dead emperor's deification, while Christians associated it with Christ's Resurrection.

Dragon

The Western dragon is characterised as the embodiment of evil, being equated with the 'serpent' Satan in Christian belief. Said to breathe fire, the dragon may have a bat's wings, a raptor's talons, a reptile's scaly skin and a snake's tail (which, if knotted, signifies its defeat).

The Four Seasons

See also
Corn and wheat,
page 11
Cornucopia,
page 25

The European tradition of representing the seasons of the year as female figures stems from the ancient Greeks, who envisaged them as three or four goddesses known as the *Horai* ('Hours'). The *Horai*, who were believed to control natural seasonal changes, were each portrayed holding appropriate natural attributes, but from Renaissance times other Graeco-Roman gods could take their place. Because they denote the passing of time and the cycle of existence, the Four Seasons may also allude to the four stages of human life in art, symbolising other allegorical quartets, too, such as the Four Elements (*see pages 224–5*).

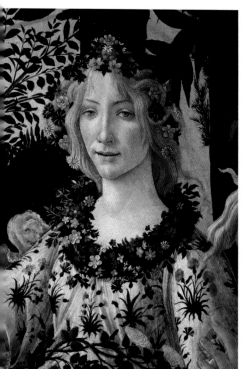

Symbol of spring
A multitude of delicate flowers bedecks Flora in this detail of Italian artist Sandro Botticelli's masterpiece *Primavera* (*c.*1478), or *Spring*. Flora was an ancient Roman goddess of flowers and spring, who could consequently symbolise this season in allegorical paintings, particularly in Renaissance art.

Spring

The *Hora* that represents spring is depicted holding flowers – spring flowers alone may symbolise this season – and the Graeco-Roman deities often substituted for her are Aphrodite/Venus and Flora. Spring may also be signified by a baby or child, and is associated with the element of air.

Summer

Ripe crops are harvested in summer, so the *Hora* that represents this season (or else Demeter/Ceres) may be portrayed adorned with ears of corn and carrying a wheat sheaf, sickle or scythe. Fruit may also symbolise summer, which is linked with the prime of human life and fire.

Autumn

In the Mediterranean region, grapes are picked in autumn, which is why they, along with vine leaves, may decorate the *Hora* that signifies this season, or, alternatively, the Graeco-Roman god Dionysus/Bacchus. A cornucopia may also symbolise autumn, which denotes the mature stage of human life, and earth.

Winter

Winter may be represented by various figures in art: by a woman wrapped up warmly; by a cloaked elderly man; or by the Graeco-Roman Hephaestus/Vulcan, Boreas (god of the north wind) or Irene, alongside a leafless tree (a typical wintry symbol). Winter signifies old age and death, and water.

Life & death

See also
Skeleton, page 47
Death, page 95

Although symbolic allusions to life and death may appear in any painting, these themes are the primary concerns of two types of allegories: those representing the ages of man (or humankind), and those referring to life's transience and the ultimate worthlessness of earthly possessions. While the brevity of life is implicit in ages-of-man representations – which span the course of human existence from infancy through maturity to old age, but of which there is no set number – it is the central message of the *Vanitas* (Latin for 'Vanity' or 'Emptiness') still-life paintings that were particularly popular in 17th-century Europe.

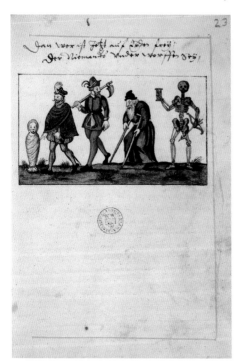

The five ages of man
A 17th-century illustration accompanying an alchemical poem in a German manuscript depicts five ages of man. A baby in swaddling clothes, denoting birth and childhood, stands to the left of two figures representing youth and maturity, with old age and death following on behind.

Birth and childhood

Because a bird's egg has the potential to nurture developing offspring, it may be equated with the human womb and may symbolise fertility, new life, birth and children. Young animals, spring flowers and, indeed, human babies and infants also represent this initial phase of life.

Courtship and betrothal

Young adulthood has always been a time of courtship, and because matchmaking often had serious dynastic significance in centuries past, art might be commissioned to promote or mark engagements. In Renaissance art, a betrothal could be symbolised by a carnation.

Marriage and maturity

Just as eggs may symbolise children, so a pair of birds – lovebirds – can represent their prospective parents in European art. When romantic love (leading to marriage) is signified, the birds depicted are typically white doves, for these were sacred to Aphrodite/Venus, the Graeco-Roman goddess of love and fertility.

Old age and death

While a stick may signify old age in representational art, an hourglass (which suggests that the sands of time are fast running out) is often seen in *Vanitas* paintings. Similar symbols of (impending) death include other timepieces, guttering or snuffed-out candles, as well as skulls, skeletons and empty shells.

The Seven Liberal Arts

See also
The Four Arts of the Chinese scholar, pages 160–61

The grouping of subjects classified as the Seven Liberal Arts dates back to ancient Rome; it was immortalised in the 5th century in an allegorical text, *The Marriage of Philology and Mercury*; and was regarded, in medieval and Renaissance times, as the basis of a good education.

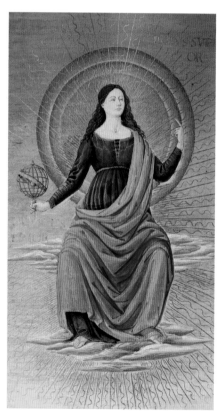

Comprising the *Trivium* ('Three Roads' in Latin) of Grammar, Logic or Dialectic and Rhetoric, and the *Quadrivium* ('Four Roads') of Geometry, Arithmetic, Astronomy and Music, the seven could be portrayed as women, sometimes with their 'mother', Philosophy. Each could also be symbolised by an appropriate attribute (four being shown here) or historical figure.

Astronomy's armillary sphere

The figure of Astronomy (*Astrologia*) grasps the armillary sphere that is one of her most distinctive attributes in this allegorical portrayal from a 16th-century Italian manuscript entitled *Delle Arti e Delle Scienze* (*Of the Arts and Sciences*). The armillary sphere may symbolise the universe.

Astronomy (*Astrologia*)

The figure of Astronomy (*Astrologia* in Latin) may hold, or be symbolised by, an armillary sphere (as depicted at right) or a celestial globe representing a map of the heavens. Other of Astronomy's attributes may include a pair of compasses, a sextant or an astrolabe. Ptolemy may represent Astronomy, too.

Grammar (*Grammatica*)

Grammar (*Grammatica* in Latin) is often portrayed as a woman instructing her pupils, with a whip (as shown above) or rod in hand with which to reinforce her lesson. Alternatively, she may be depicted watering plants. The historical figures that can instead represent Grammar are the grammarians Priscian or Donatus.

Music (*Musica*)

Music (*Musica* in Latin) is usually portrayed as a woman holding an instrument, such as a lute or a harp; another attribute is a swan, which was said to sing only when dying. The men who may denote Music are Pythagoras or Tubal-cain, a descendant of Cain.

Arithmetic (*Arithmetica*)

The attributes that are frequently depicted in association with the female personification of Arithmetic (*Arithmetica* in Latin), or that symbolise the subject, include a tablet or scroll inscribed with numbers, an abacus or a ruler. Pythagoras is the celebrated mathematician who can alternatively represent Arithmetic.

Introduction

See also
Octopus, page 49

Kangaroo tracks
The tracks of indigenous creatures in Australian Aboriginal paintings look exactly as they would if you were tracking that animal, bird or reptile by following in its footsteps. A kangaroo's path is symbolised by a pair of parallel lines, each of which terminates at the bottom in a short, outward-pointing, diagonal line.

Although their representational styles reveal distinct cultural differences, the art forms of Oceania share many symbolic similarities. For underlying this region's art is a powerful ancestral connection with nature in all of its forms, be they landscape features, creatures of the earth, air and water, or climactic conditions. Australian Aboriginal art is primarily concerned with conveying the events and concepts of the Dreamtime, whose figurative and symbolic language may be replicated in rock, bark and body painting to affirm a sacred sense of collective identity. Maori art is less specifically focused, its traditional art forms – notably carving – being dominated by stylised, curvilinear motifs that embody dynamic energy.

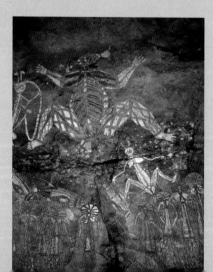

Aboriginal rock art
A small, white representation of Barrginj (*see* Dreamtime ancestors, opposite) is visible in this rock painting at the Kakadu National Park, Northern Territory, in Australia. The large 'X-ray style' figure above her portrays Namondjok, an Aboriginal creation ancestor.

Dreamtime ancestors

Ancient Australian Aboriginal rock art portrays such Arnhem Land Dreamtime ancestors as Barrginj, whose breasts and genitalia symbolize her ability to bear and nourish children. Barrginj, the wife of the lightning man Namarrgon, was said to be the mother of the Alyurr (known to non-Aborigines as Leichhardt's grasshoppers).

Tiki

Tiki means 'human image', also being the name of the first man in Maori belief. Stylised male and female *tiki* figures represent both mythic and actual forebears, symbolising a protective ancestral presence. The *tiki*'s thrust-out tongue is intended to signal defiance and scare evil influences away from its living descendants.

Koru

The *koru* is one of the most frequently represented motifs in Maori art. Describing as it does a circle consisting of an inward-curling spiral, the *koru* resembles the young fronds of New Zealand's native ferns. It therefore symbolises such dynamic concepts as the life force, growth and evolution.

Australian Aboriginal Dreamtime spirits

See also
Wawalag sisters,
page 241
**Snake and
lightning,** page 92

Aboriginal sacred belief focuses on the Dreamtime, or Dreaming, when primordial beings roamed Australia, creating its natural features and instructing humans in life skills. Such beings include the Mimi spirits, ancient rock-art portrayals of which are said to have been created by the spirits themselves, who taught the people to paint 'Mimi-style'. Most are considered symbolically (and actually) still part of the here and now, including rainbow serpents, which are believed to inhabit bodies of water, while lightning spirits make their presence felt during the wet season. And the Wandjinas are believed to have transformed themselves into ghost-like images.

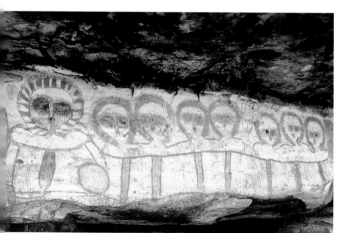

Wall of Wandjinas
A row of Wandjina spirits stare out from an Australian rock painting. According to Aboriginal belief, the Wandjinas transformed themselves into such painted images when they moved from sea to land; these 'portraits' therefore represent their spiritual presence.

Mimi spirits

Regarded as tricksters, Mimi spirits are portrayed as stick-like figures, often engaged in hunting or another pursuit that they are said to have taught people. They are symbolised by their extreme thinness, which enables them to live in rocky cracks, but not to withstand the wind.

Rainbow serpents

Belief in rainbow serpents is prevalent throughout Aboriginal Australia, with most symbolising water, their serpentine form representing water's movement, and their rainbow colouring, the rainy season. The rainbow serpent may denote fertility, but also destructive forces like flash-flooding.

Lightning spirits

Spectacular sheets of lightning are caused, according to some Aboriginal beliefs, by lightning spirits like Namarrgon. Such spirits may be symbolised by the arcs (denoting lightning) that surround them, created by the thunder-axes that are often shown on their person.

Wandjina spirits

Their hazy features and cloud-like haloes symbolise the Wandjinas' association with water. Said to have emanated from the clouds via the sea, these rain-bringing spirits are portrayed with round eyes and a nose, but no mouth; lines radiating from their haloes may signify lightning.

Aboriginal ancestral & totemic beings

See also
Kangaroo tracks,
page 236
Rainbow serpents,
page 239

Ancestral and totemic beings feature prominently in Australian Aboriginal artworks, their significance often lying in the tribe-establishing role that they played during the Dreamtime, or Dreaming, and in their continuing close connection with the individuals and clans claiming kinship with them. They may be portrayed in the form of humans, animals, birds, reptiles, insects or plants (many are credited with shape-shifting powers), the distinctive cross-hatched patterns (called *rarrk*) that may give substance and movement to their bodies further symbolising clan kinship. Totemic ancestors, such as the Wawalag sisters, and creatures like the kangaroo, the goanna and the possum, may be considered the primary symbols of a clan's collective identity.

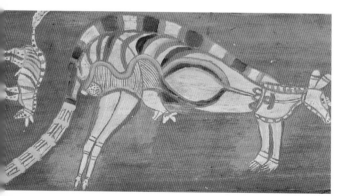

Kangaroo, joey and dingo
Irvala, an artist of Arnhem Land, has depicted a small figure of a dingo alongside a larger representation of a kangaroo in the bark painting reproduced here. Her joey, or baby, can be seen tucked into her pouch.

Wawalag sisters

There are many variations of the story of the Wawalag sisters, but the common theme underlining the interconnection between humankind and nature tells of a waterhole-inhabiting great python (a masculine symbol) swallowing and regurgitating the Wawalag sisters (feminine symbols).

Kangaroo

As well as having totemic significance, kangaroos have traditionally been a source of food. The 'X-ray style' in which kangaroos (and other creatures) can be portrayed in Aboriginal art serves an educational function, demystifying animal anatomy, thus aiding hunting and butchery.

Goanna

The goanna (a monitor lizard) may be represented either figuratively, as seen above, or in the form of a symbol consisting of a line (denoting its body) flanked by its footprints. A Dreamtime myth relates that a goanna turned itself into Queensland's Mount Maroon.

Possum

The large-eyed, prehensile-tailed possum, or opossum, may be depicted exactly as it looks, but this totemic Australian marsupial may alternatively be symbolised by its paw prints in Aboriginal art, each paw typically being shown as a diagonal line from which four smaller lines protrude, rather like a four-toothed comb.

Australian Aboriginal abstract symbols

See also
Adinkrahene,
page 69

U shapes
A U shape – which
may be inverted –
represents a person,
describing as it does
the mark created
when someone has
sat down on
the ground.

Some Australian Aboriginal artworks may appear, to the uninitiated eye, to be little more than abstract designs, yet their underlying significance is profoundly sacred and informative. Inspired by the Dreamtime – when wandering spirits brought the continent's natural components into being – and reflecting the traditionally nomadic Aboriginal way of life, these images may simultaneously convey a particular Dreamtime story symbolically and map out the specific area connected with it. The geometric and other symbols that feature in such artworks are, perhaps, most easily understood and decoded if you imagine that you are viewing an aerial photograph of a landscape.

Sacred map
The coiled body of
a serpent forms the
focal point of this
colourful Australian
Aboriginal painting.
The two sets of
concentric circles
on either side of
it may symbolise
resting points or
waterholes, while
the lines that lead
from them may
signify paths or
watercourses.

Concentric circles

Concentric circles may represent a number of landscape features, both static and ephemeral, but generally denote a site. They may, for example, signify a waterhole or a hole in a rock or the ground, or else a camping spot, or even just a meeting place.

Wavy lines

Wavy lines may signify flowing water or the irregular movement of another dynamic natural force, such as lightning, a bushfire or smoke. A wavy line may also represent the sinuous body of a reptile, in which case a head or feet may be suggested.

Dots

Dots symbolise a number of natural features or occurrences, including raindrops, sparks from a fire, starlight, berries and eggs. If an entire painting is covered in dots, these may be intended to obscure the image's sacred meaning from the uninitiated.

Short lines

Short, oval, bar-like lines, as illustrated above, may represent digging sticks (traditionally used to dig up edible roots) or clapping sticks (used in ritual singing and dancing). Short straight lines, sometimes hooked at one end, may symbolise spears.

Straight lines

Straight lines represent direct movement, and especially the route taken to get to a certain place, such as a campsite (as depicted here). A straight line shown between an animal's tracks may symbolise the creature's body, or its progress.

Maori fantastic creatures

See also
Thunderbird,
page 87
Dragon,
page 159

Terrible *taniwha*
Taniwha dominate
a reconstruction
of a Maori rock
drawing; one has
devoured a human,
it is thought, and is
drowning another.
The 16th-century
original was
outlined on the
ceiling of a
limestone shelter
in New Zealand.

An array of fantastic creatures features in the symbolic vocabulary of the Maori carving tradition. Especially notable are representations of the bird-like *manaia* and the aquatic *taniwha*, with the *poukai* (a terrifyingly enormous bird of prey) and the *marakihau* (a distinctive 'species' of *taniwha*) also being included in Maori artists' repertoire of fantastic – and usually fearsome – animal-, fowl- and fish-based forms. These imaginary creatures usually symbolise unknown, little-understood or dangerous natural forces and conditions, which may be considered a threat to the Maoris, their world or their worldview, but may also act as protective powers.

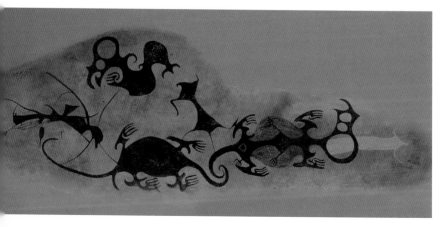

Manaia

Although *manaia* often resemble lizards, the similarity of their pointed jaws to birds' beaks has caused them to be identified as 'bird-men' (their bodies may be human, albeit with three claw-like digits per limb). *Manaia* may represent spirit guides and guardians, particularly after death.

Poukai

Portrayed as a huge, winged creature with a curved beak, the *poukai* seizes and devours humans, according to Maori myths. Although the *poukai* may once have existed (as the now-extinct Haast's eagle), it today symbolises destructive airborne forces that may strike without warning.

Taniwha

The monstrous *taniwha* inhabit and symbolise specific bodies of water, so they are often depicted with the tail of an aquatic creature. Some *taniwha* are believed to be enemies of humankind, and others, benevolent and powerful guardians.

Marakihau

A type of *taniwha*, the *marakihau* haunts the depths of the ocean. The *marakihau*'s most notable physical feature is the tubular tongue with which it sucks up its prey, thus denoting the potentially all-consuming power that lurks within the seas.

Glossary

ACHIEVEMENT OF ARMS in heraldry, a complete representation of armorial bearings, typically displaying a shield, helm, crest wreath or coronet, mantling, crest and supporters.

ACROSTIC a section of text within which certain letters form a significant word or words.

AEGIS in Graeco-Roman mythology, the shield of Zeus/Jupiter, which Athena/Minerva was also depicted wearing as a cloak or bearing as a shield.

AFFRONTY a heraldic term meaning facing the viewer head-on.

ALLEGORY an artwork that symbolically alludes to a deeper or more abstract meaning or idea.

AMORETTO/AMORETTI see **PUTTO/PUTTI**.

AMULET a symbolic object or image that is believed to have the power to ward off evil or to bring good luck.

ANICONIC not represented as a human or an animal, but by means of symbols.

ARCHETYPE an inherited symbolic image, contained within humankind's collective unconscious, that represents an aspect of the universal human experience.

ARMIGER meaning 'armour-bearer' in Latin, a heraldic expression signifying a person who is entitled to bear arms.

ARMS in heraldry, a shield of arms (sometimes also an achievement of arms is meant; *see above*).

ASANA a ritual pose in Hinduism and Buddhism.

ATTRIBUTE an object or feature that identifies or symbolises a deity or saint, and which may be depicted either accompanying him or her or on its own.

AVATAR meaning 'descent' in Sanskrit, one of Vishnu's nine earthly manifestations in Hinduism.

BADGE in heraldry, also known as a heraldic or armorial badge: a heraldic device separate from an achievement of arms (*see above*) that can be used by a bearer's allies and associates, as a symbol of allegiance or belonging.

BESTIARY a collection of annotated, moralising illustrations of animals and fabulous creatures popular in Europe during the medieval period.

BLAZON the language, or vocabulary, used to describe the components of British heraldry.

BODHISATTVA an enlightened being who has elected to remain on the human plane in Buddhist belief.

BRISURE see **CADENCY, MARK OF**.

BUDDHAPADA Buddha's footprints.

CADENCY, MARK OF a heraldic term, also called a brisure, denoting one of nine different small charges, or symbols, positioned centrally on a shield to denote a son's position within a family.

CADUCEUS the winged, serpent-entwined staff carried by the Graeco-Roman messenger god Hermes/Mercury.

CARTOUCHE the oval shape enclosing the hieroglyphs spelling out an ancient Egyptian pharaoh's *praenomen* and *nomen*.

CHAKRA Sanskrit for 'wheel' or 'circle'; the eight-spoked *dharma-chakra* is the 'Wheel of the Law' in Buddhism.

CHARGE a symbol or emblem positioned on an ordinary or heraldic shield.

CHERUBIM an order of angels in the Judaeo-Christian tradition.

CHTHONIC relating to the underworld.

CINQUEFOIL a five-petalled, stylised flower used in heraldry.

CLAN a group of interrelated people, often with a common ancestor.

CODEX, CODICES a volume, or volumes, comprising separate leaves of ancient manuscripts.

COSMOLOGY an account of how the cosmos came into being, and its characteristics.

CREST 1) in European heraldry, a three-dimensional symbolic device surmounting a helmet; 2) a symbolic emblem of the peoples of North America's Northwest Coast.

CROSS-HATCHING two sets of crossing parallel lines.

CULTURE HERO in mythology, a being that creates, aids or promotes human culture.

DETERMINATIVE in the ancient Egyptian system of writing, a sign that determines or clarifies the meaning, or sense, of other hieroglyphs.

DEXTER in heraldry, the right-hand side of a shield from the bearer's point of view, but the left-hand side when regarded from the viewer's perspective.

DORJE *see* **VAJRA**.

DREAMTIME (OR DREAMING) in Australian Aboriginal belief, the period when primordial spirits and ancestral beings created the land and its components.

FIELD a heraldic term signifying the background of a shield or flag.

FORM LINES the system of stylised lines used to represent creatures in the art of the Northwest Coast region of North America.

GLYPH a symbolic image.

GORGONEION a Classical symbol representing the severed head of the Gorgon Medusa, which was believed to have the power to fend off evil.

HELM a heraldic word for a helmet.

HEXAGRAM 1) a six-pointed star; 2) in the *I Ching* (*Book of Changes*), a symbol comprising six broken or unbroken horizontal lines.

HIEROGLYPH a pictorial character used in the ancient Egyptian system of writing.

HOMONYM a word that sounds or looks like another, but has a different meaning.

'HUMOURS' the four fluids that were once thought to influence the human personality.

'HUNTING MAGIC' the creation of symbolic scenes depicting hunted animals in the belief that these would be magically reproduced in the real world.

ICONOGRAPHY 1) the symbols used in art and their meanings; 2) the collective body of images used to represent a particular figure or subject.

IDEOGRAM a written symbol that represents an object or concept.

IMPRESA/IMPRESE meaning 'devices' in Italian, *imprese* are personal emblems or symbols often seen in Renaissance art.

INSIGNIA a symbol or emblem of office or membership.

KACHINA rain-bringing spirit helper of the Pueblo peoples (notably the Hopi and Zuni) of the North American Southwest region.

LABEL a heraldic mark of cadency signifying an eldest son, comprising a horizontal line from which are suspended three or five 'points'.

LAKSHANA a physical sign in the Indian subcontinent; 32 *lakshanas* identify the Buddha.

LINGAM a symbol denoting a phallus, the masculine principle or Shiva in Hindu and Tantric art.

LOGOGRAM a written symbol that represents an entire word or phrase.

LOZENGE an unmarried or divorced female armiger's diamond-shaped alternative to a man's shield in heraldry.

MACROCOSM a large, complex structure representing a totality.

MANDALA 'circle' in Sanskrit, a circular symbolic representation of the cosmos or consciousness used for meditation, particularly in Buddhism.

Glossary

MEMENTO MORI a Latin phrase meaning 'Remember you must die', often expressed symbolically in art through symbols that represent death or the transience of life.

MESOAMERICA Central America.

MESOPOTAMIA a region of southwestern Asia, roughly between the Tigris and Euphrates rivers.

MICROCOSM a miniature representation or symbol of a far larger equivalent (a macrocosm), such as a human figure in relation to the cosmos.

MON a circular Japanese heraldic badge.

MONOGRAM a stylised design comprising one or more letters, usually initials.

MORAN a Masai warrior.

MUDRA a ritual, symbolic hand gesture in Hindu and Buddhist tradition.

MULLET (OR MOLET) a five-pointed, unpierced star, a heraldic mark of cadency identifying a third son.

NETSUKE a sculpted toggle, the carving of which has become a Japanese art form.

NIRVANA in Buddhist and Hindu belief, release from *samsara*.

NOMEN Latin for 'name', referring to the ancient Egyptian pharaoh's birth name.

ORDINARY in heraldry, a linear shape on a shield.

OTHERWORLD in Celtic belief, the realm of the dead or the spirit world.

PA-KUA (OR BAGUA) TRIGRAMS in Chinese tradition, eight trigrams that each denote different permutations of the interaction between *yin* and *yang*.

PANTHEON a religion's deities.

PENTAGRAM a five-pointed star.

PHONOGRAM a written symbol that signifies a sound.

PICTOGRAM/PICTOGRAPH a written symbol that signifies a word or words.

'POWER' SYMBOL a symbol (often the image of a creature) that is believed to have the magical ability to impart its qualities to a person associated with it.

PRAENOMEN literally, 'before name' in Latin, the ancient Egyptian pharaoh's throne name.

PSYCHOPOMP a being (such as a deity, an angel or an animal) who conducts the souls of the dead from the world of the living to the realm of the dead.

PUTTO/PUTTI Italian for 'boy', or 'boys', also known as *amoretto/amoretti* or cherubs, portrayed in Western art as small, chubby boys, sometimes with wings.

QUADRUPLICITY in astrology, a quality (cardinal, fixed or mutable) shared by four zodiacal signs.

RANGOLI colourful symbolic Hindu dry paintings, traditionally drawn on floors.

REBUS a Latin word meaning 'concerning the things', referring, in heraldry, to an image representing a word or name, often being a pun on the name of an armiger.

RUNE one of the characters that make up the various Germanic runic alphabets, such as the Anglo-Saxon futhorc.

SAMSARA the endless cycle of life, death and rebirth in Hindu and Buddhist belief.

SAMURAI a member of the aristocratic Japanese warrior caste.

SAND (OR DRY) PAINTING a sacred image traditionally created from different-coloured grains of sand or dry material for ritual ceremonies, notably by the Navajo of North America (and by other peoples in other parts of the world, too).

SCARIFICATION deliberate scarring of the skin to form patterns that often have tribal significance.

SERAPHIM an order of angels in Judaeo-Christian belief.

SHAKTI in Hinduism and Tantrism, the active feminine divine creative energy.

SHAPE-SHIFTING a being's ability to change its form or appearance.

SOMA in Hinduism, an intoxicating liquid.

STATANT GUARDANT a heraldic term describing a beast represented with all four feet on the ground (statant) facing the viewer (guardant).

STELE an upright stone slab, usually inscribed or decorated.

STUPA a domed Buddhist or Jainist sacred monument.

SUPPORTERS in heraldry, figures positioned on either side of a shield of arms that appear to be supporting it.

SURREALISM a 20th-century European artistic movement influenced by Freudian theories, whose aim was to express the fantastic, dream-like images produced by the subconscious mind.

SYMBOL something that represents something else.

SYMBOLISM in the context of European art history, a movement spanning the late 19th and early 20th centuries that emphasised symbolic images and techniques.

SYNCRETISATION the combination of aspects of different religions or beliefs.

TABLETA the large headdress worn by dancers and dolls representing the *kachinas* of the North American Southwest.

TAI-CHI (TAIJI OR YIN–YANG) CIRCLE Chinese Taoism's stylised circle symbolising the ideal interaction between *yin* and *yang*.

TANTRISM a mystical form of Hinduism and Buddhism based on the concept of cosmic sexuality.

TAROT traditionally, a system of divination using a set of 22 major-arcana and 56 minor-arcana cards.

THANGKA (OR TANKA) a 'flat' painting or piece of decorative needlework portraying a Tantric Buddhist subject, commonly seen in Tibet and Nepal.

THYRSUS the pine-cone-tipped, ivy-ringed staff carried by Dionysus/Bacchus, the Graeco-Roman god of wine, and his followers.

TINCTURE a word used to denote a colour in heraldry.

TOTEM a symbol signifying a clan or tribe, often representing a common ancestor.

TREFOIL a symbol comprising three stylised leaves or petals.

TRICKSTER in mythology, a being whose energetic, erratic behaviour may be beneficial or destructive.

TRIGRAM a symbol consisting of three lines.

TRIMURTI Sanskrit for 'Having Three Forms'; in Hinduism, the divine trio of Brahma, Vishnu and Shiva.

UKIYO-E 'pictures of the floating world' in Japanese, a style of art popular from the 17th to 19th centuries in Japan.

URAEUS the rearing cobra that was often depicted above a god or pharaoh's forehead in ancient Egyptian art.

VAHANA the 'vehicle' or 'mount' of a Hindu deity.

VAJRA the 'thunderbolt' or 'diamond' staff or mace, also known as a *dorje*, carried by certain Hindu or Buddhist deities.

VANITAS 'Vanity' or 'Emptiness' in Latin, a genre of allegorical still-life paintings in Western art, symbolising the transience of life and the inevitability of death.

VEVE a symbol representing a Voodoo deity or spirit.

YANG the masculine, positive, active universal energy, according to Chinese Taoist belief.

YANTRA 'instrument' in Sanskrit, a complex Tantric geometrical, diagrammatic image, akin to a mandala, that symbolises the universe.

YIN in Chinese Taoist belief, the female, negative, passive universal energy.

YONI a symbol signifying the vulva, feminine principle or *shakti* in Hindu and Tantric art.

Resources

General bibliography

COOPER, J C, *An Illustrated Encyclopaedia of Traditional Symbols* (Thames & Hudson, London, 1978)

GIBSON, CLARE, *Goddess Symbols: Universal Signs of the Divine Female* (Saraband, Rowayton, 1998)

GIBSON, CLARE, *The Hidden Life of Art: Secrets and Symbols in Great Masterpieces* (Saraband, Glasgow, 2006)

GIBSON, CLARE, *Sacred Symbols: A Guide to the Timeless Icons of Faith and Worship* (Saraband, Rowayton, 1998)

GIBSON, CLARE, *Signs & Symbols: An Illustrated Guide to Their Meaning and Origins* (Saraband, Rowayton, 1996)

HALL, JAMES, *Hall's Illustrated Dictionary of Symbols in Eastern and Western Art* (John Murray, London, 1994)

SHEPHERD, ROWENA, & SHEPHERD, RUPERT, *1000 Symbols: What Shapes Mean in Art & Myth* (Thames & Hudson, London, 2002)

WERNESS, HOPE B, *The Continuum Encyclopedia of Native Art: Worldview, Symbolism & Culture in Africa, Oceania & Native North America* (The Continuum International Publishing Group, New York, 2000)

Africa

ADKINS, LESLEY & ROY, *The Little Book of Egyptian Hieroglyphs* (Hodder & Stoughton, London, 2001)

GIBSON, CLARE, *The Hidden Life of Ancient Egypt: Decoding the Secrets of a Lost World* (Saraband, Glasgow, 2009)

LURKER, MANFRED, *The Gods and Symbols of Ancient Egypt: An Illustrated Dictionary* (Thames & Hudson Ltd, London, 1980)

McDERMOTT, BRIDGET, *Decoding Egyptian Hieroglyphs: How to Read the Secret Language of the Pharaohs* (Duncan Baird Publishers, London, 2001)

OWUSU, HEIKE, *African Symbols* (Sterling Publishing Company, New York, 2000)

ROBINS, GAY, *The Art of Ancient Egypt* (The British Museum Press, London, 1997)

WILKINSON, RICHARD H, *Reading Egyptian Art: A Hieroglyphic Guide to Ancient Egyptian Painting and Sculpture* (Thames & Hudson Ltd, London, 1992)

The Americas

FEEST, CHRISTIAN F, *Native Arts of North America* (Thames & Hudson, London, 1992)

KEW, DELLA, and GODDARD, P E, *Indian Art and Culture of the Northwest Coast* (Hancock House Publishers, Surrey, BC, 1974)

MILLER, MARY, and TAUBE, KARL, *The Gods and Symbols of Ancient Mexico and the Maya: An Illustrated Dictionary of Mesoamerican Religion* (Thames & Hudson, London, 1993)

TAYLOR, COLIN F, *The Plains Indians: A Cultural and Historical View of the North American Plains Tribes of the Pre-reservation Period* (Salamander Books, London, 1994)

WHERRY, JOSEPH H, *The Totem Pole Indians* (Thomas Y Crowell Company Inc, New York, 1974)

Asia

FRÉDÉRIC, LOUIS, *Buddhism* (Flammarion, Paris, 1995)

GIBSON, CLARE, *The Ultimate Birthday Book: Revealing the Secrets of Each Day of the Year* (Saraband, Rowayton, 1998)

McARTHUR, MEHER, *Reading Buddhist Art: An Illustrated Guide to Buddhist Signs & Symbols* (Thames & Hudson, London, 2002)

UNTERMAN, ALAN, *Dictionary of Jewish Lore & Legend* (Thames & Hudson Ltd, London, 1991)

WILLIAMS, C A S, *Chinese Symbolism and Art Motifs: A Comprehensive Handbook on Symbolism in Chinese Art Through the Ages* (Tuttle Publishing, North Clarendon, VT, 1974)

Europe

BEDINGFELD, HENRY, and GWYNN-JONES, PETER, *Heraldry* (Bison Books, London, 1993)

DUCHET-SUCHAUX, G, and PASTOUREAU, M, *The Bible and the Saints* (Flammarion, Paris, 1994)

ELLWOOD POST, W, *Saints, Signs and Symbols: A Concise Dictionary* (SPCK, London, 1972)

FISHER, SALLY, *The Square Halo & Other Mysteries of Western Art: Images and the Stories that Inspired Them* (Harry N Abrams, New York, 1995)

FOX-DAVIES, A C, *A Complete Guide to Heraldry* (Thomas Nelson & Sons, London, 1925)

FRIAR, STEPHEN, *Heraldry: For the Local Historian and Genealogist* (Alan Sutton Publishing Limited, Stroud, 1992)

GIBSON, CLARE, *The Hidden Life of Renaissance Art: Secrets and Symbols in Great Masterpieces* (Saraband, Glasgow, 2007)

GIBSON, CLARE, *The Ultimate Birthday Book: Revealing the Secrets of Each Day of the Year* (Saraband, Rowayton, 1998)

GIBSON, CLARE, *The Ultimate Book of Relationships: Revealing the Secrets of Compatible Partnerships* (Saraband, Glasgow, 2004)

GREEN, MIRANDA J, *Dictionary of Celtic Myth and Legend* (Thames & Hudson, London, 1992)

OSWALT, SABINE G, *Concise Encylopedia of Greek and Roman Mythology* (Wm Collins Sons & Co, Glasgow, 1969)

Oceania

CARUANA, WALLY, *Aboriginal Art* (Thames & Hudson, London, 1993)

LEWIS, DAVID, and FORMAN, WERNER, *The Maori Heirs of Tane* (Orbis Publishing, London, 1982)

THOMAS, NICHOLAS, *Oceanic Art* (Thames & Hudson, London, 1995)

USEFUL WEBSITES

Africa

Adinkra Symbols and Meanings
www.welltempered.net/adinkra/htmls/adinkra_index.htm
www.africawithin.com/tour/ghana/adinkra_symbols.htm

The Americas

Northwest Coast Native Art
www.pathgallery.com

Native American Symbols and Meanings
www.buckagram.com/buck/symbols
www.collectorsguide.com/fa/fa040.shtml

Asia

Online Asian art gallery
ww.orientaloutpost.com

Europe

The British Museum
www.britishmuseum.org/explore/explore_introduction.aspx

The Metropolitan Museum of Art/the Heilbrunn Timeline of Art History
www.metmuseum.org/toah/

The National Gallery
www.nationalgallery.org.uk/collection/default.htm

Oceania

Galleries of Aboriginal Art
www.aboriginal-art.com
www.aboriginalartonline.com
www.aboriginalartstore.com.au

Index

Index

Acknowledgements

AUTHOR ACKNOWLEDGEMENTS

🖐 Sincere thanks to Sara Hunt, for setting, and keeping, me on the symbols path.

🖐 Heartfelt thanks to Mike Haworth-Maden, for his constant support.

🖐 *Tausend Dank* to Marianne Gibson and John Gibson, for their unfailing encouragement, and for some invaluable source material.

🖐 Finally, I am most grateful to Caroline Earle and the team at Ivy Press, not least for their hard work and attention to detail.